AIRPORT DESIGN

daab

Airports / Location	Architects / Designers	Page

Airports / Location	Architects / Designers	Page

INTRODUCTION

Airports are highly appealing places. Gateways to the big wide world, they represent international movement and inspire travel. Spielberg's film, "The Terminal" shows the full fascination these places exercise. Transferring his film's entire scenario to John F Kennedy International Airport in New York, Spielberg tells the story of a man forced to spend a long time living at the airport because of problems with his identity-papers. We soon realise international airports are a universe on their own—a world between worlds.

The boom in international air travel of recent years has resulted in a vast number of new airport buildings—a real challenge for architects. Passenger-flows must be watched, journey times shortened, high standards of security maintained, and many different needs catered for—all under one roof. Recently, lots of airports have become more like shopping malls—with add-on runways where airplanes take off and land. They risk being too vast to be user-friendly, and all the bright lights, gimmicks and gizmos make it hard for passengers to get their bearings. Here, more straightforward architecture would help.

Aviation history is only a century old, and so no definite style has yet evolved for airport terminal buildings. Architects are always trying out new ways of organizing and presenting buildings—while meeting strict and complex demands. At best they manage to free up more space and turn concepts like "movement", "dynamics" and "lightness" into one overall design, creating buildings that are both expressive and have attitude.

These pages show you not only real terminals but also airport-specific design and architecture—from VIP lounges to passenger routes, from control towers to hangars and airplane museums. Because of their size and the range of their services, airports often seem to be a city within a city. Pulling together airports from all over the world, this book presents a full picture of airport buildings built in the last few years. It also peers behind the scenes into new design plans, revealing ideas that are waiting to happen. As well as visions that may or may not be realized, the book shows many projects which will definitely take shape in the near future.

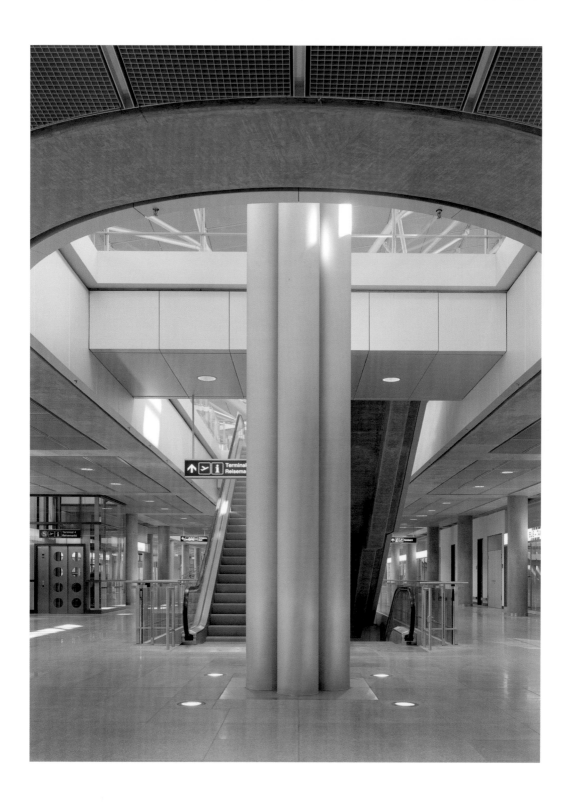

Flughäfen sind Orte von besonderer Anziehungskraft. Sie sind das Tor zur weiten Welt, stehen für Internationalität und wecken Fernweh. Wie groß die Faszination sein kann, die von ihnen ausgeht, zeigt der Film „Terminal". Steven Spielberg fing die Atmosphäre des John F. Kennedy International Airport in New York ein und verlegte die Handlung komplett in den Flughafen. Er erzählt die Geschichte eines Mannes, der wegen Problemen mit seinen Ausweispapieren gezwungen ist, über einen längeren Zeitraum auf dem Flughafen zu leben. Hier wird deutlich: Internationale Flughäfen bilden einen Kosmos mit eigenen Gesetzen, eine Welt zwischen den Welten.

Da Fernreisen in den letzten Jahren boomten, ist auch eine Vielzahl neuer Flughafenbauten entstanden – für die Architekten eine große Herausforderung. Passagierströme müssen gelenkt, Wege kurz gehalten, hohe Sicherheitsstandards beachtet und unterschiedlichste Funktionen unter einen Hut gebracht werden. Viele Flughäfen sind inzwischen eher Shoppingcenter mit angehängter Start- und Landebahn. Sie laufen Gefahr durch die bunte Welt des Einkaufsrummels an Übersichtlichkeit zu verlieren und dem Fluggast die Orientierung zu erschweren. Eine klare Architektur kann hier Abhilfe schaffen.

Da die Geschichte der Luftfahrt erst rund hundert Jahre alt ist, hat sich für die Bauaufgabe Flughafen noch kein fester Typus entwickelt. Architekten experimentieren immer wieder mit der Organisation und dem Erscheinungsbild der Gebäude, soweit dies im eng gesteckten Rahmen der komplexen Anforderungen möglich ist. In günstigen Fällen schaffen sie sich den Freiraum, Themen wie „Bewegung", „Dynamik" und „Leichtigkeit" gestalterisch umzusetzen und lassen ausdrucksstarke Bauten entstehen.

Dieses Buch zeigt nicht nur die eigentlichen Terminals, sondern Design und Architektur rund ums Thema Flughafen: von der First Class Lounge über das Orientierungssystem, den Kontrollturm und den Hangar bis hin zum Flugzeugmuseum. Durch ihre Größe und die Vielfalt der verschiedenen Bauten mit ihren unterschiedlichen Funktionen bilden Flughäfen oft eine Stadt in der Stadt. Anhand von Beispielen aus aller Welt gibt das Buch einen Überblick über Gebäude, die in den letzten Jahren entstanden sind, schaut aber auch hinter die Kulissen der Planungsbüros und zeigt, was diese noch in Petto haben. Neben Visionen, deren Realisierung ungewiss ist, stellt das Buch auch Projekte vor, die in naher Zukunft verwirklicht werden sollen.

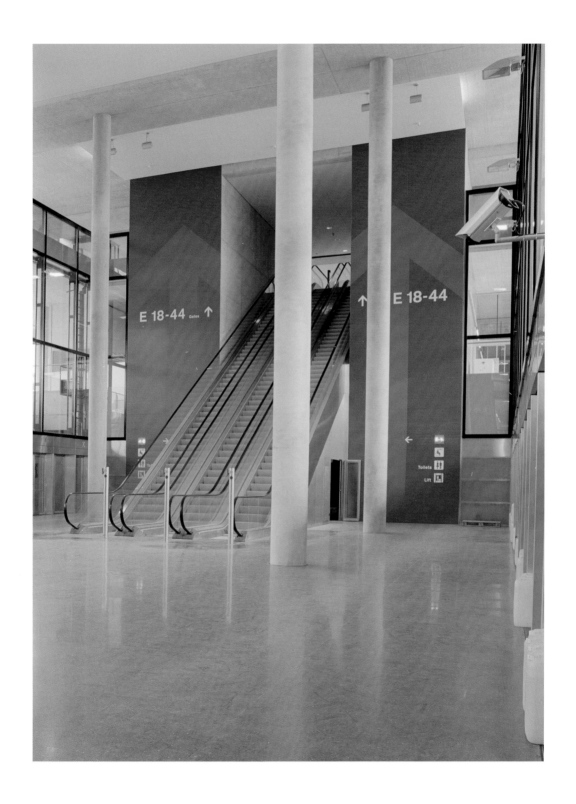

Les aéroports sont des lieux qui possèdent une force d'attraction bien particulière. Ils sont la porte ouverte sur le vaste monde, ils représentent l'internationalité et éveillent l'envie de courir le monde. Le film «Terminal» de Spielberg montre à quel point la fascination qu'ils exercent peut être grande. Stephen Spielberg rend l'atmosphère de l'aéroport John F. Kennedy à New York et place l'action du film du début à la fin dans l'aéroport. Il raconte l'histoire d'un homme qui, à cause de problèmes de papiers d'identité, est obligé de vivre pendant une longue période dans l'aéroport. On se rend alors clairement compte d'une chose : les aéroports forment des microcosmes avec leurs propres lois, des mondes entre les mondes.

Le nombre des voyages lointains ayant ces dernières années énormément augmenté, beaucoup de constructions d'aéroports ont vu le jour, ce qui représente un véritable défi pour les architectes. Les flots de passagers doivent être canalisés, les parcours optimisés, les exigeants standards de sécurité respectés, et on doit concilier les fonctions les plus différentes. De nombreux aéroports sont devenus entre-temps beaucoup plus des centres commerciaux avec des pistes de décollage et d'atterrissage attenantes. Le danger est grand que toutes ces boutiques différentes ne nuisent à la clarté des lieux et que le passager ait bien du mal à s'y orienter. Une architecture claire peut remédier à cet état de fait.

L'histoire de l'aviation ne datant que d'une centaine d'années, il ne s'est pas encore développé de lignes claires dans le domaine de la construction d'aéroport. Les architectes expérimentent continuellement avec l'organisation et l'apparence des bâtiments autant que les limites étroites du cadre des contraintes complexes le permettent. Dans les cas les plus favorables, ils prennent la liberté de travailler sur des thèmes comme «le mouvement», «la dynamique», «la légèreté» et conçoivent des bâtiments expressifs.

Ce livre ne montre pas seulement les terminaux mêmes, mais aussi le design et l'architecture autour du thème des aéroports : de la lounge première classe jusqu'au musée de l'aviation, en passant par le système d'orientation, la tour de contrôle et le hangar. De par leur grandeur et la diversité des nombreux bâtiments avec leurs différentes fonctions, les aéroports constituent souvent une ville dans la ville. A l'aide d'exemples provenant du monde entier, ce livre donne un aperçu des constructions qui ont vu le jour ces dernières années, et va aussi regarder dans les coulisses des bureaux d'architecture pour montrer ce qu'ils ont encore dans leurs tiroirs. Outre des conceptions visionnaires dont la réalisation est incertaine, le livre montre aussi des projets qui vont être concrétisés dans un futur proche.

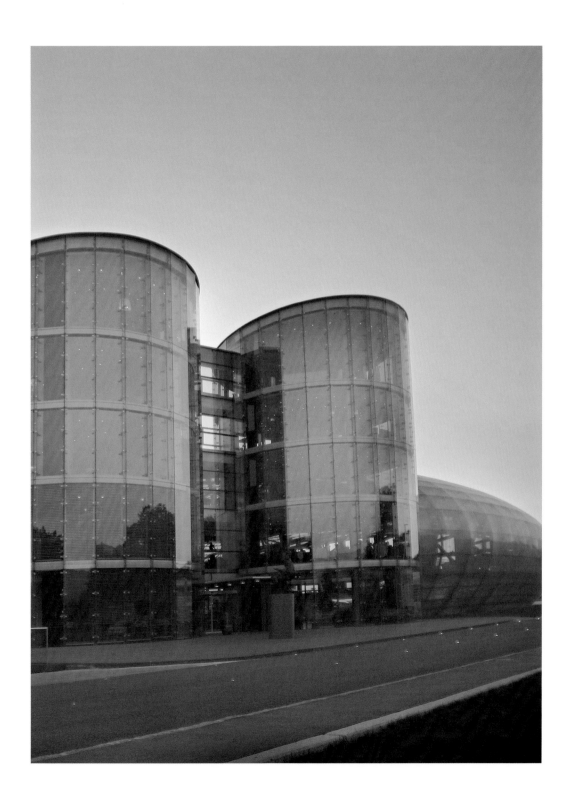

Los aeropuertos son lugares con un poder de atracción especial. Son la puerta hacia el mundo lejano, simbolizan internacionalismo y despiertan nostalgia de países lejanos. Lo grande que puede ser la fascinación que emana de ellos lo muestra la película "Terminal". Steven Spielberg captó la atmósfera del John F. Kennedy International Airport de Nueva York y trasladó totalmente la acción al aeropuerto. Explica la historia de un hombre que, debido a problemas con sus documentos de identidad, está obligado a vivir en el aeropuerto durante algún tiempo. Aquí queda claro: los aeropuertos internacionales forman un cosmos con leyes propias, un mundo entre los mundos.

Puesto que los viajes lejanos han experimentado un boom en los últimos años, también ha surgido una variedad de edificios nuevos de aeropuertos, para los arquitectos un gran desafío. Los flujos de pasajeros deben ser dirigidos, los trayectos han de ser cortos, los altos estándares de seguridad han de ser cumplidos y las funciones más distintas deben ser compaginadas. Muchos aeropuertos son, entretanto, más bien centros comerciales con pista de despegue y aterrizaje agregada. Corren el riesgo de perder claridad por el mundo variopinto del ajetreo de las compras, dificultando al pasajero la orientación. Una arquitectura clara puede poner aquí remedio.

Como la historia de la aviación sólo tiene alrededor de cien años, para la labor constructora de un aeropuerto todavía no se ha desarrollado un tipo fijo. Los arquitectos experimentan una y otra vez con la organización y la imagen de los edificios, siempre que ello sea posible dentro del estrecho marco de las exigencias complejas. En los casos más favorables, pueden tomarse la libertad de expresar creativamente temas como el "movimiento", la "dinámica" y la "ligereza", dando lugar así a edificios de fuerte expresividad.

Este libro no solamente muestra las verdaderas terminales, sino el diseño y la arquitectura entorno al tema de los aeropuertos: desde la First Class Lounge, pasando por el sistema de orientación, la torre de control y el hangar, hasta el museo del avión. Debido a sus dimensiones y a la variedad de los diferentes edificios con sus funciones distintas, los aeropuertos forman con frecuencia una ciudad dentro de la ciudad. Por medio de ejemplos de todo el mundo, el libro da una visión de conjunto sobre edificios que han surgido en los últimos años, pero también mira entre los bastidores de las oficinas de proyectos lo que éstas tienen todavía en reserva. Junto a visiones cuya realización es incierta, el libro también presenta proyectos que habrán de ser realidad en un futuro cercano.

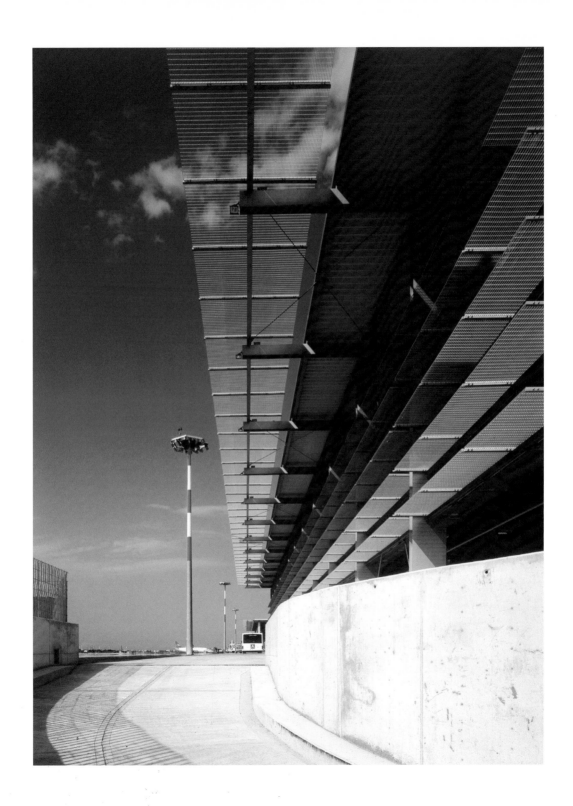

L'aeroporto è un luogo dal fascino tutto particolare. Sinonimo di internazionalità, esso è una porta sul mondo, il luogo dove nasce spontaneo il desiderio di evadere e visitare paesi lontani. Con quale dirompenza ciò possa avvenire è dimostrato dal film "The Terminal". Il regista Steven Spielberg è riuscito a cogliere l'atmosfera che si respira all'aeroporto John F. Kennedy di New York, dove si snoda l'intera trama. Il film racconta la storia di un uomo costretto a vivere in aeroporto per un lungo periodo a causa di una serie di problemi burocratici con i suoi documenti d'identità. Il messaggio è chiaro: l'aeroporto internazionale come microcosmo governato da leggi proprie, mondo fra i mondi.

Il boom dei viaggi a lungo raggio verificatosi negli ultimi anni ha portato alla costruzione di molte strutture aeroportuali: una grande sfida per gli architetti, chiamati a sincronizzare le esigenze dettate dai flussi di passeggeri nel rispetto della logica dei percorsi, degli elevati standard di sicurezza nonché delle funzionalità più svariate. Molti aeroporti assomigliano ormai a shopping center con annesse piste di decollo e di atterraggio. L'universo variopinto e frenetico dello shopping rischia di confonderne le strutture e di ostacolare l'orientamento dei passeggeri. Una progettazione architettonica ben definita può scongiurare questo pericolo.

Poiché l'inizio della storia dell'aeronautica risale appena a un centinaio d'anni fa, manca un modello architettonico fisso. Gli architetti stanno sperimentando nuove concezioni organizzative ed estetiche, pur con le limitazioni ineludibili rappresentate dallo spazio relativamente ristretto in cui concentrare un numero elevato di funzionalità. Gli esempi meglio riusciti dimostrano che talvolta è loro possibile ritagliarsi quel margine d'azione in virtù del quale tematiche quali "mobilità", "dinamismo" e "leggerezza" prendono forma dando vita a strutture di grande intensità espressiva.

Questo libro non intende mostrare solo il prodotto finale di questo processo creativo, i terminal veri e propri, bensì illustrare il design e le concezioni architettoniche che si celano dietro l'accezione più ampia del concetto di aeroporto: dalla First Class Lounge al sistema di orientamento e alla torre di controllo, dall'hangar al museo aeronautico. Le dimensioni imponenti e la varietà delle strutture con diversificate funzionalità conferiscono spesso all'aeroporto le sembianze di una città a sé stante. Oltre a voler offrire una panoramica delle strutture aeroportuali sorte negli ultimi anni con esempi da tutto il mondo, questo libro intende gettare uno sguardo dietro le quinte e rivelare gli orizzonti più attuali verso cui si muovono gli studi di progettazione. Accanto alle visioni destinate forse a non divenire mai realtà trovano spazio progetti che verranno realizzati in un futuro prossimo.

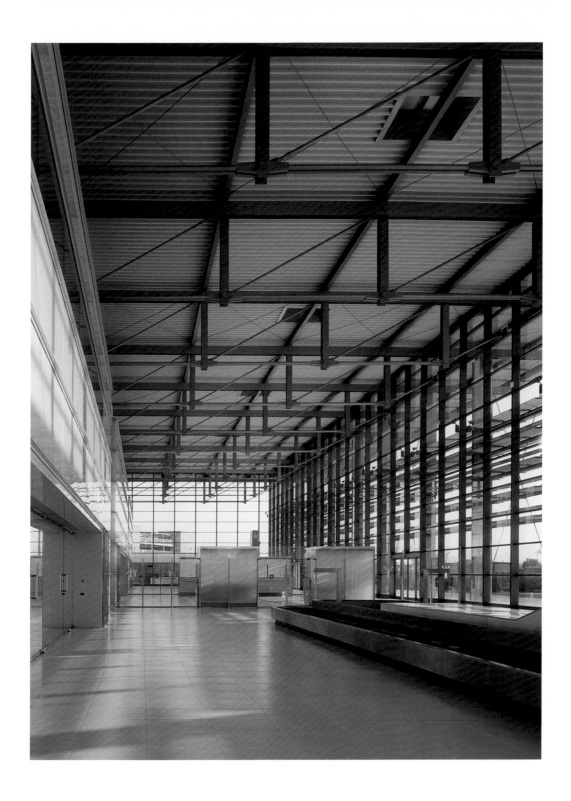

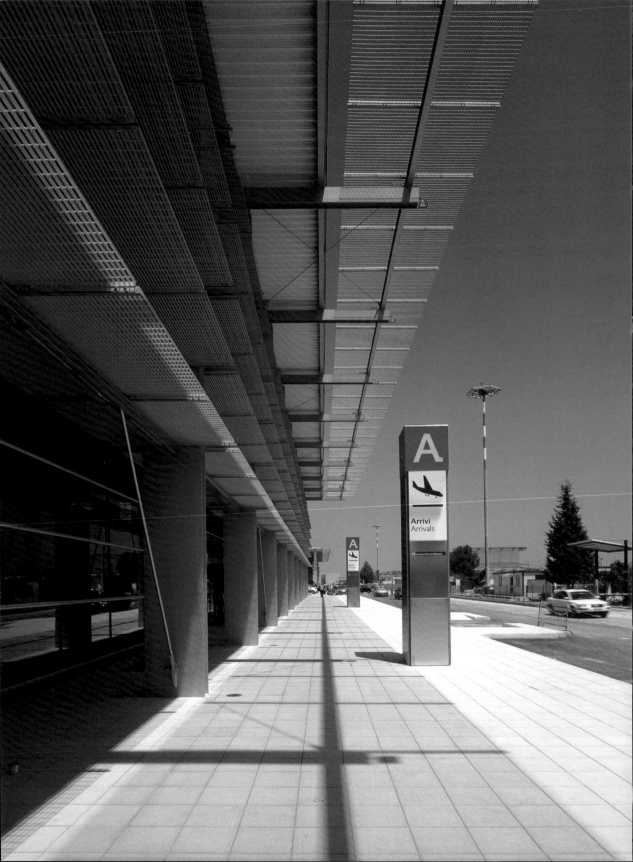

ANCONA AIRPORT | ANCONA FALCONARA, ITALY
www.ancona-airport.com
gmp – Architekten von Gerkan, Marg und Partner | Hamburg, 2004

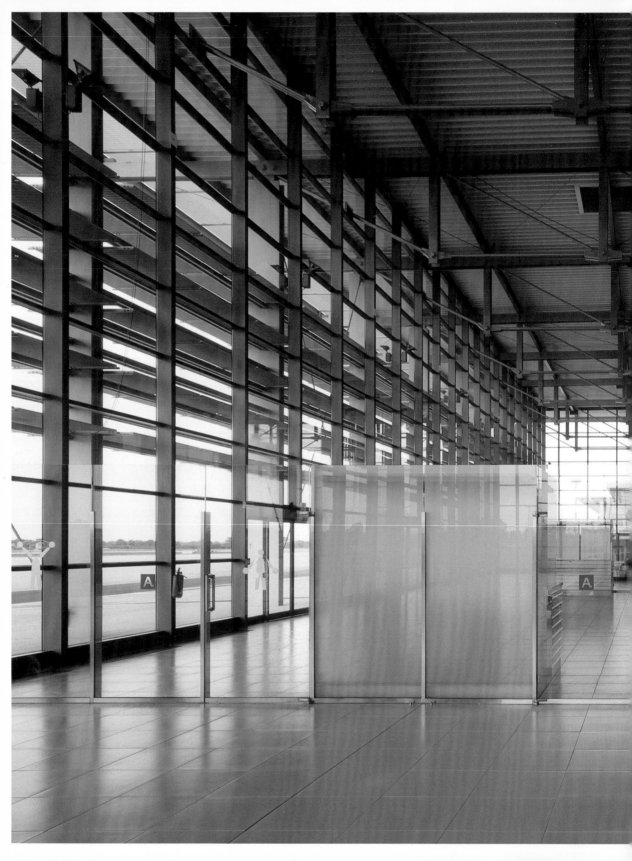

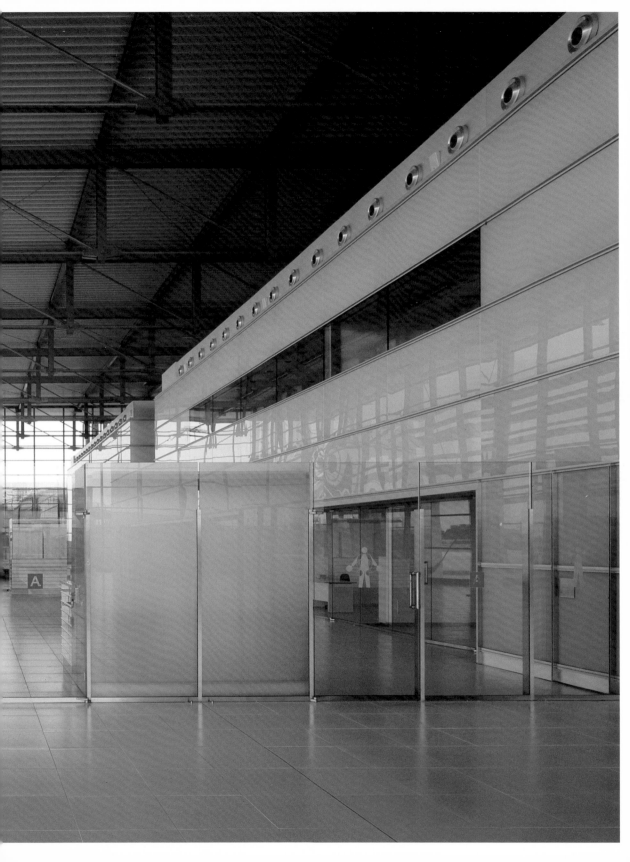

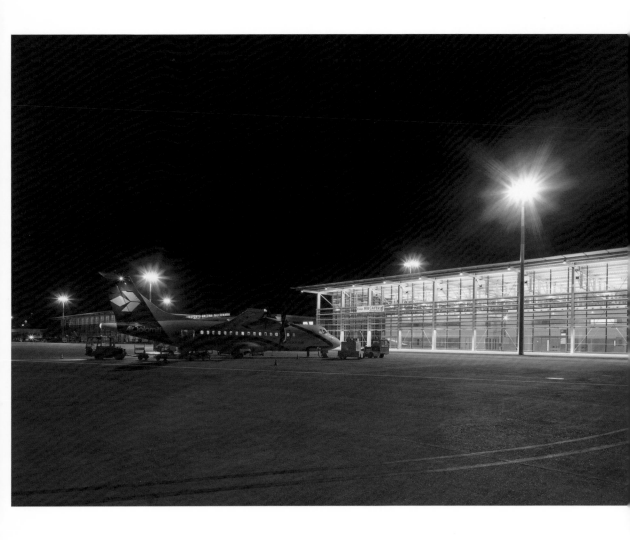

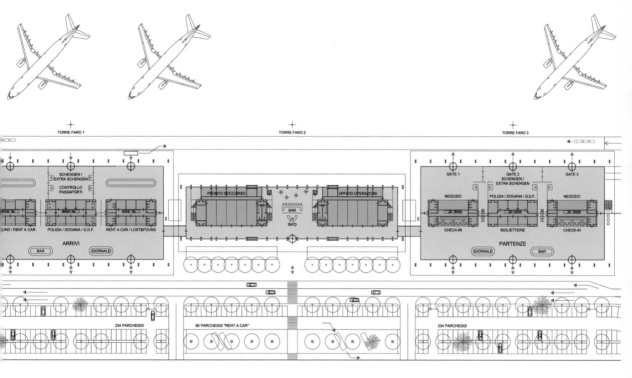

TORRE FARO 1 TORRE FARO 2 TORRE FARO 3

SCHENGEN / EXTRA SCHENGEN

CONTROLLO PASSAPORTI

UND / RENT A CAR POLIZIA / DOGANA / G.D.F. RENT A CAR / LOST&FOUND

ARRIVI

BAR GIORNALE

PRONTO SOCCORSO UFFICIO OPERAZIONI

BAR

INFO

GATE 1 GATE 2 SCHENGEN / EXTRA SCHENGEN GATE 3

NEGOZIO POLIZIA / DOGANA / G.D.F. NEGOZIO

CHECK-IN BIGLIETTERIE CHECK-IN

PARTENZE

GIORNALE BAR

234 PARCHEGGI 80 PARCHEGGI "RENT A CAR" 234 PARCHEGGI

21

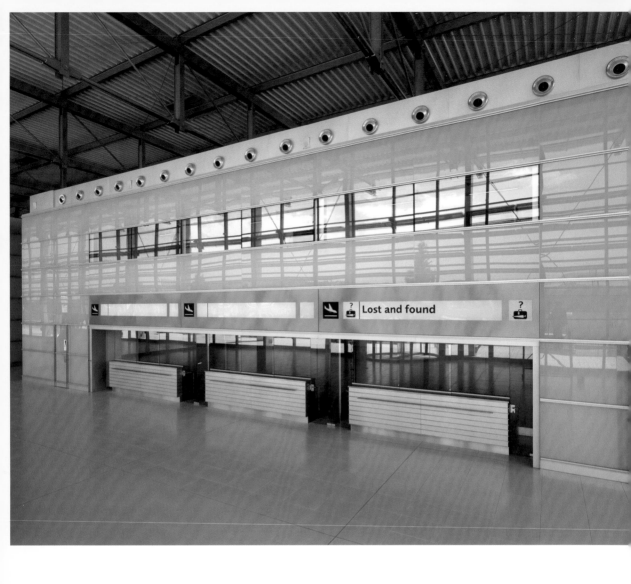

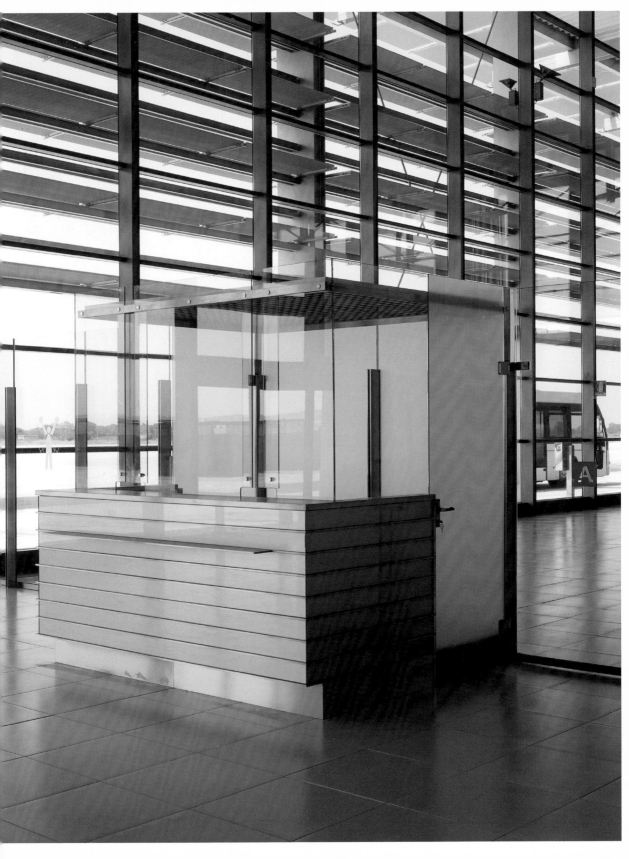

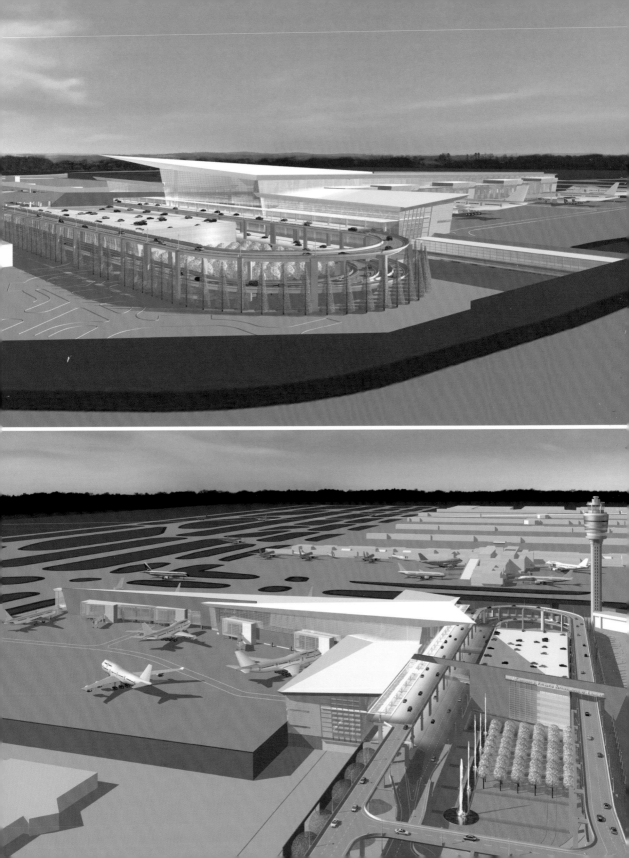

INTERNATIONAL TERMINAL AT HARTSFIELD-JACKSON
ATLANTA INTERNATIONAL AIRPORT | ATLANTA, USA
www.atlanta-airport.com
Leo A Daly, Khafra, Baker and Browder (joint venture) and Gensler | Atlanta, 2006

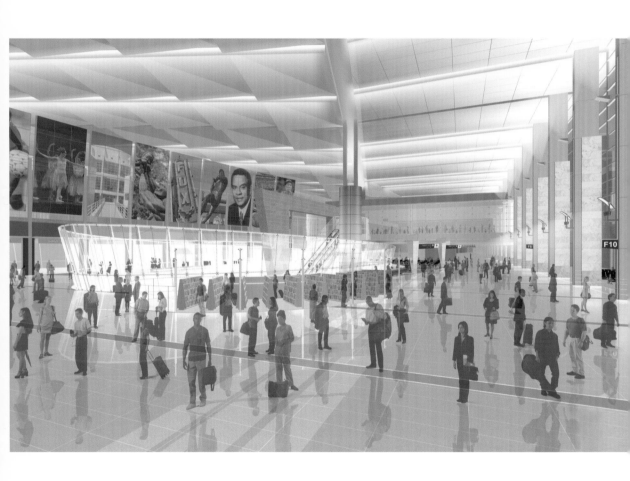

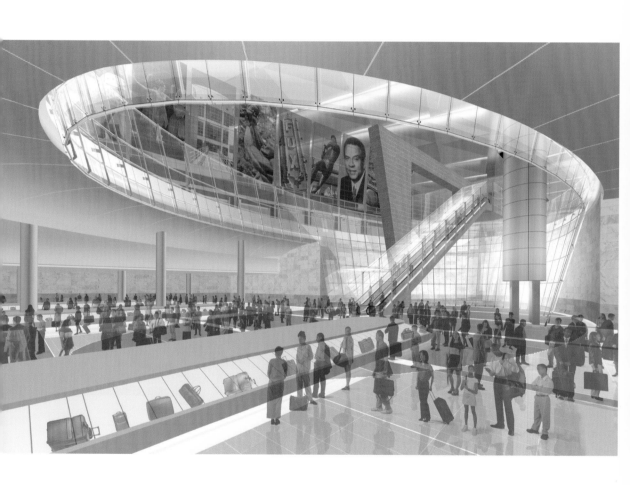

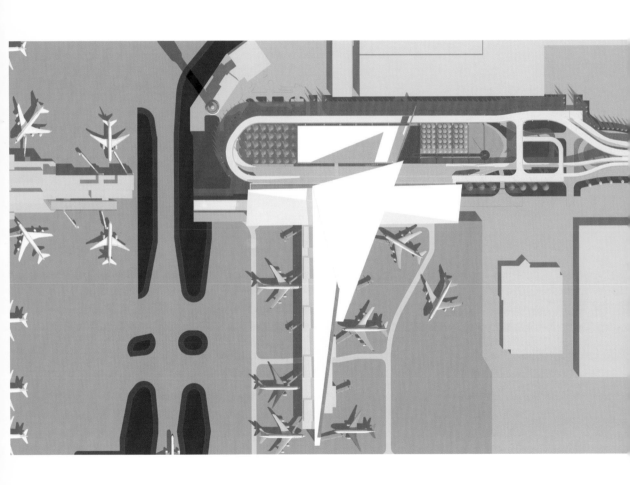

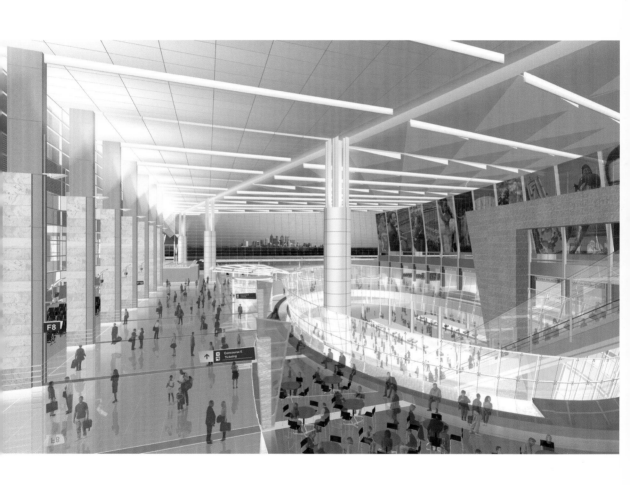

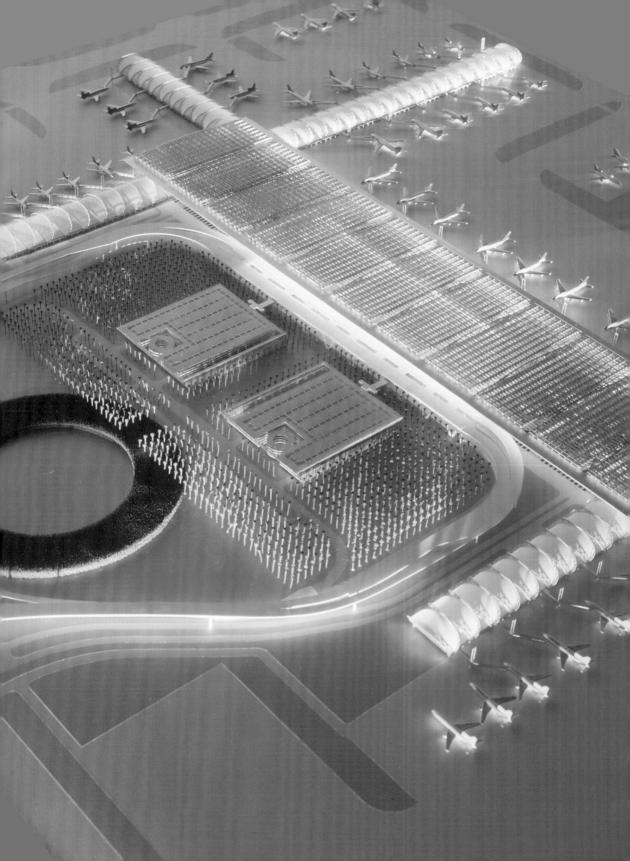

NEW BANGKOK INTERNATIONAL AIRPORT | BANGKOK, THAILAND
www.airportthai.co.th
Murphy / Jahn | Chicago, 2006

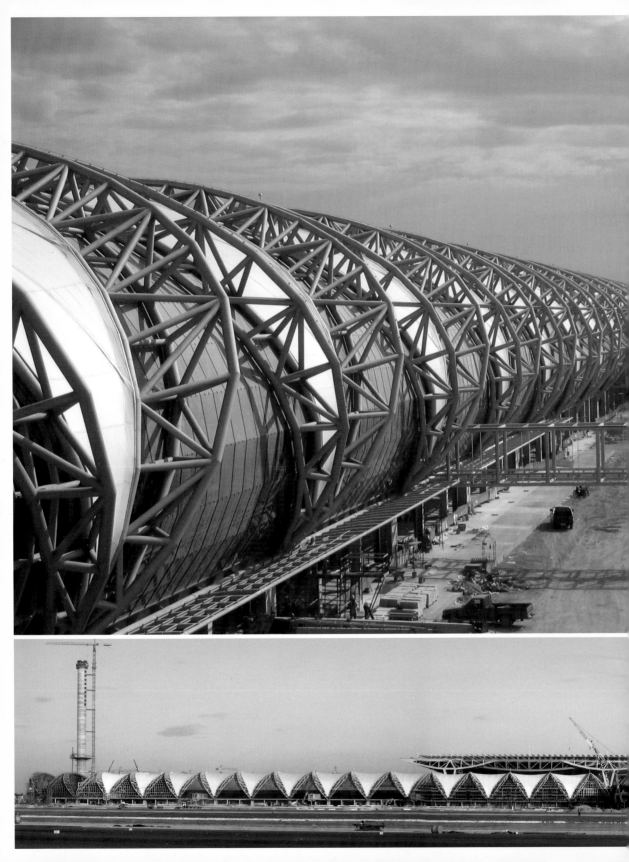

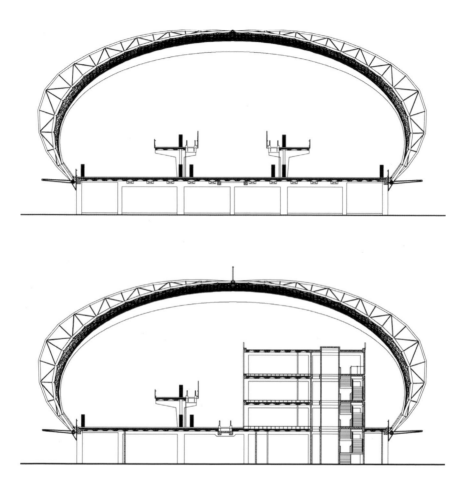
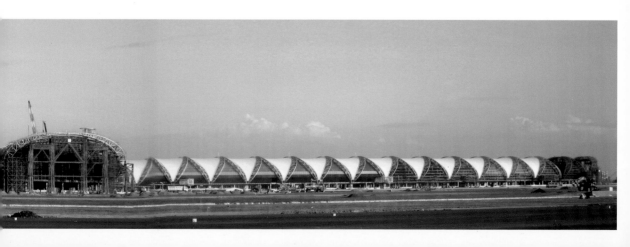

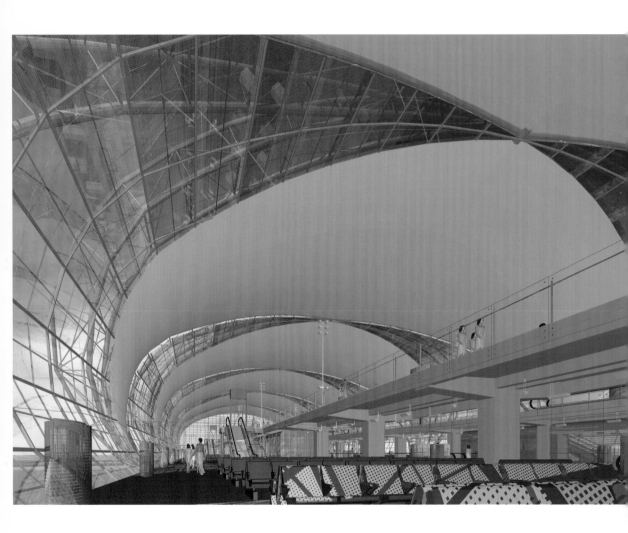

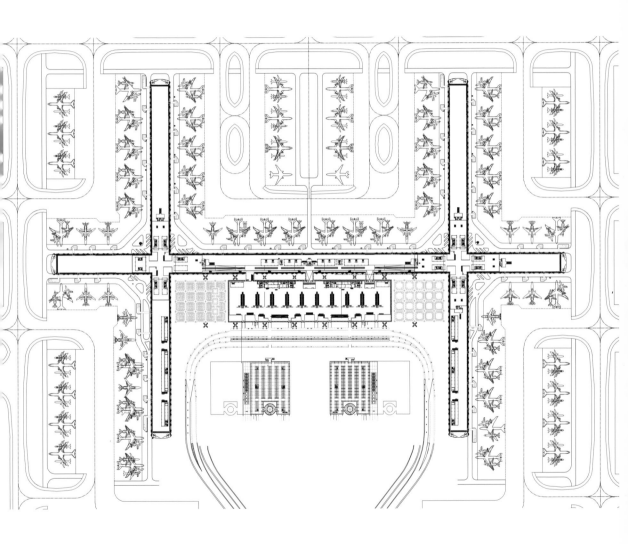

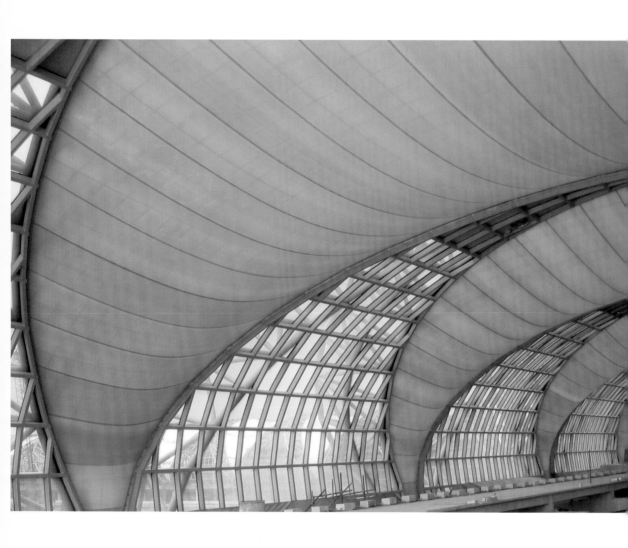

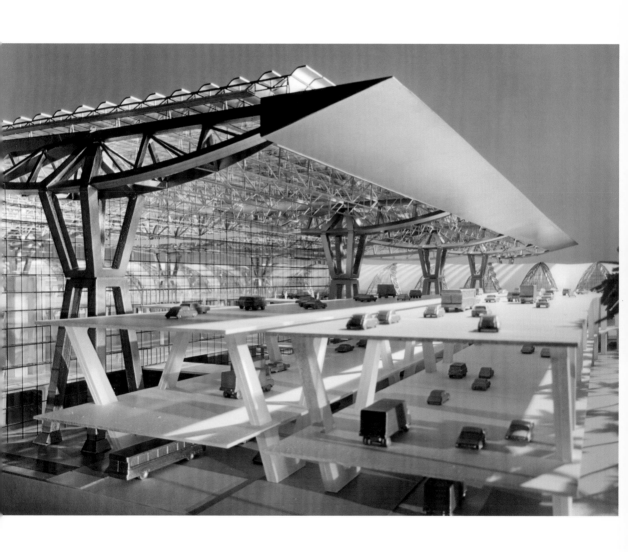

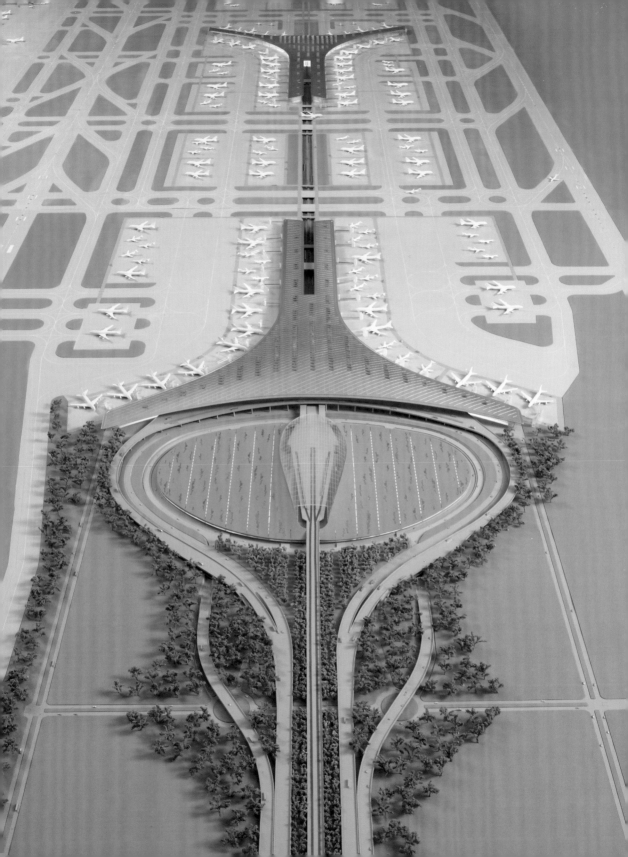

TERMINAL 3 AT BEIJING CAPITAL INTERNATIONAL AIRPORT | BEIJING, CHINA
www.bcia.com.cn /en /index.html
Foster and Partners | London, 2008

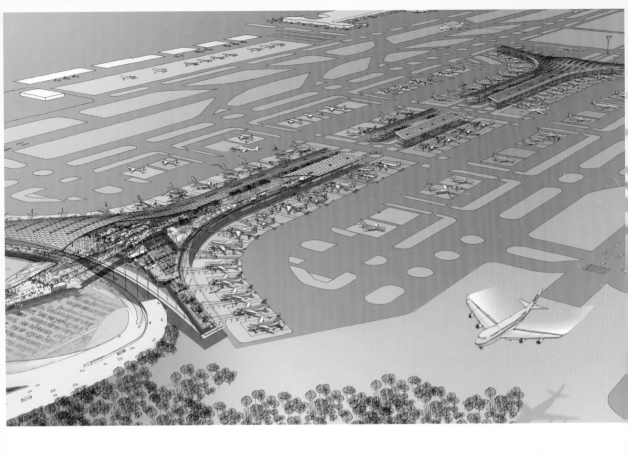

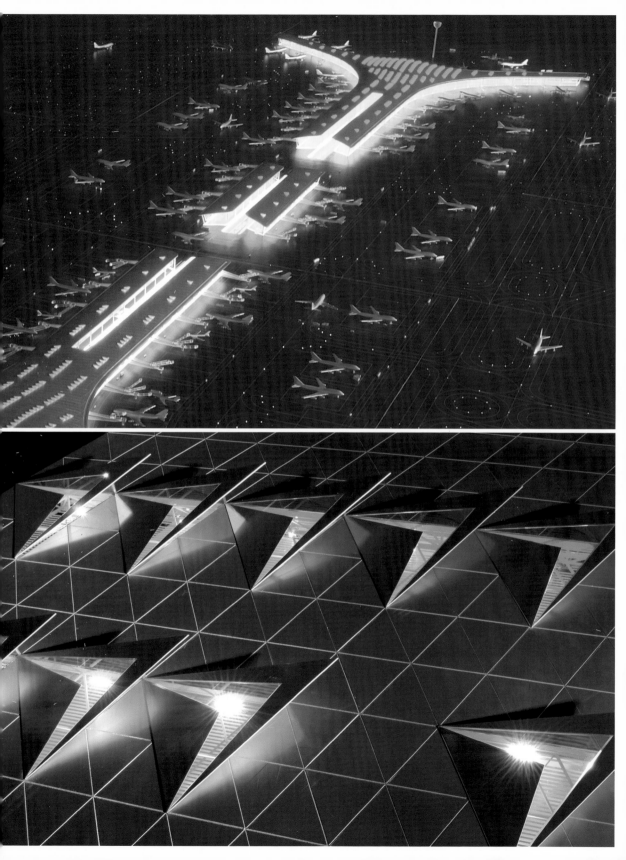

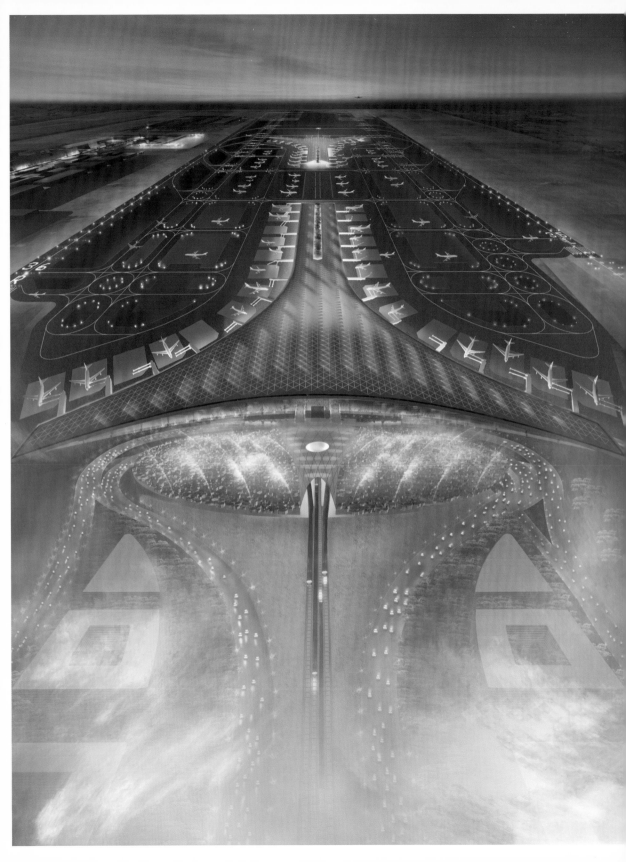

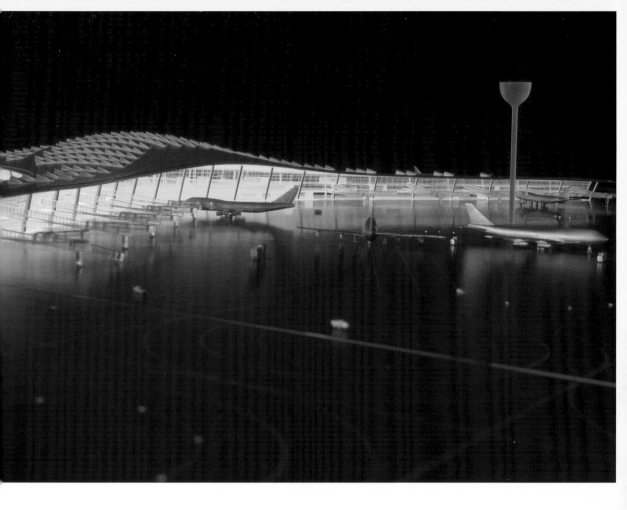

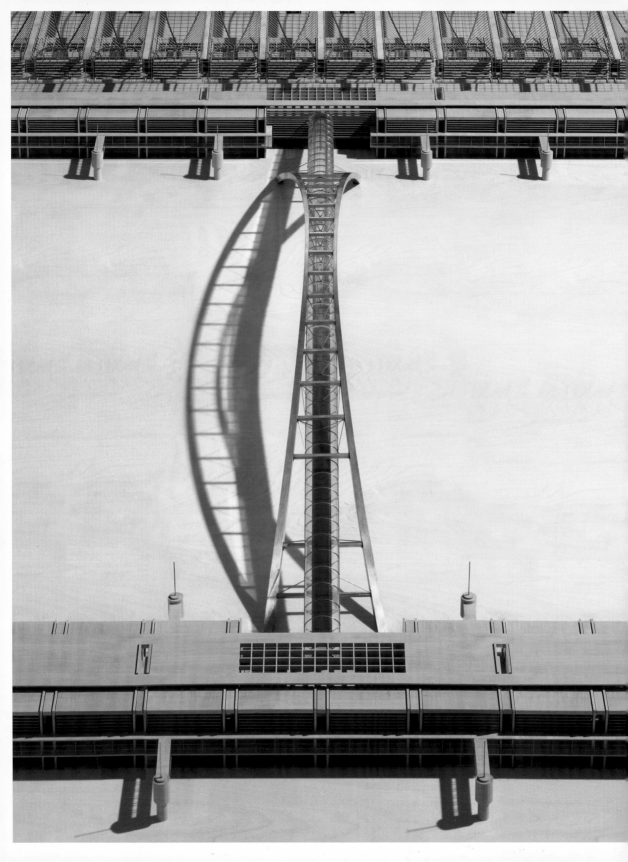

BERLIN-BRANDENBURG AIRPORT I **BERLIN, GERMANY**
www.berlin-airport.de
gmp – Architekten von Gerkan, Marg und Partner I Hamburg,1998, 2007

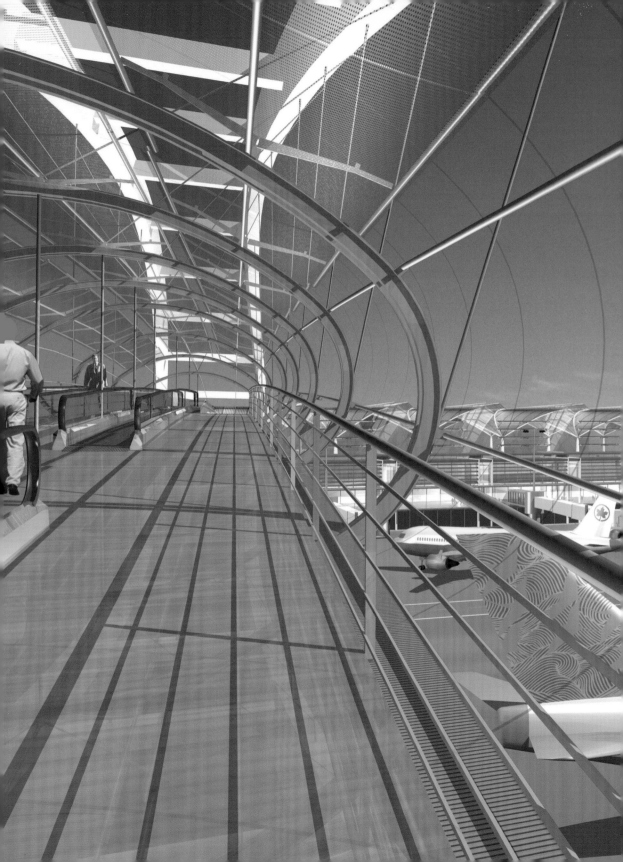

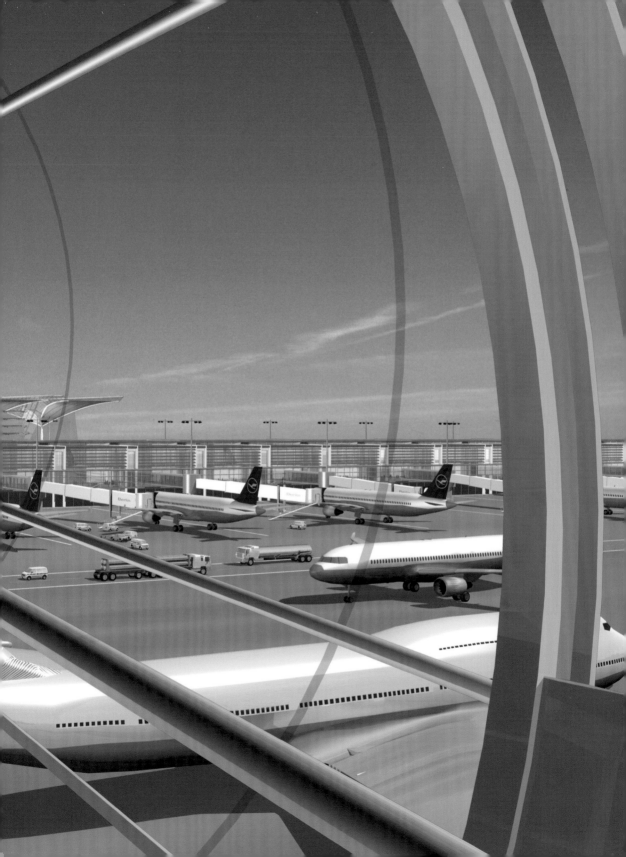

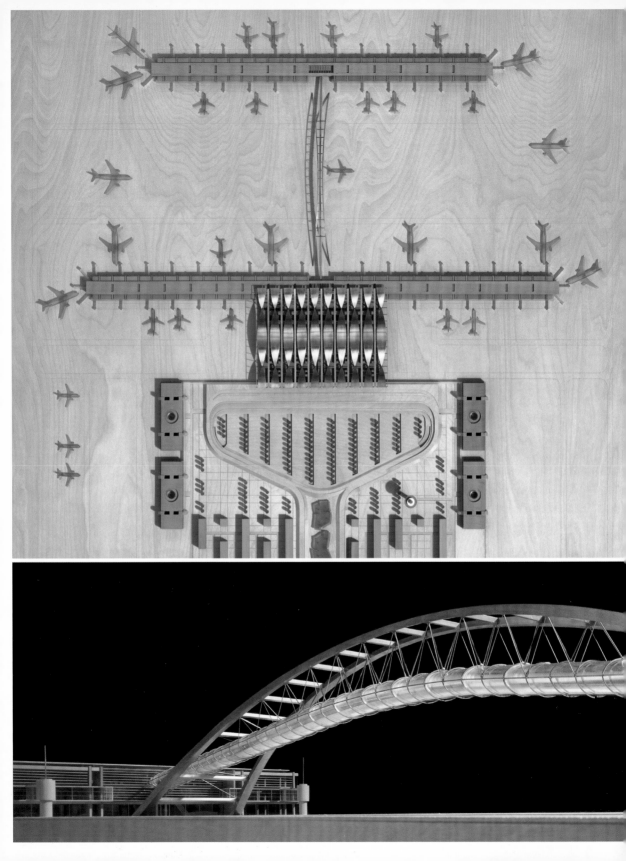

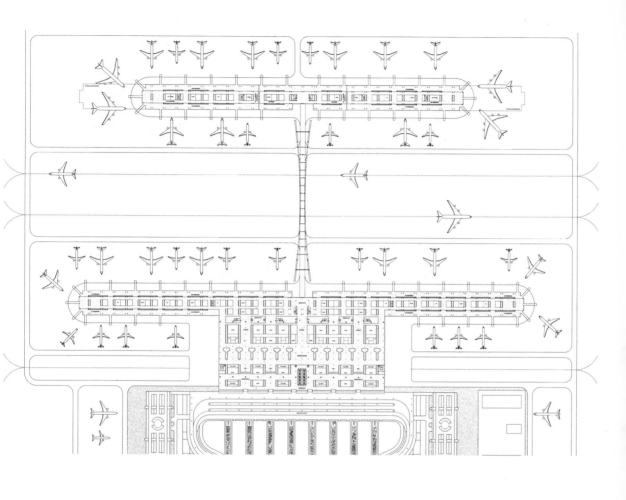

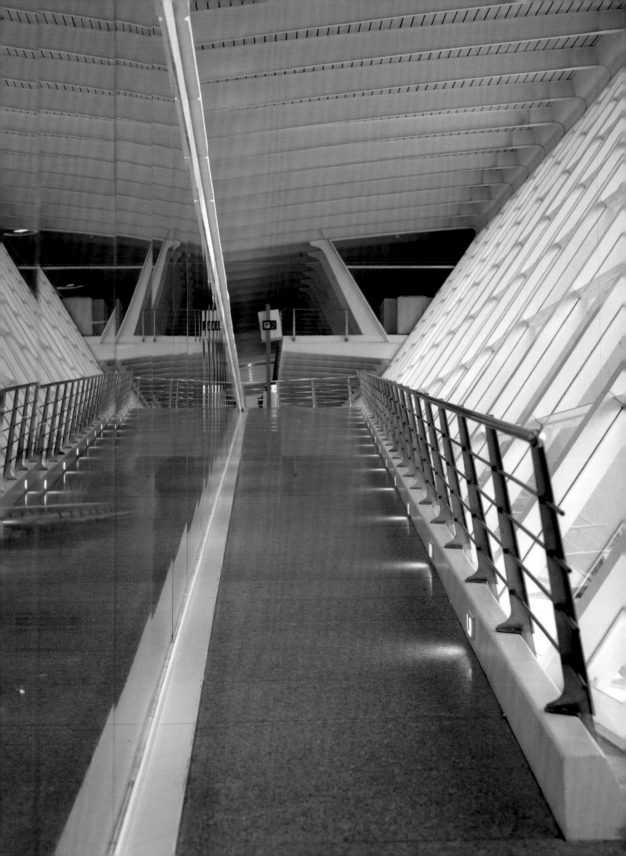

NEW TERMINAL AT SONDICO BILBAO AIRPORT | BILBAO, SPAIN
www.aena.es
Santiago Calatrava | Zurich, 2000

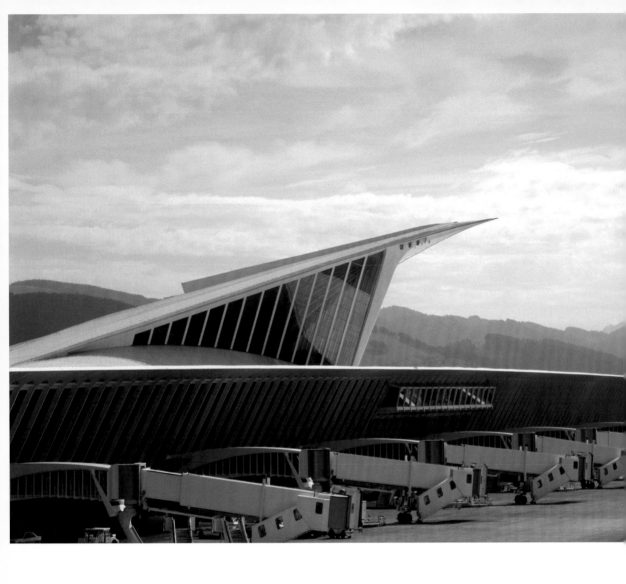

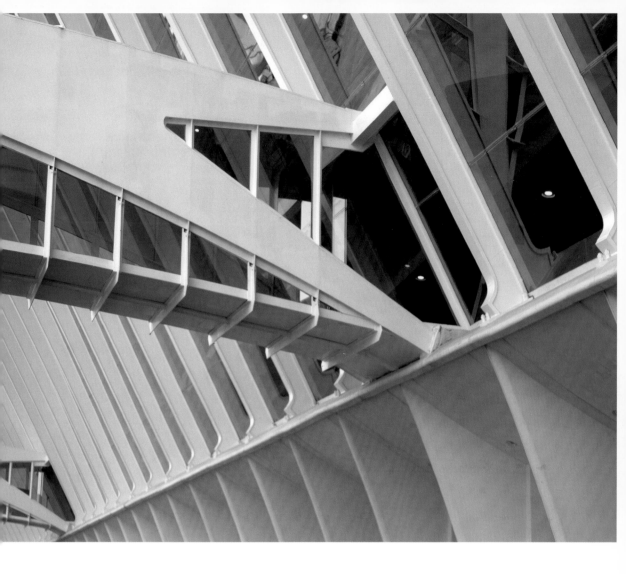

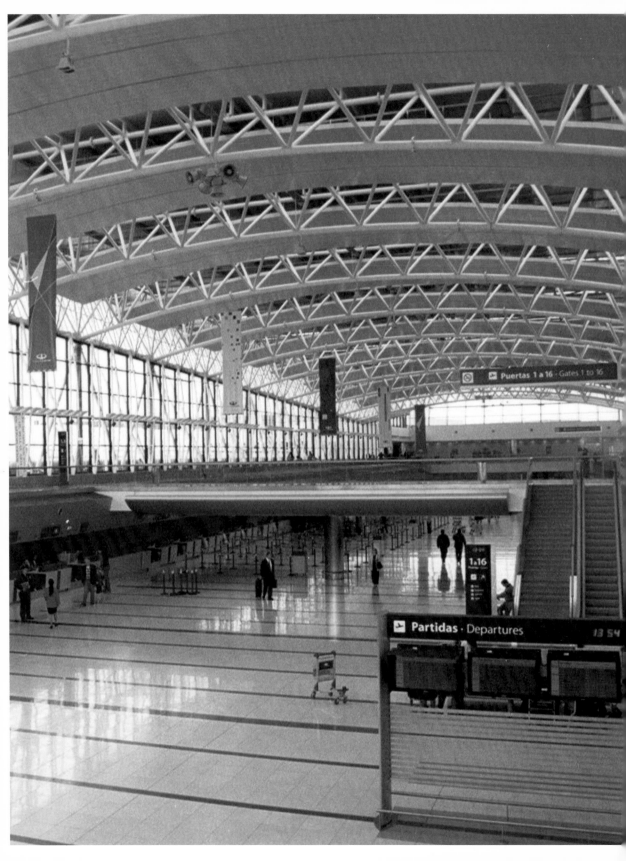

EZEIZA INTERNATIONAL AIRPORT | **BUENOS AIRES, ARGENTINA**
www.aa2000.com.ar
Leo A. Daly | Washington, not determined

EZE

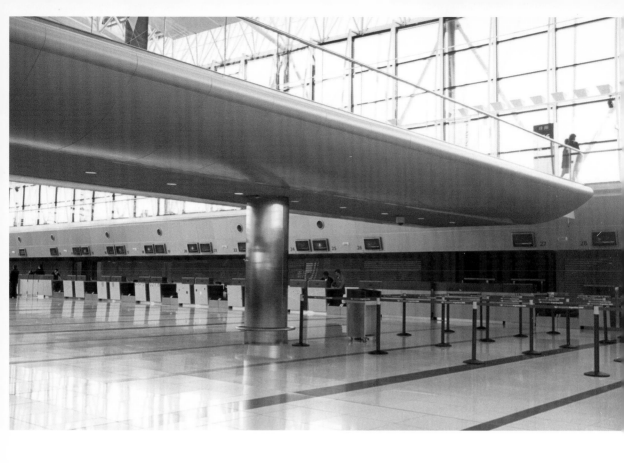

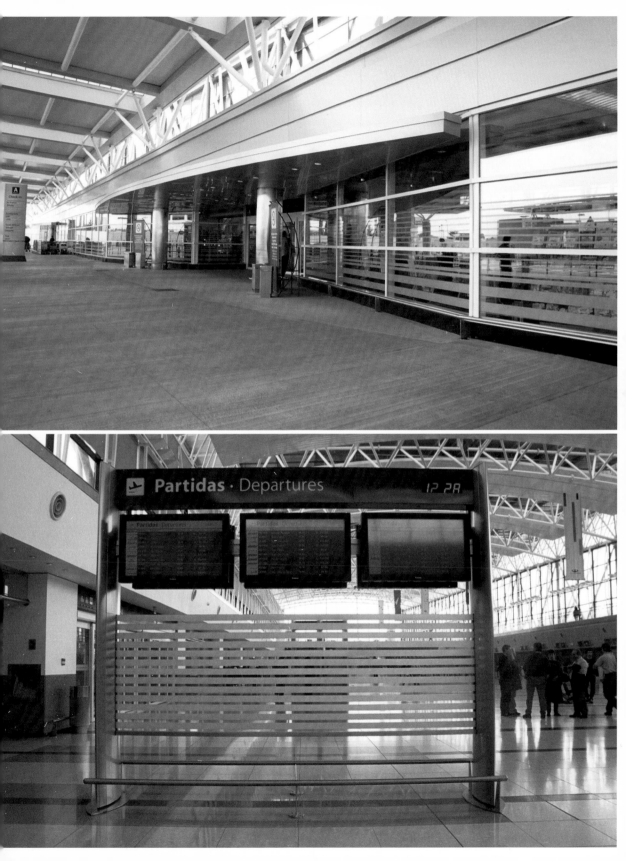

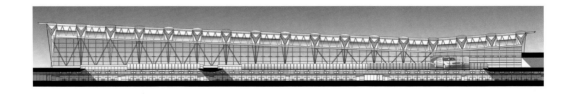

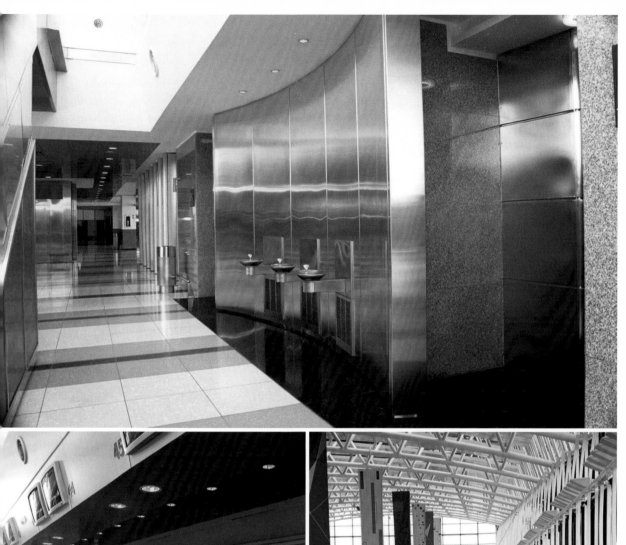
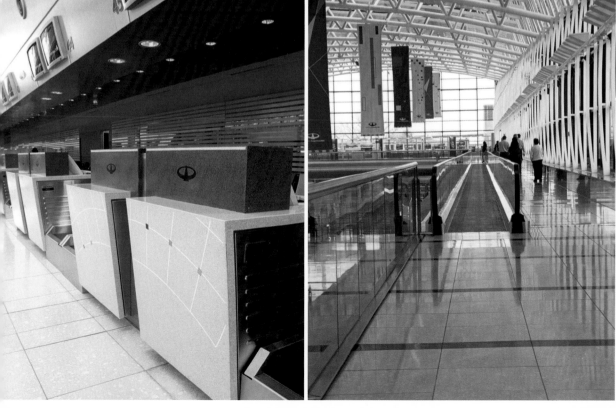

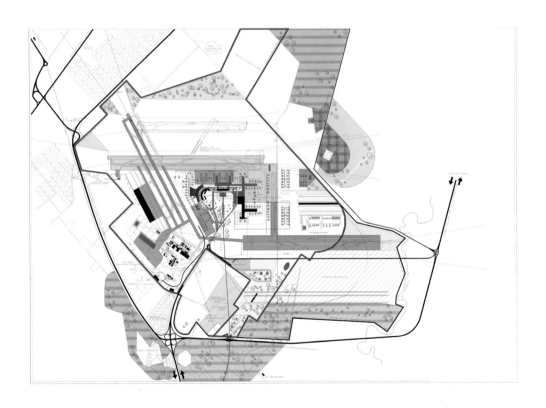

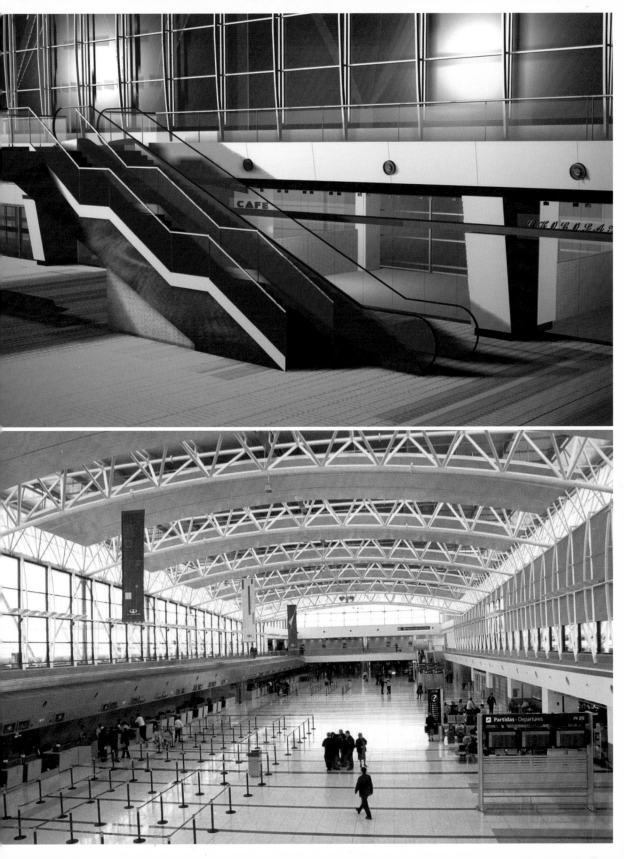

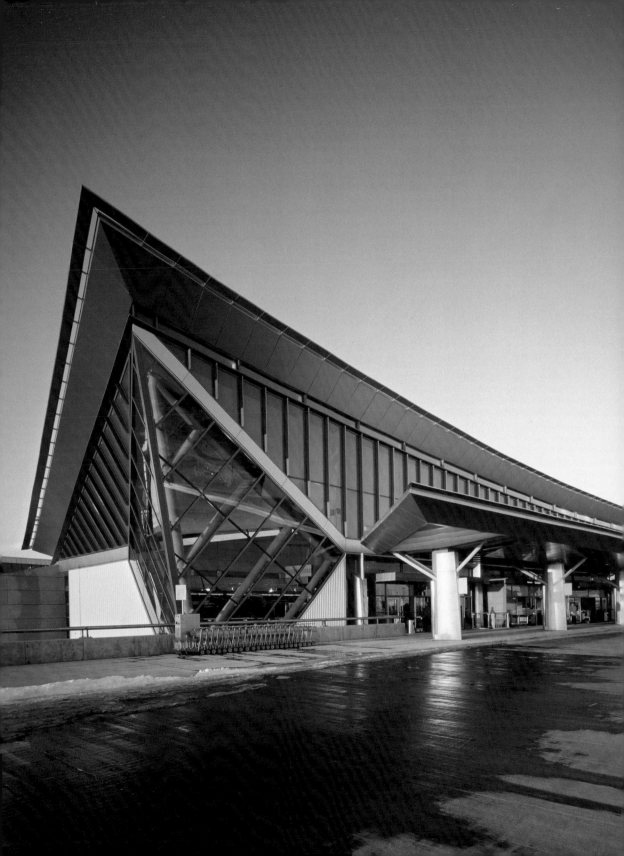

BUFFALO NIAGARA INTERNATIONAL AIRPORT | BUFFALO, USA
www.buffaloairport.com
KPF | London, 1997

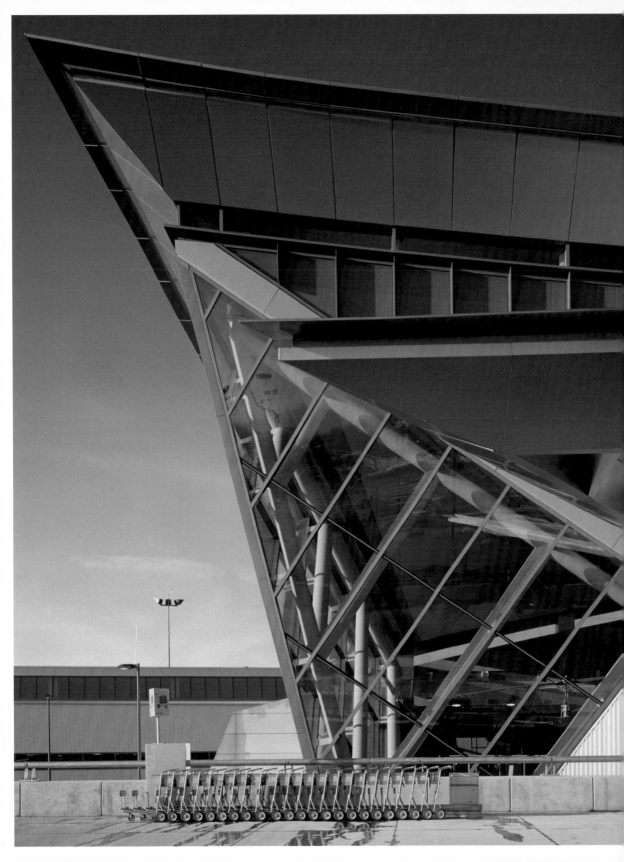

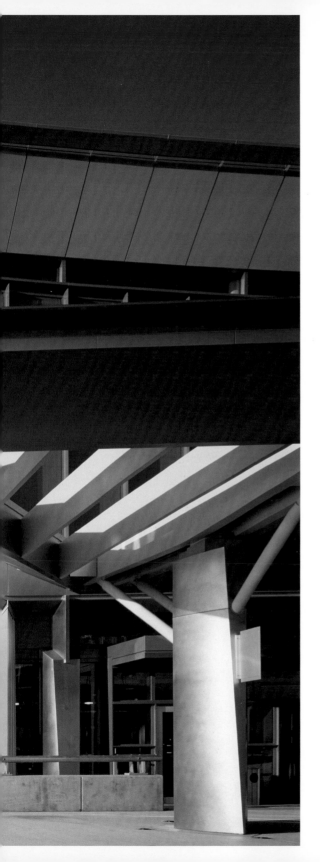

Diane M. Halle Library
ENDICOTT COLLEGE
Beverly, MA 01915

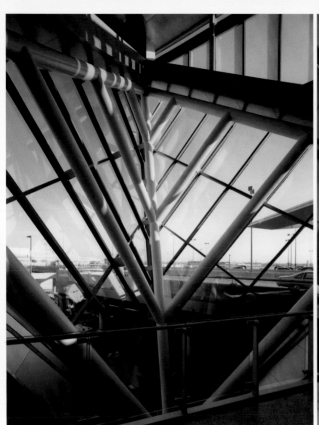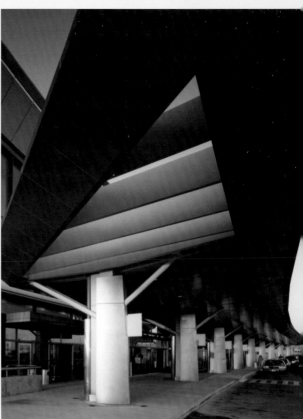

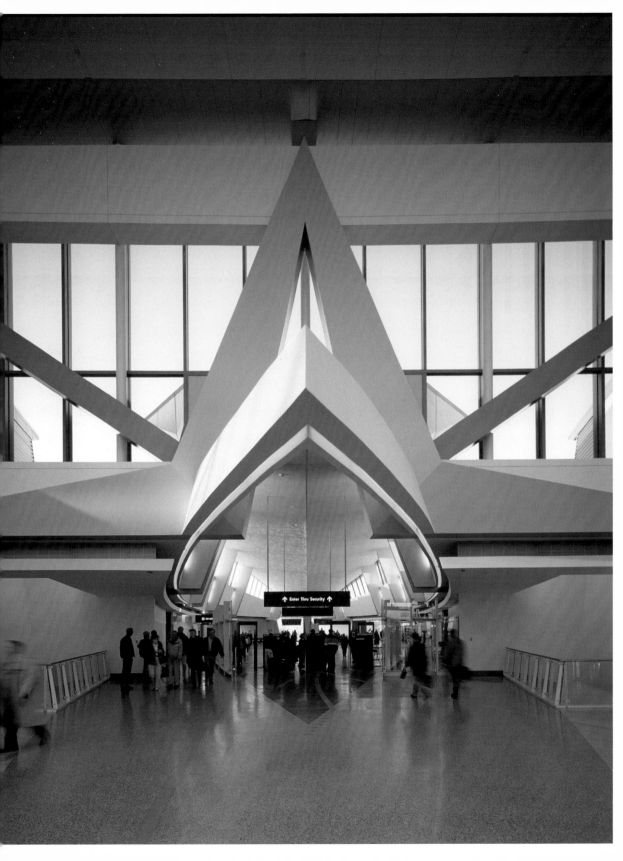

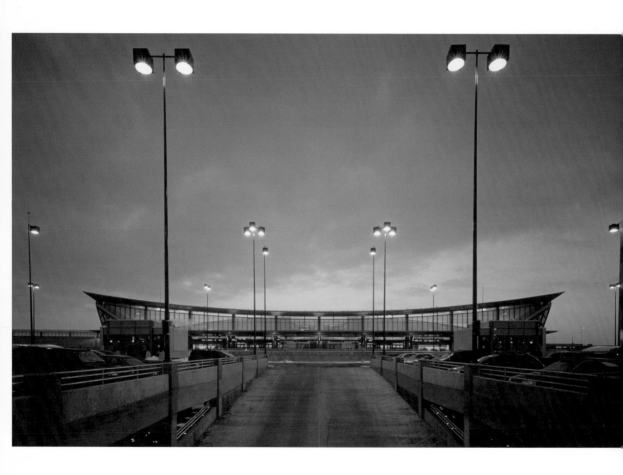

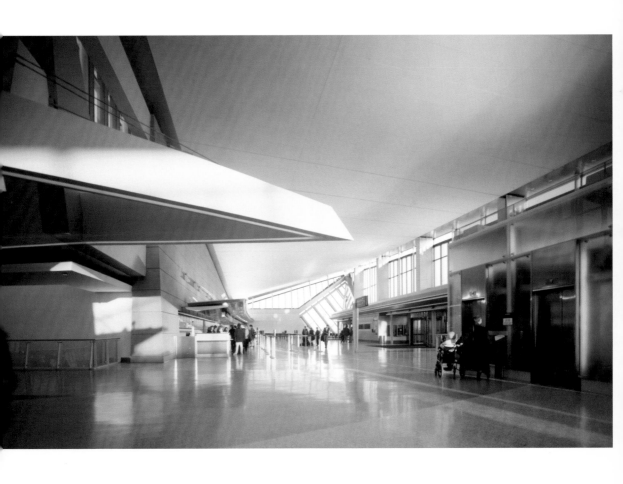

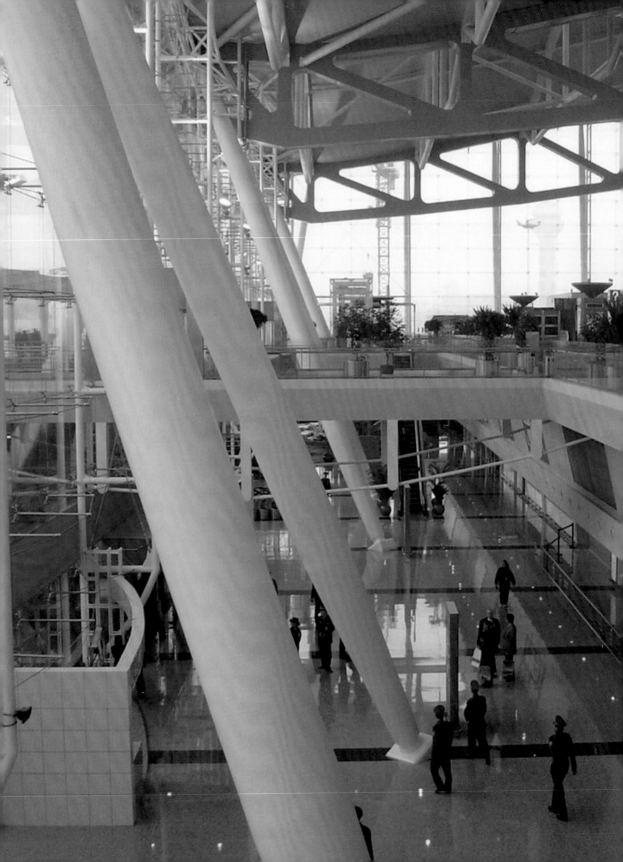

NEW INTERNATIONAL TERMINAL AT CHONGQING AIRPORT | CHONGQING, CHINA
Llewelyn Davies Ltd | London, 2004

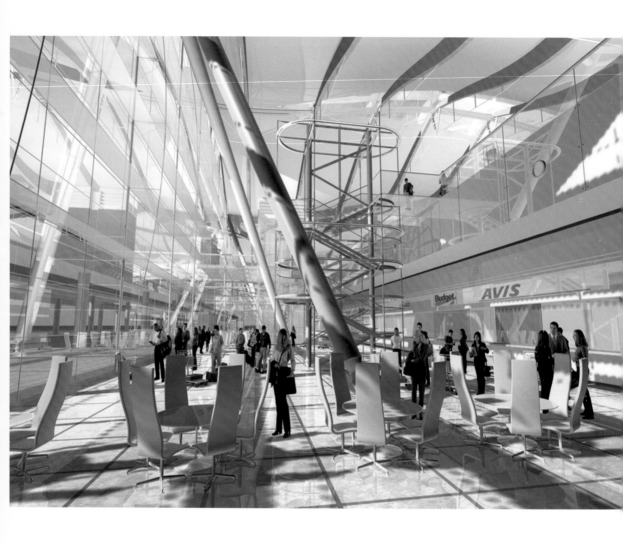

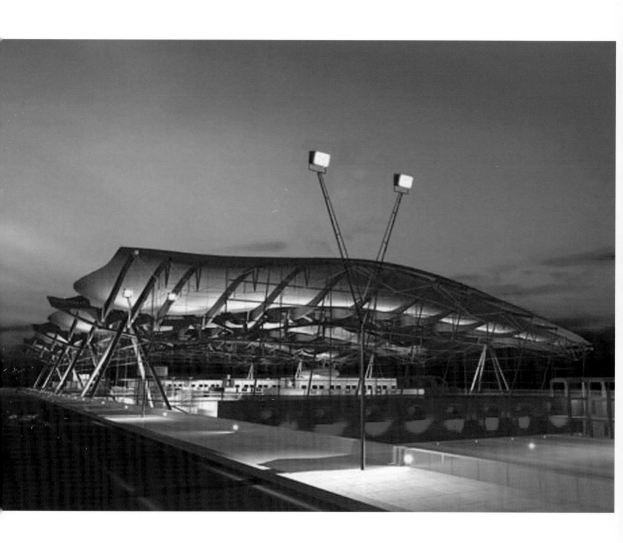

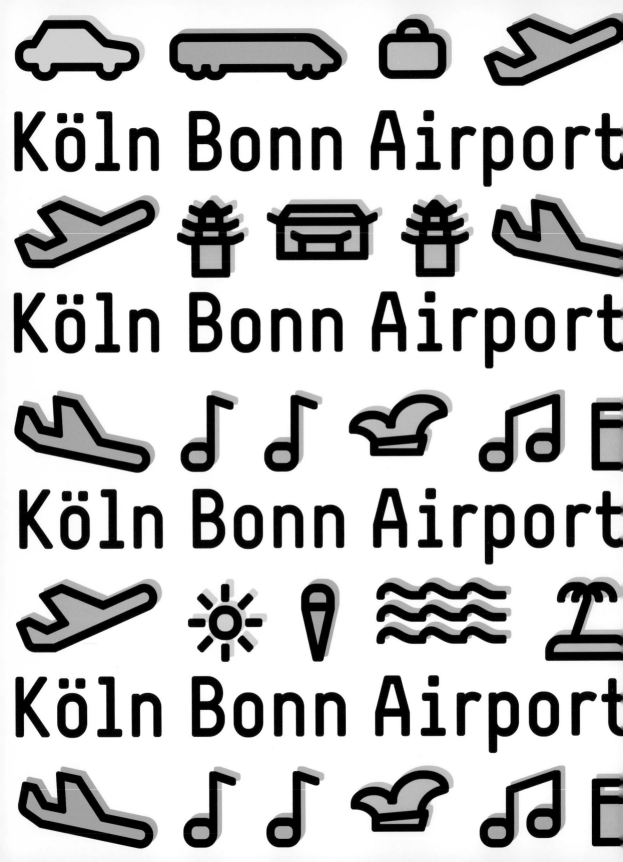

ORIENTATION SYSTEM AT KÖLN BONN AIRPORT | **COLOGNE, GERMANY**
www.koeln-bonn-airport.de
Intégral Ruedi Baur et Associés | Paris, 2004

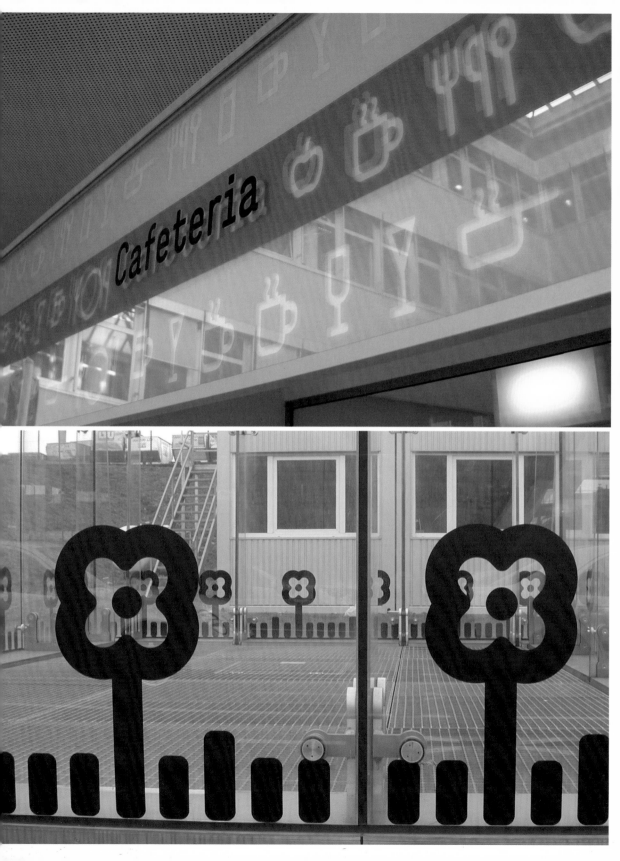

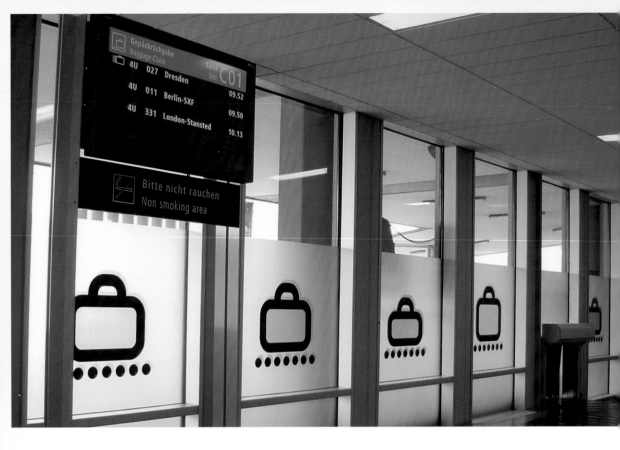

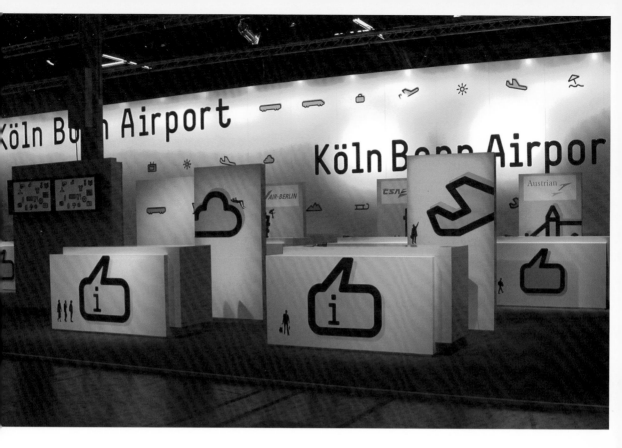

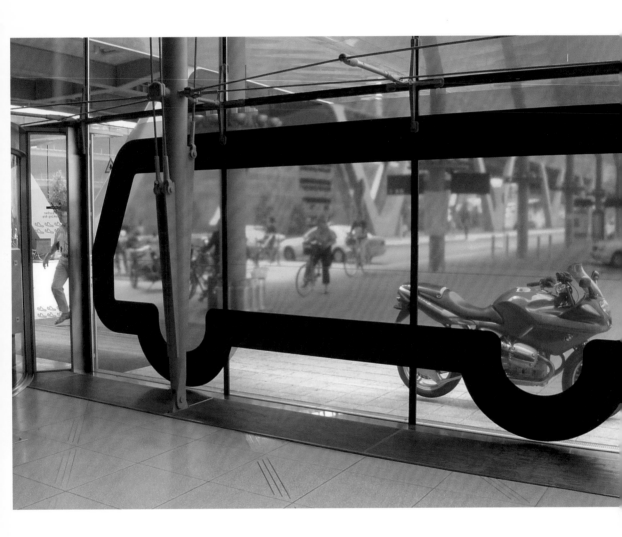

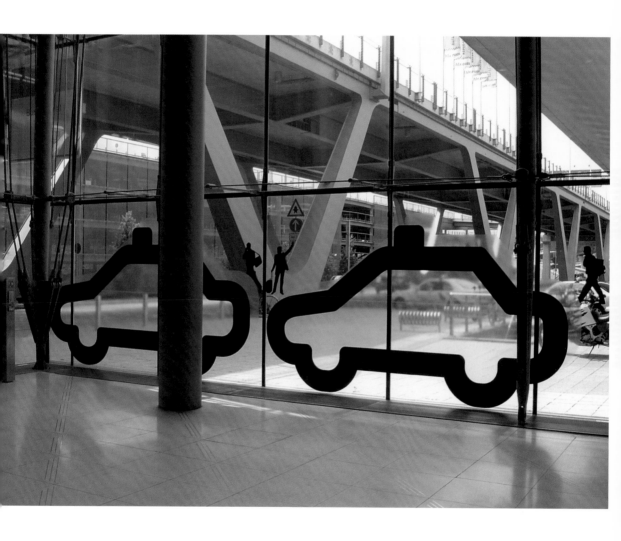

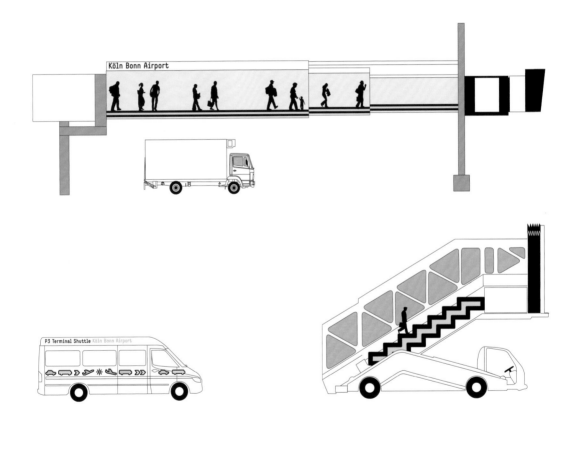

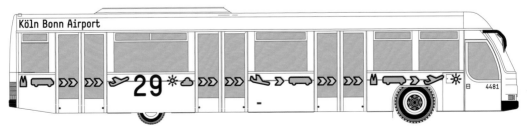

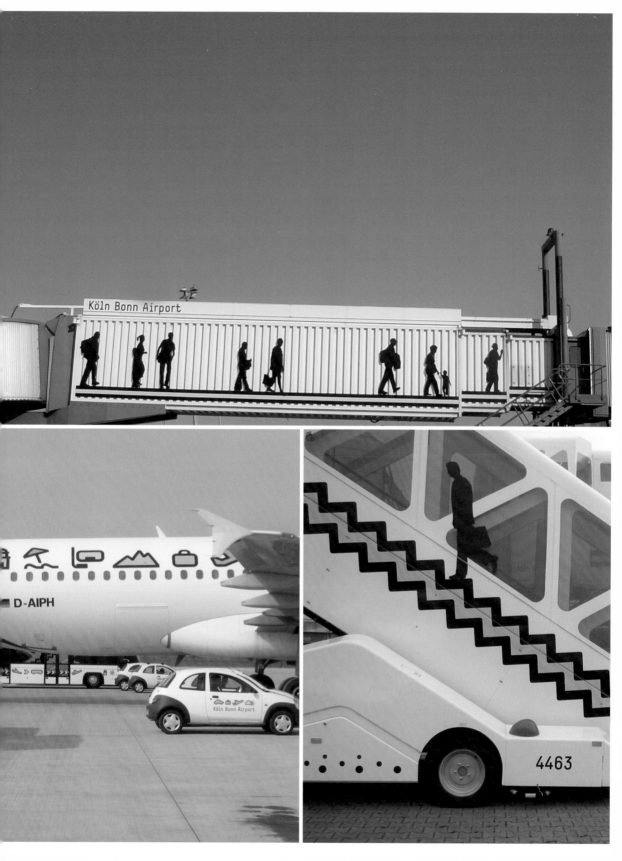

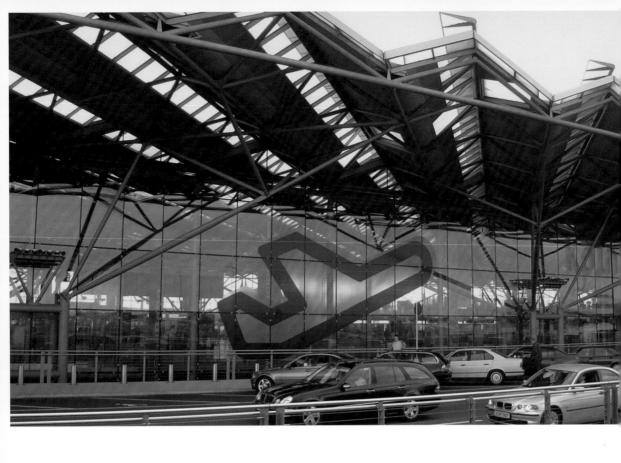

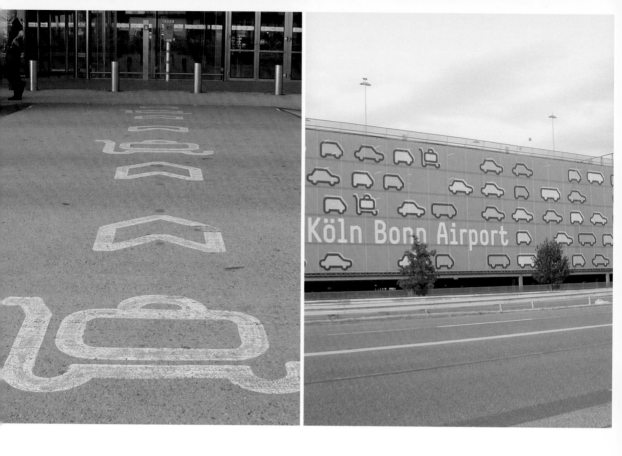

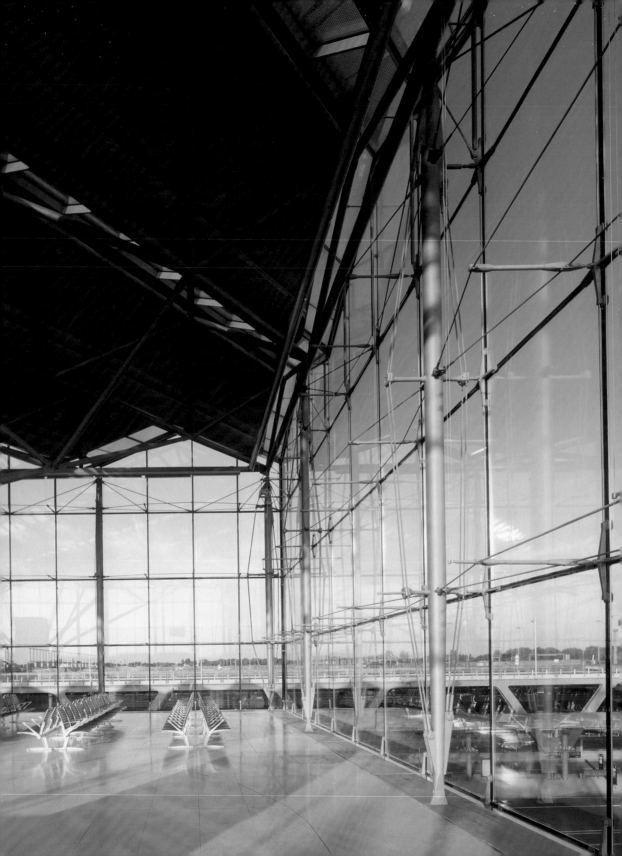

TERMINAL 2 + PARKHAUS AT KÖLN BONN AIRPORT | COLOGNE, GERMANY
www.koeln-bonn-airport.de
Murphy / Jahn | Chicago, 2000

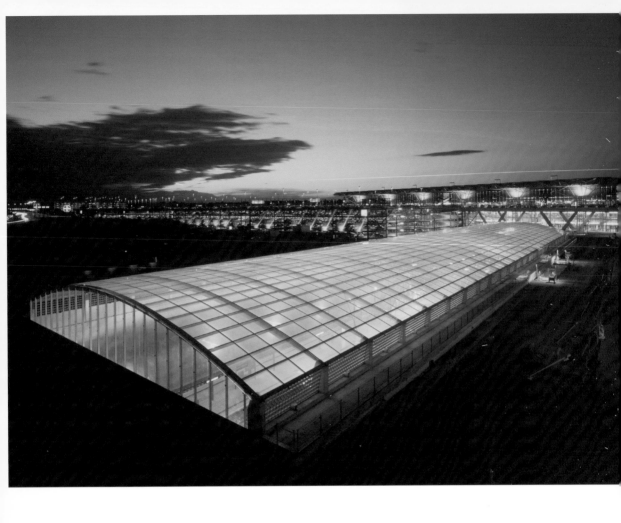

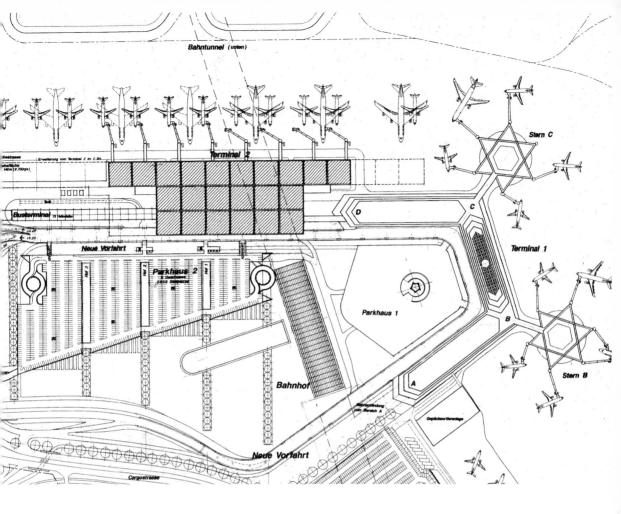

Bahntunnel (unten)

Erweiterung von Terminal 2 im 2.BA.

Terminal 2

Stern C

Terminal 1

D

C

Busterminal

Neue Vorfahrt

Parkhaus 2

Parkhaus 1

B

Bahnhof

Stern B

A

Gepäcksortieranlage

Neue Vorfahrt

Cargostrasse

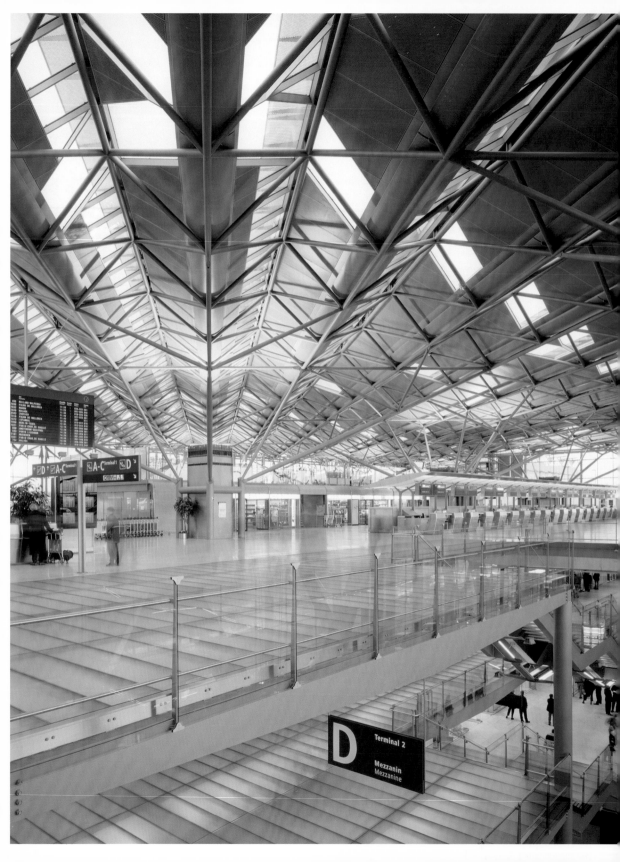

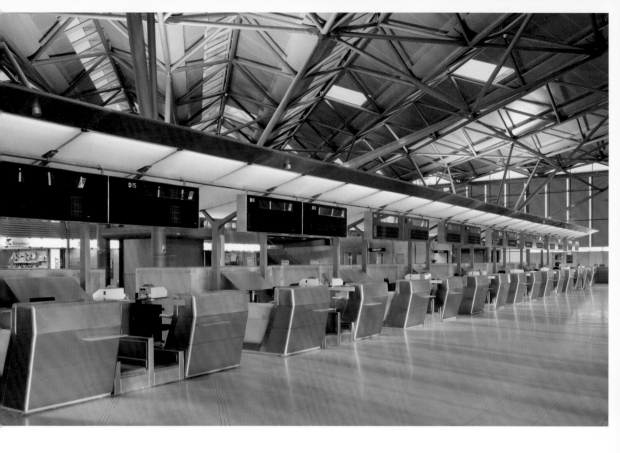

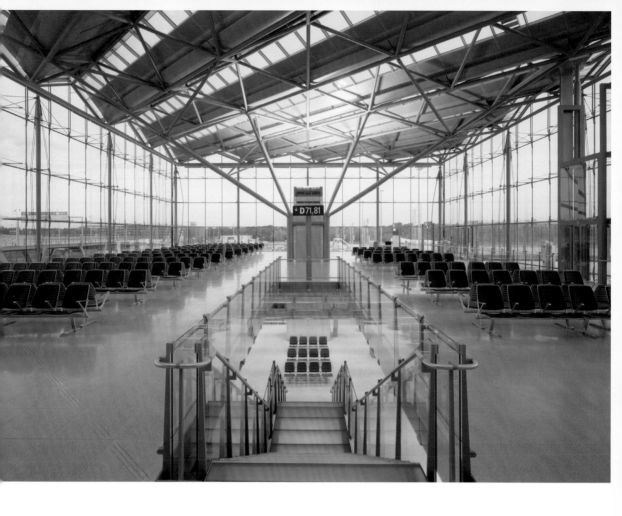

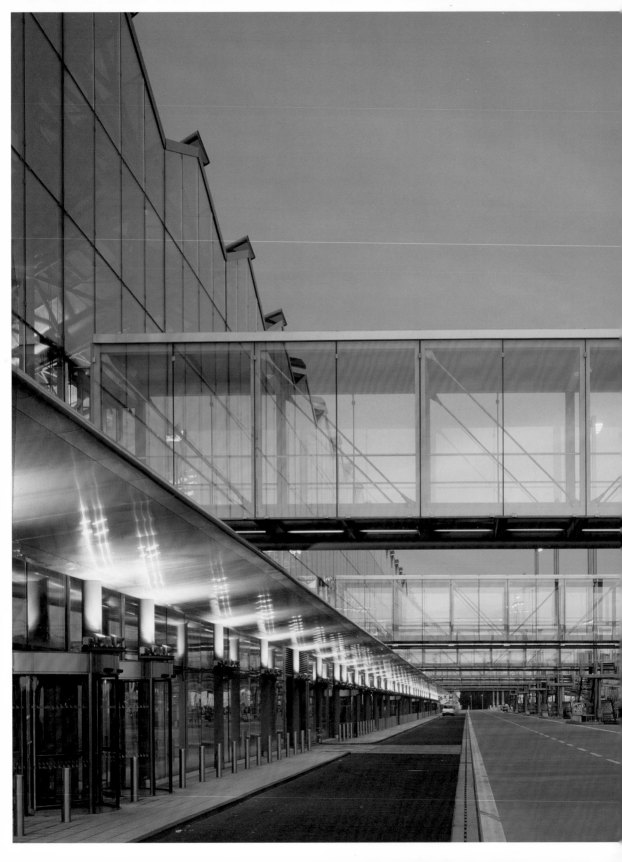

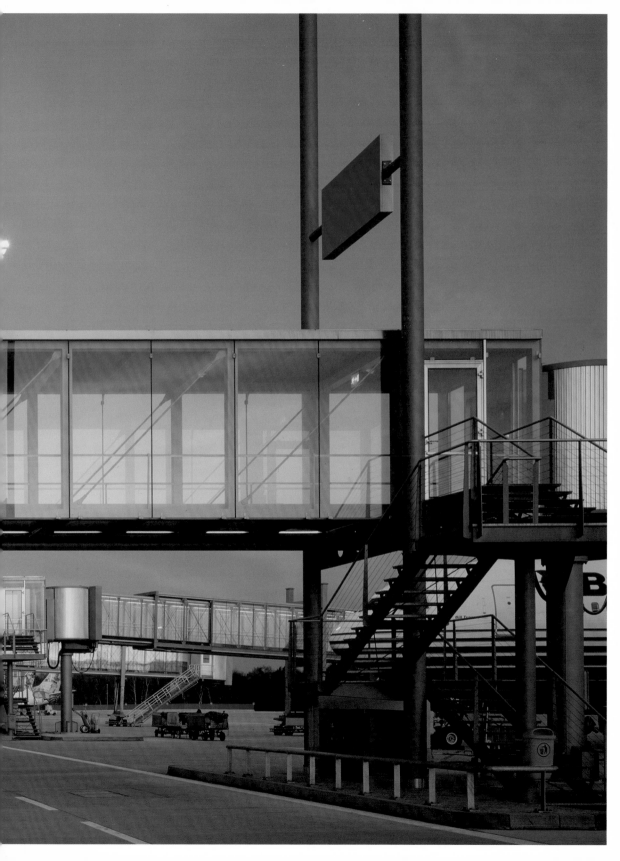

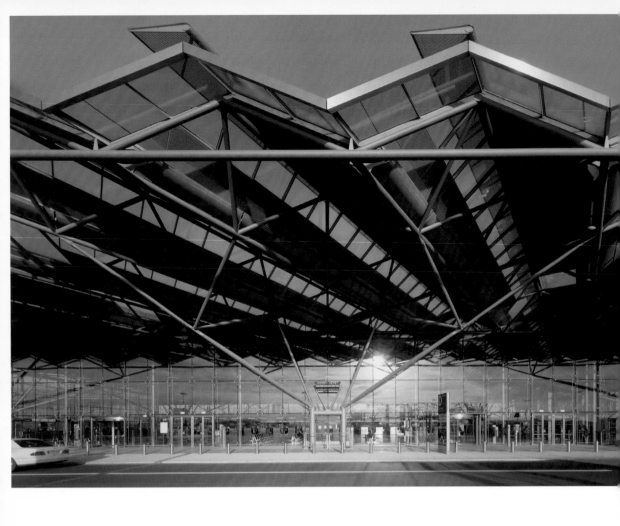

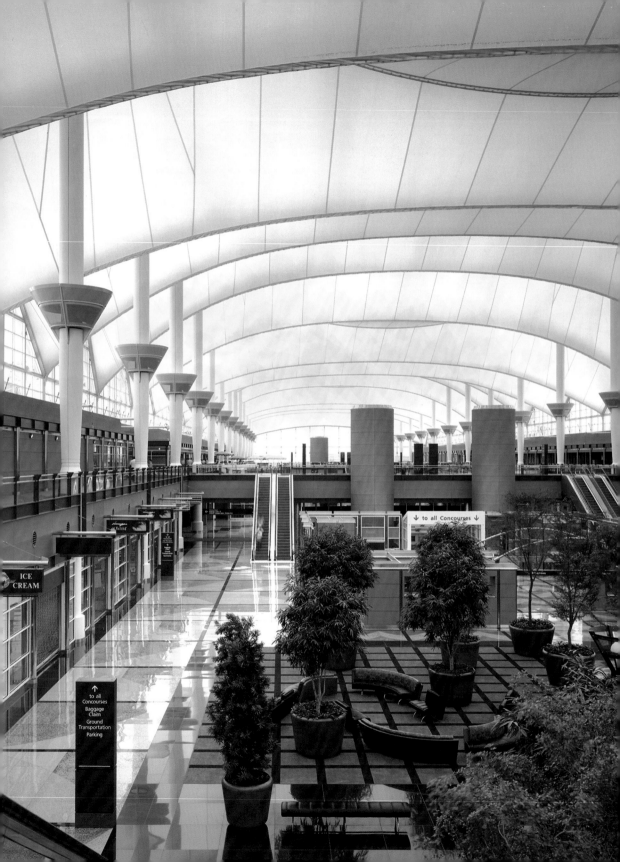

DENVER INTERNATIONAL AIRPORT | DENVER
USA
www.flydenver.com
Fentress Bradburn | Washington
1995

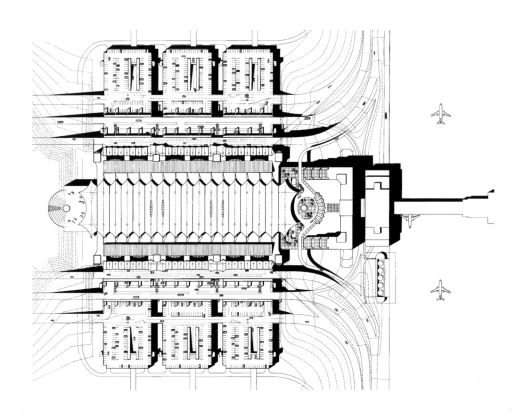

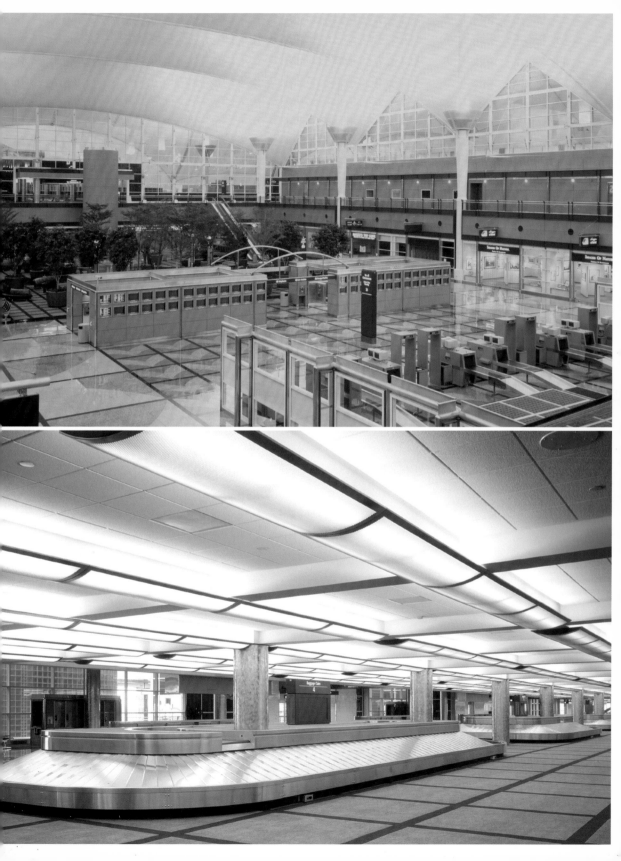

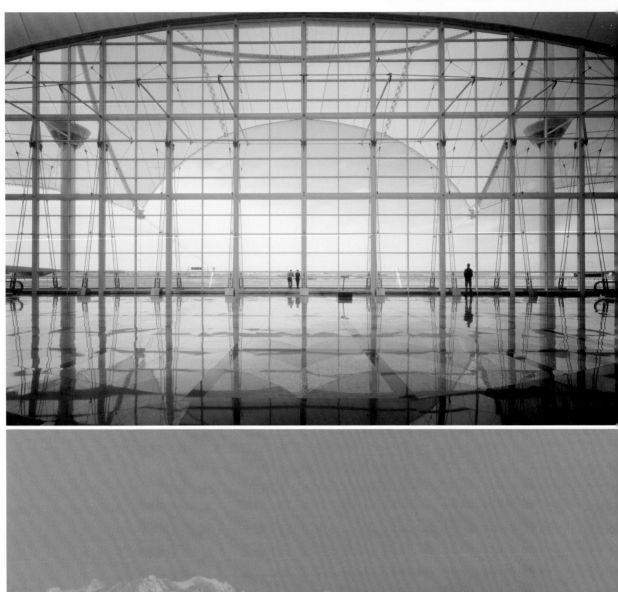

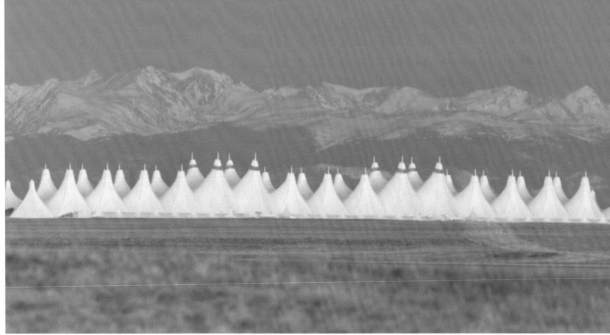

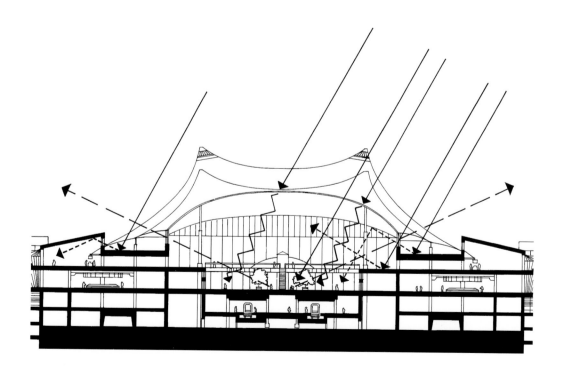

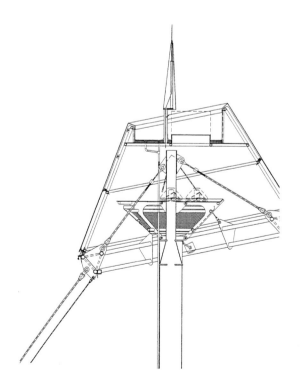

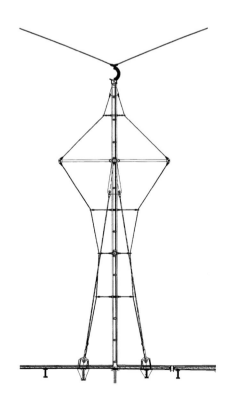

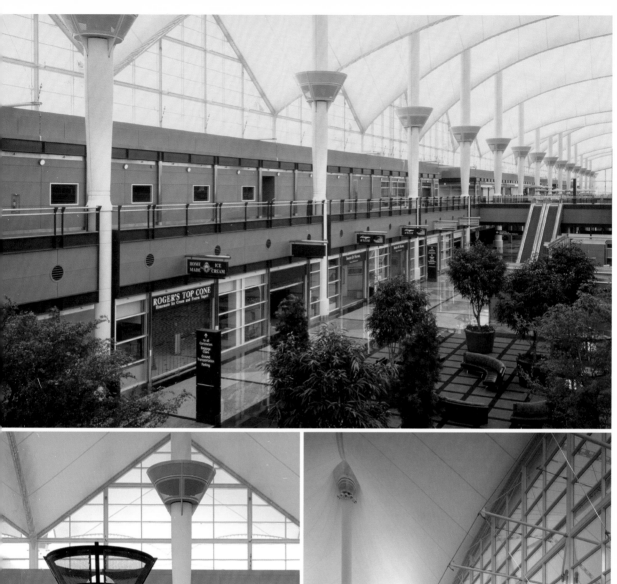

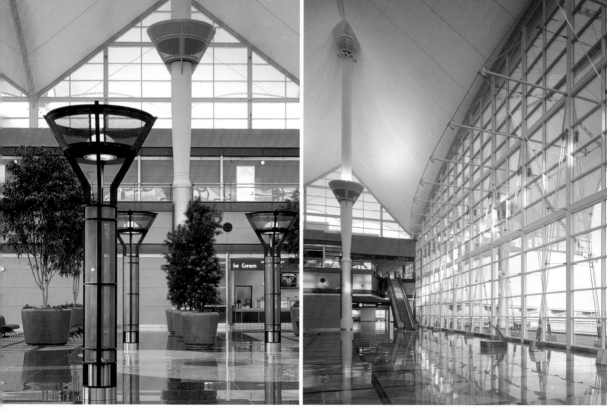

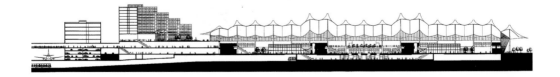

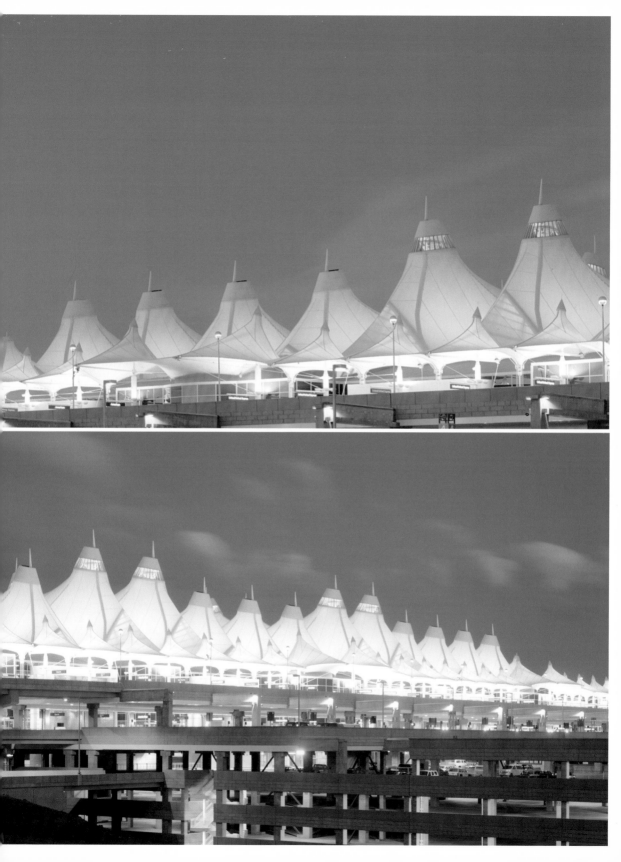

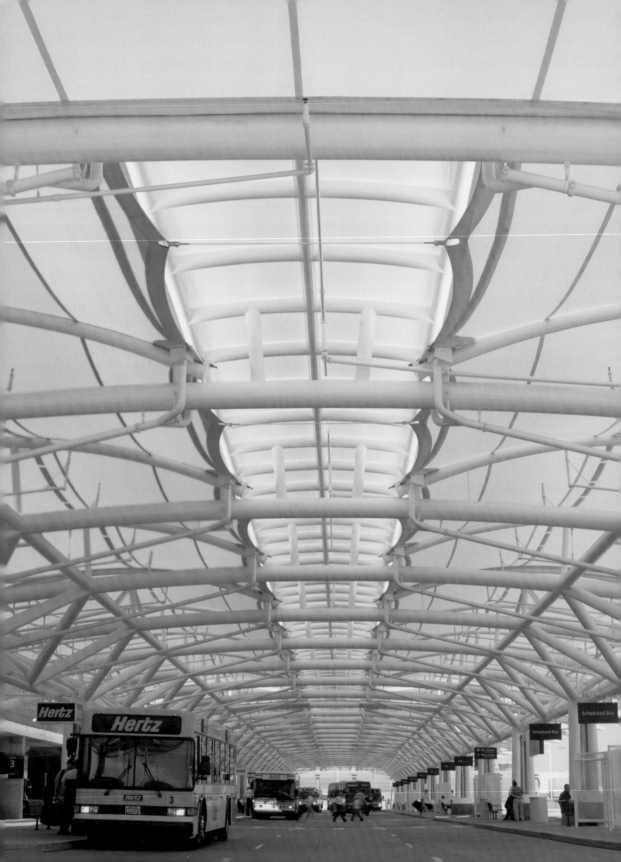

AERODYNAMIC CANOPY ADDITION TO DENVER INTERNATIONAL AIRPORT I DENVER, USA
www.flydenver.com
Leo A Daly I Los Angeles, 2004

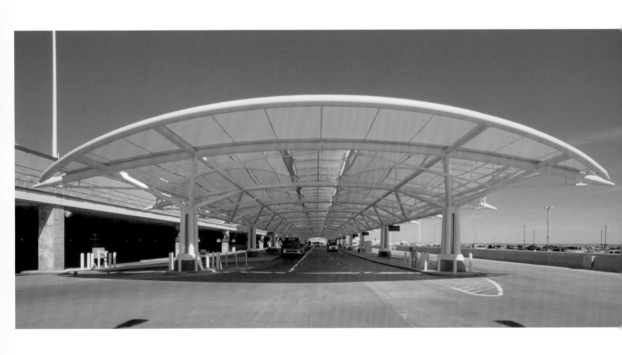

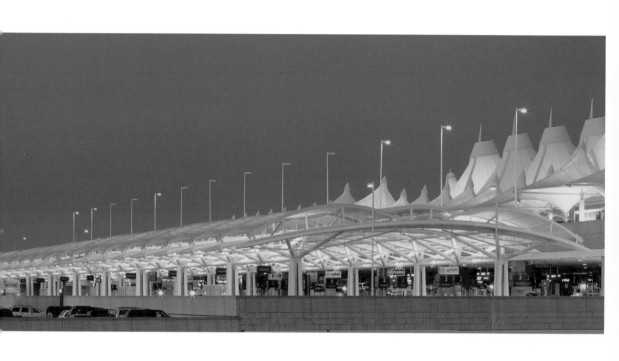

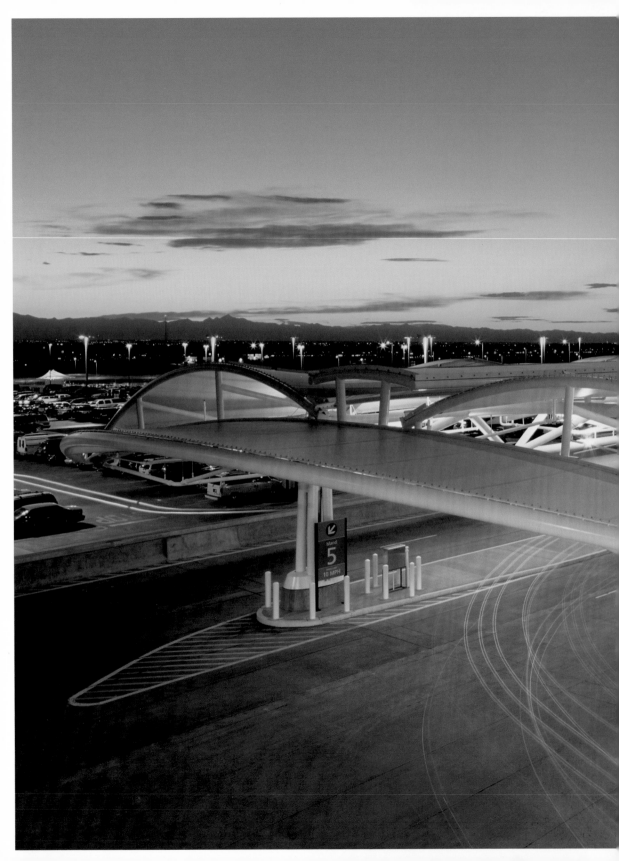

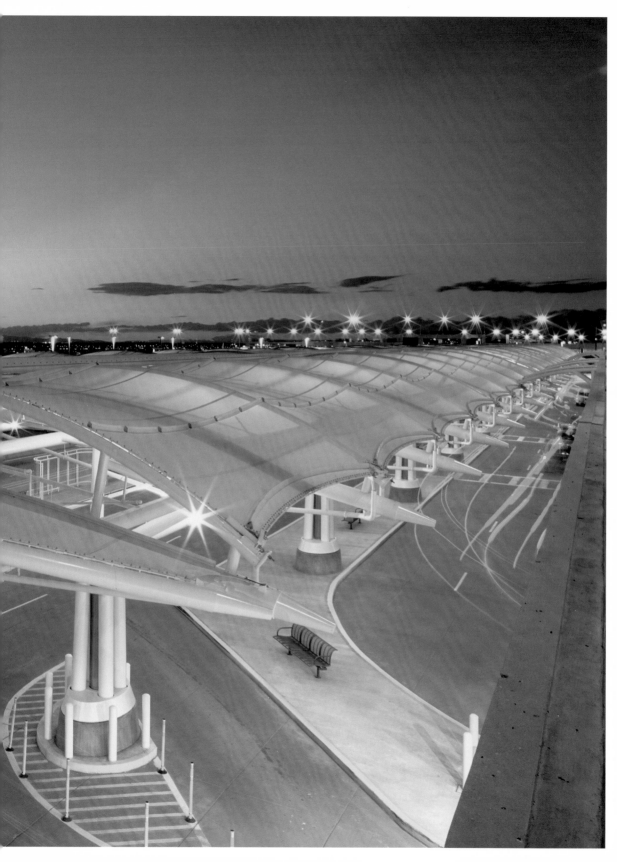

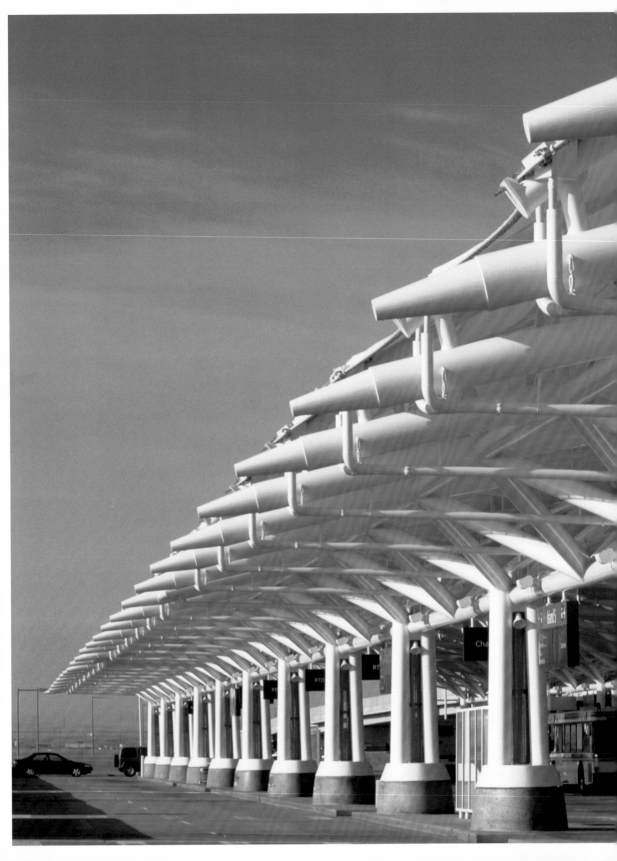

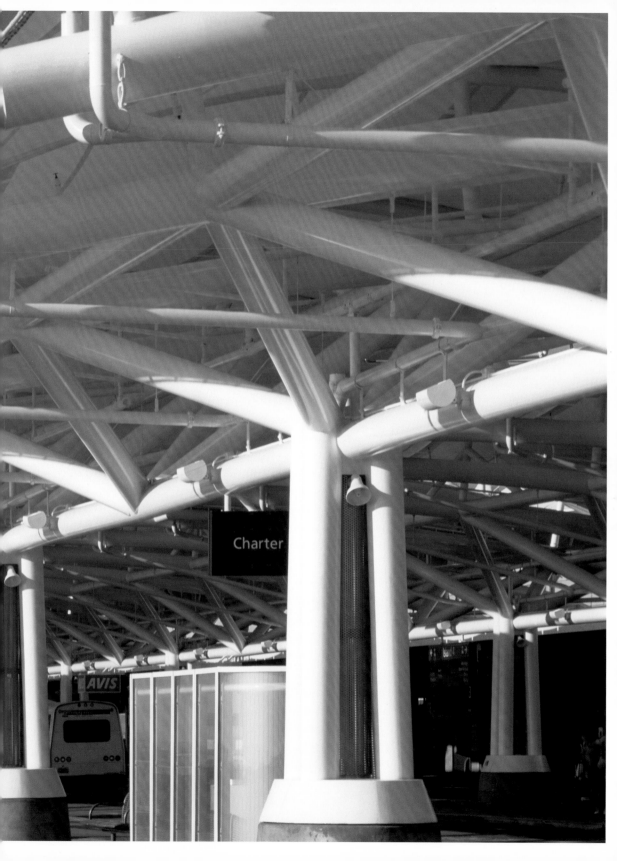

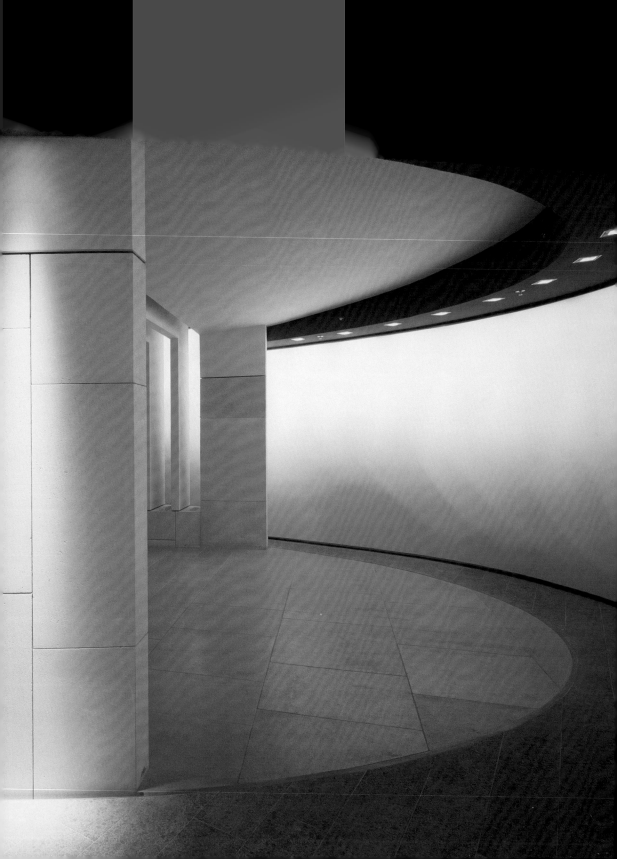

**NON-CONFESSIONAL PRAYER AND MEMORIAL ROOM
AT DÜSSELDORF INTERNATIONAL I DÜSSELDORF, GERMANY**
www.duesseldorf-international.de
Hahn Helten Architekten I Aachen, 2002

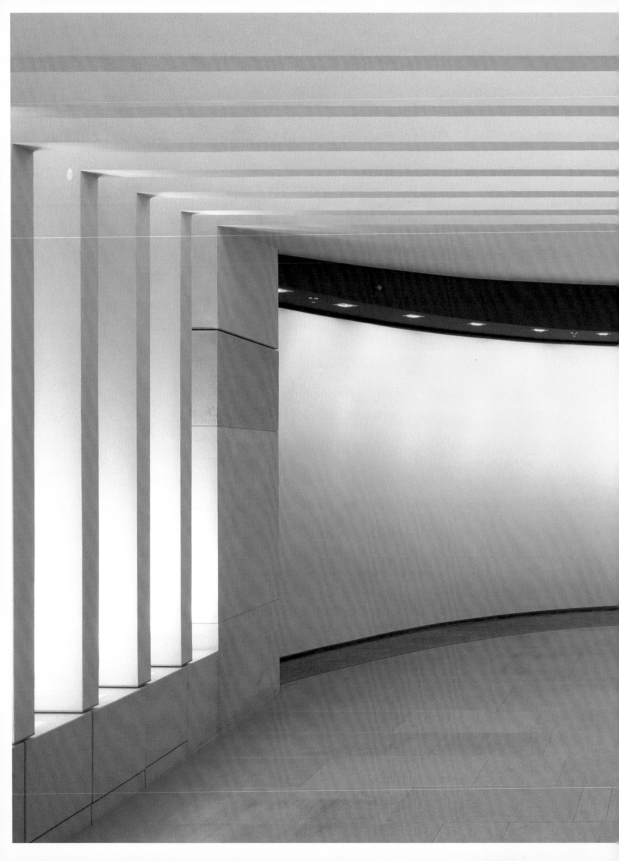

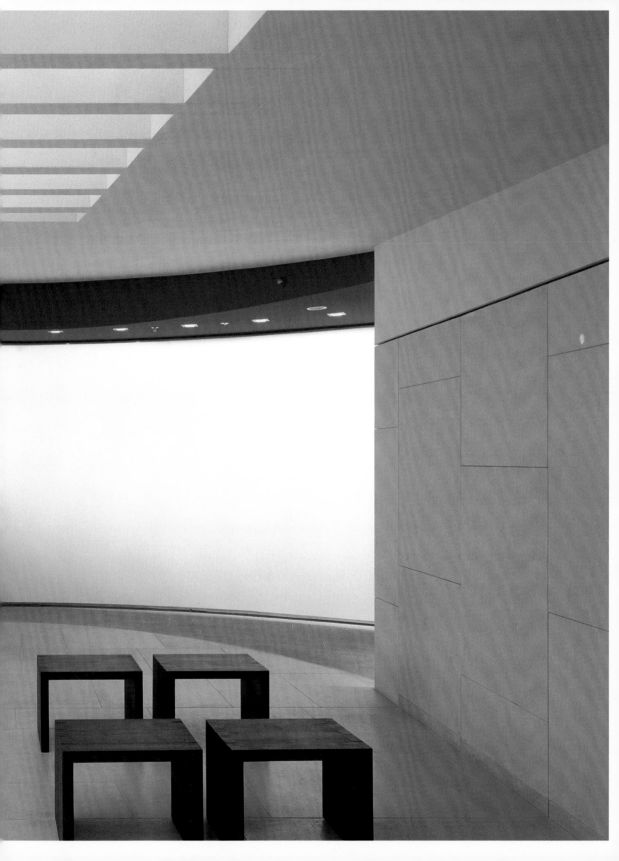

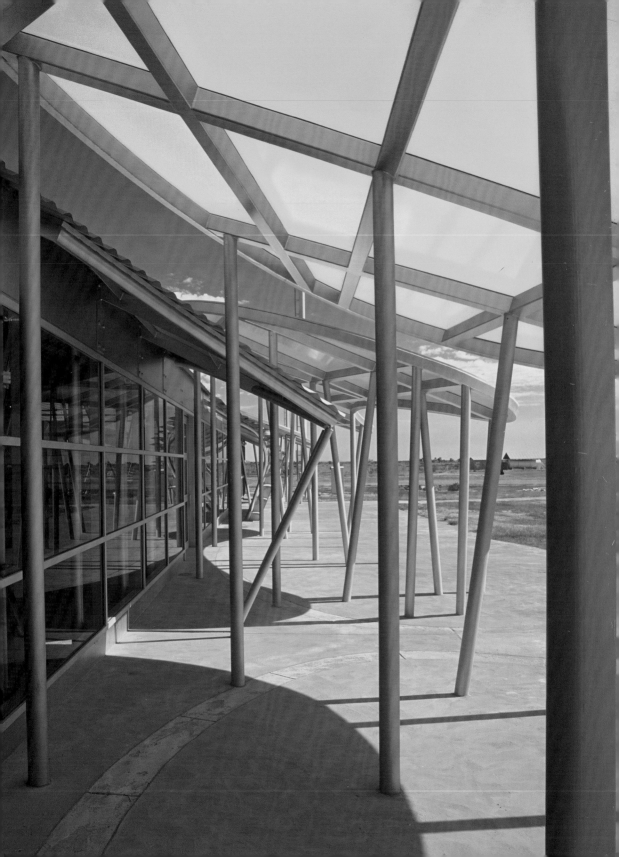

LEARMONTH INTERNATIONAL AIRPORT | EXMOUTH, AUSTRALIA
Jones Coulter Young | Perth, 2000

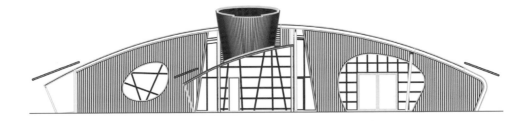

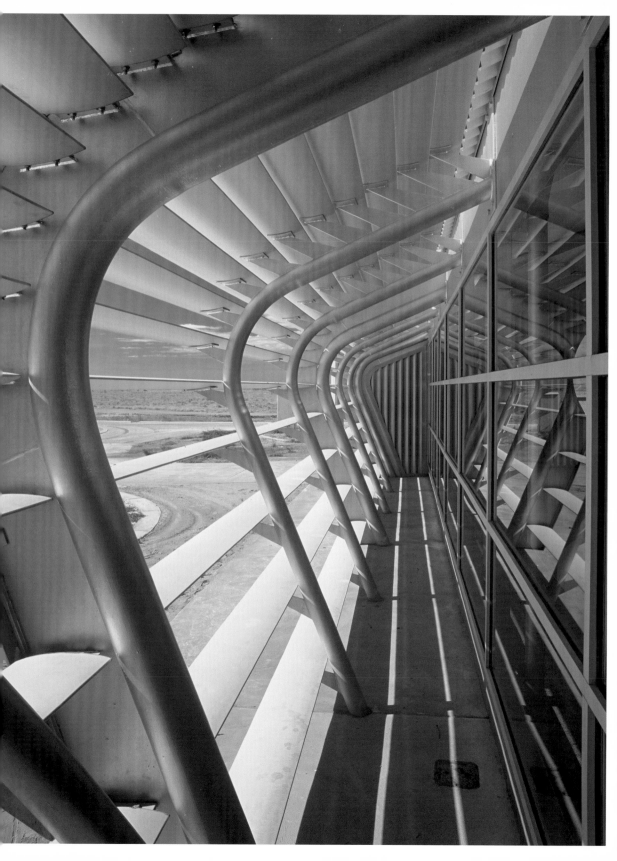

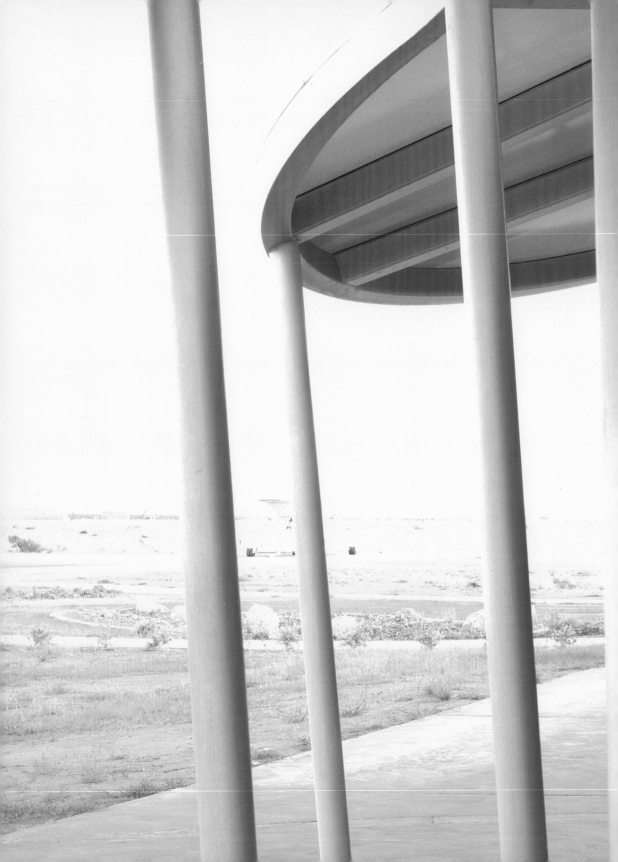

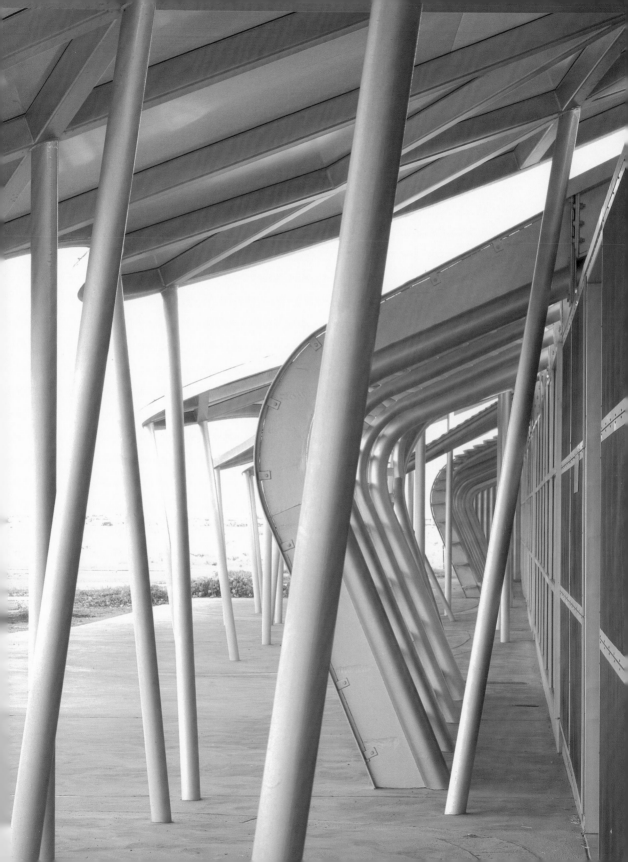

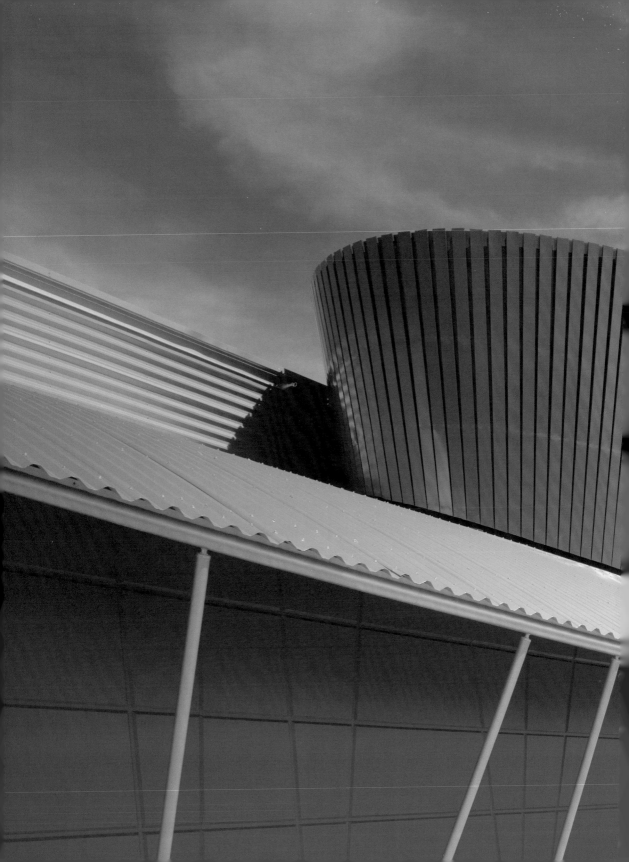

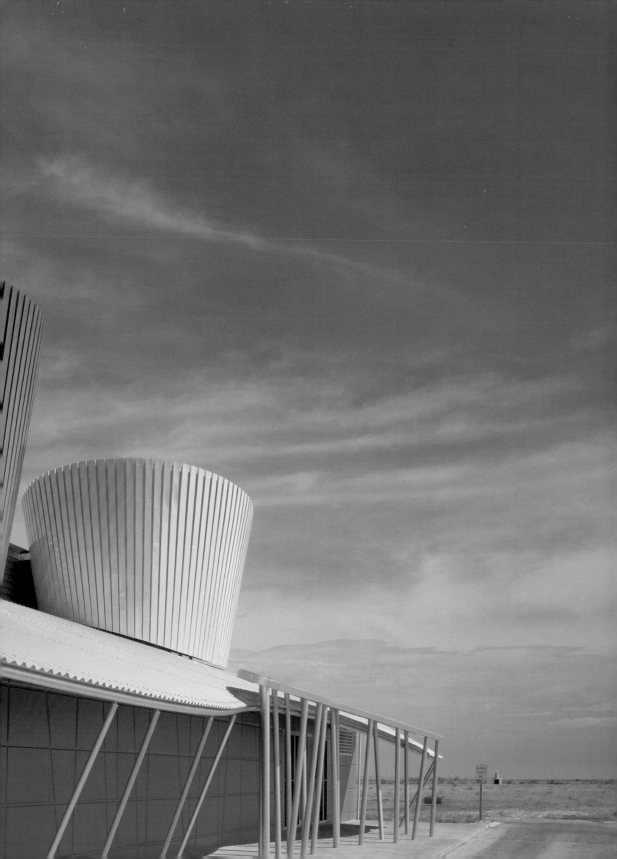

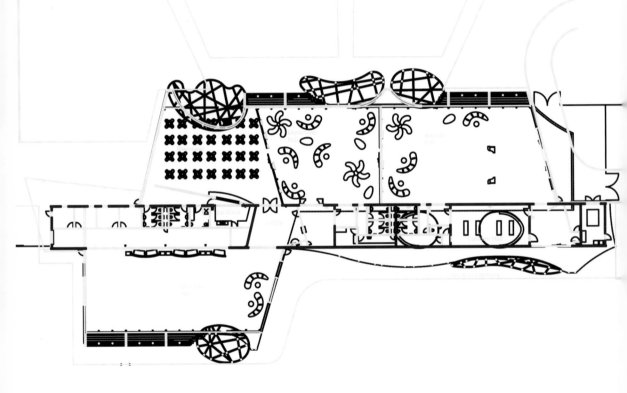

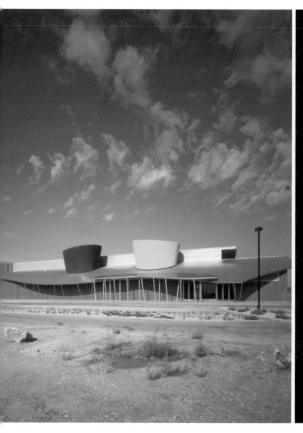
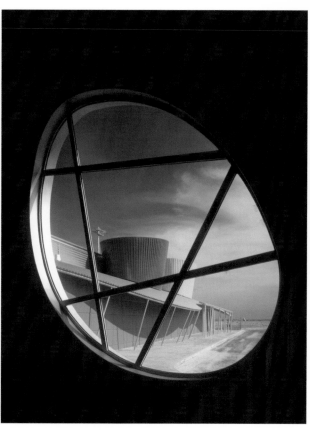

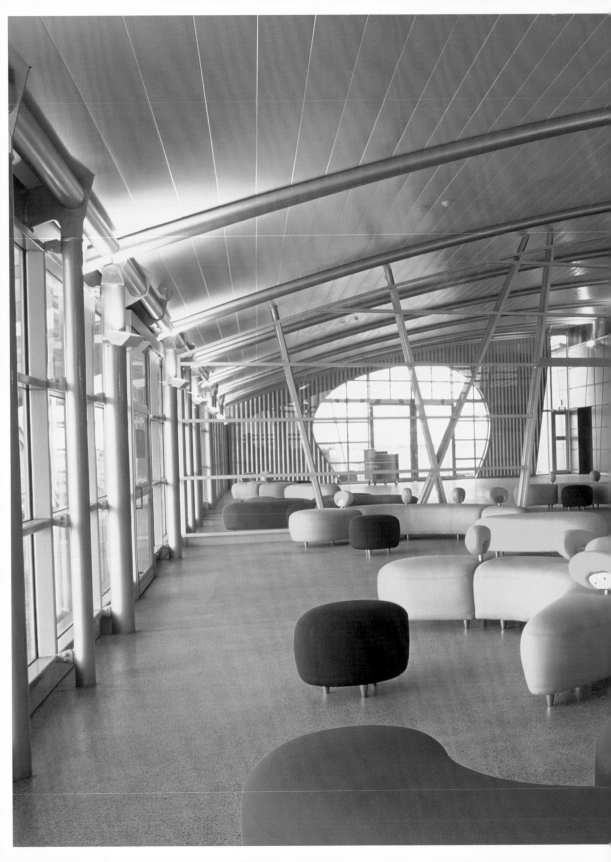

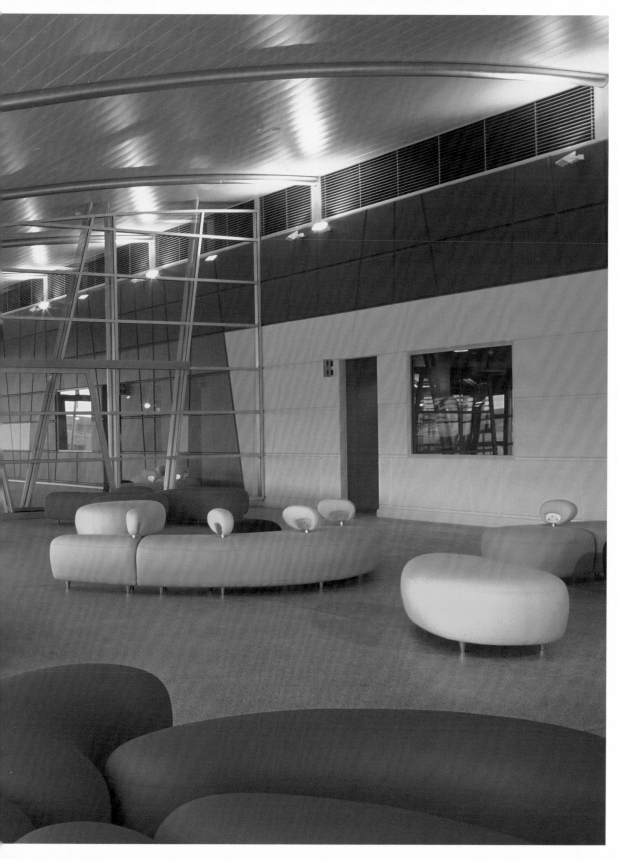

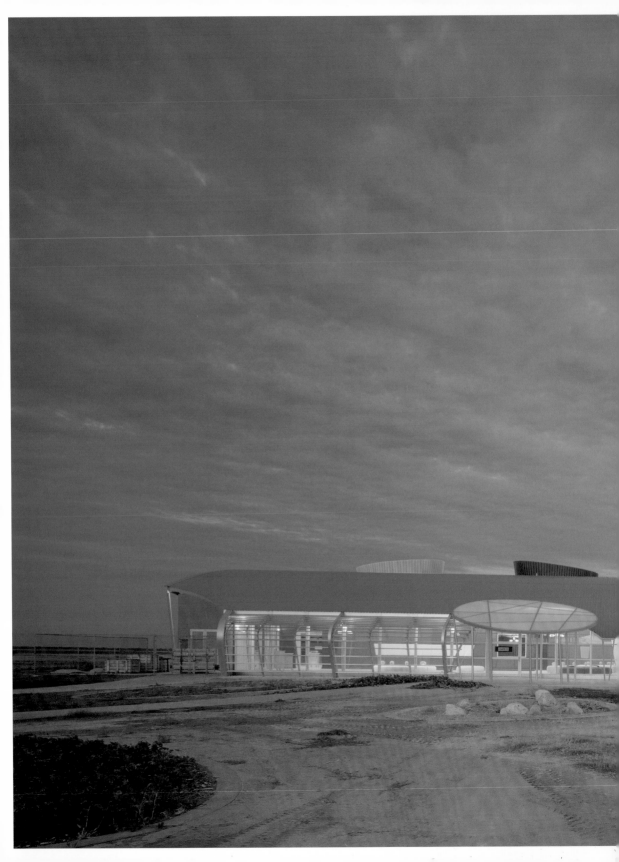

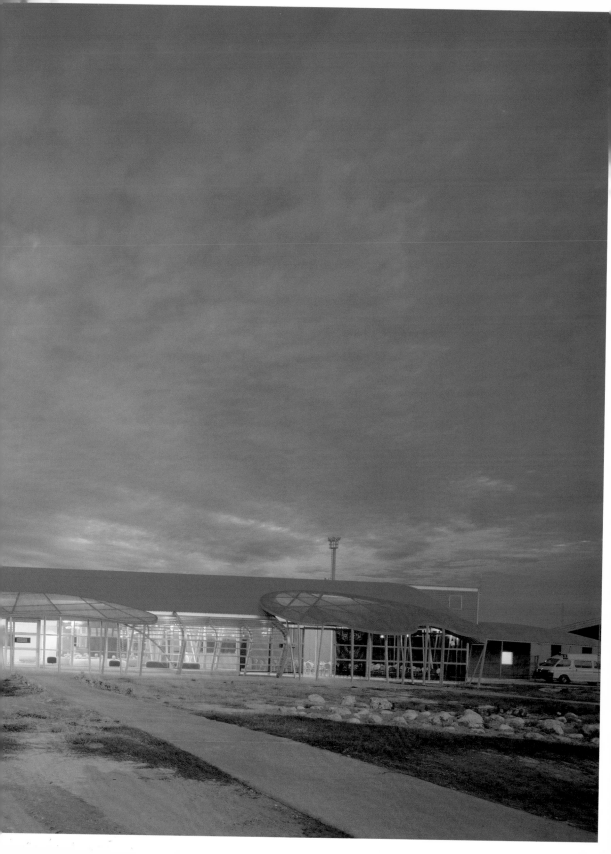

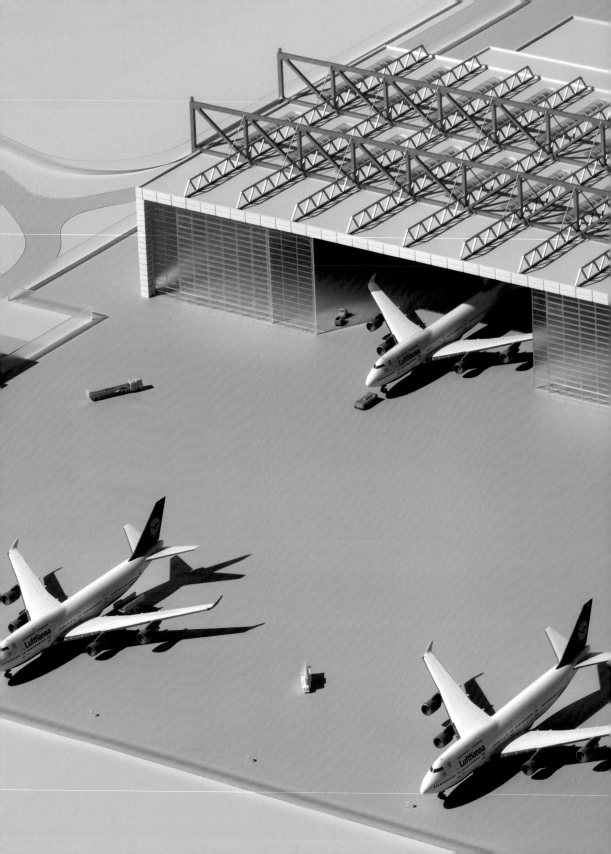

LUFTHANSA A380 MAINTENANCE BUILDING AT FRANKFURT AIRPORT | FRANKFURT, GERMANY
www.frankfurt-airport.de
gmp – Architekten von Gerkan, Marg und Partner | Hamburg, 2007

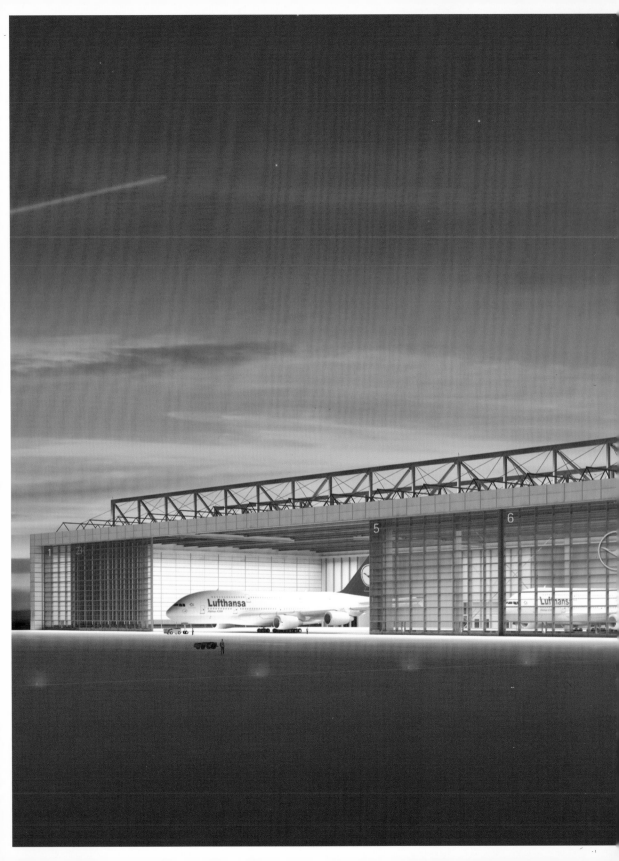

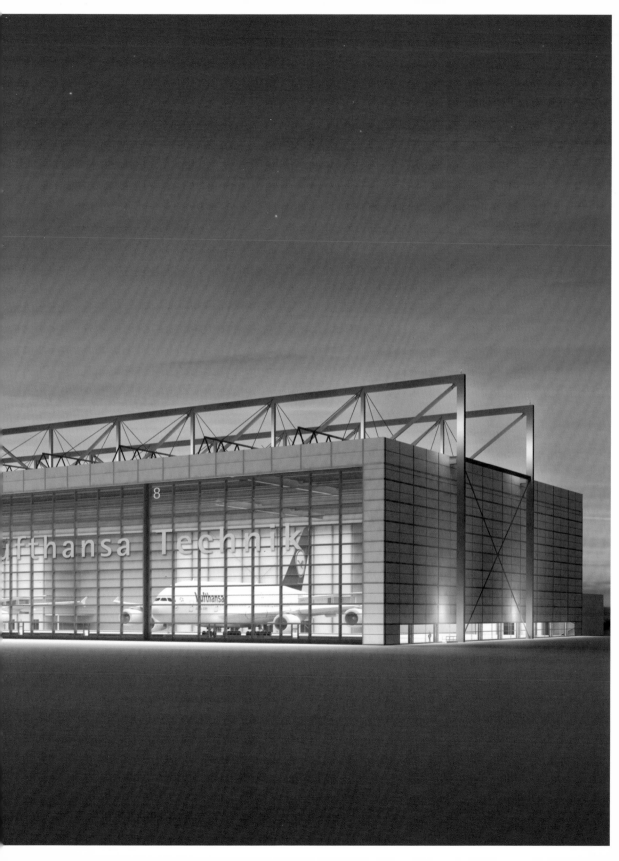

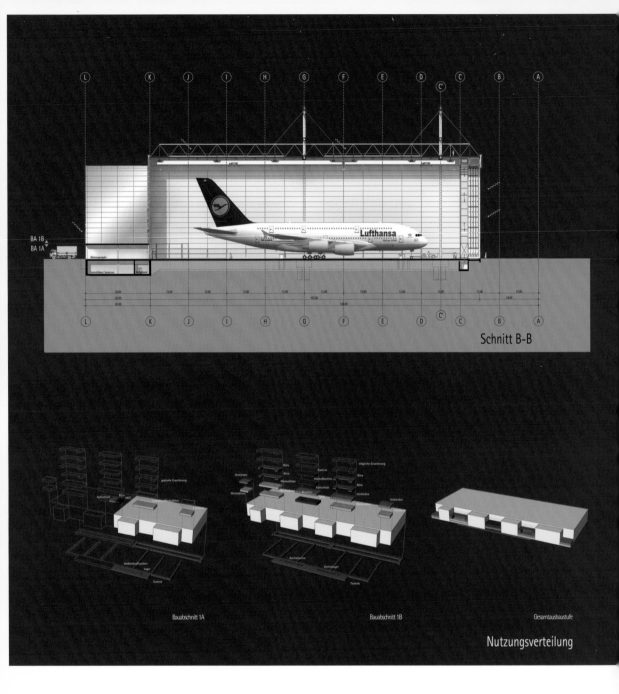

Schnitt B-B

Bauabschnitt 1A

Bauabschnitt 1B

Gesamtausbaustufe

Nutzungsverteilung

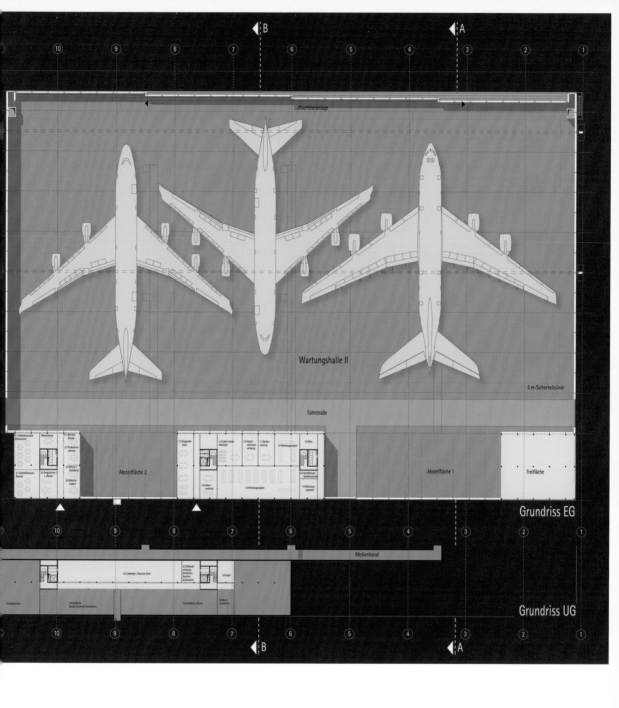

B◀ A◀

⑩ ⑨ ⑧ ⑦ ⑥ ⑤ ④ ③ ② ①

Luftschleieranlage

Wartungshalle II

5 m-Sicherheitslinie

Fahrstraße

Abstellfläche 2

Abstellfläche 1

Freifläche

Grundriss EG

⑩ ⑨ ⑧ ⑦ ⑥ ⑤ ④ ③ ② ①

Medienkanal

Grundriss UG

⑩ ⑨ ⑧ ⑦ ⑥ ⑤ ④ ③ ② ①

B◀ A◀

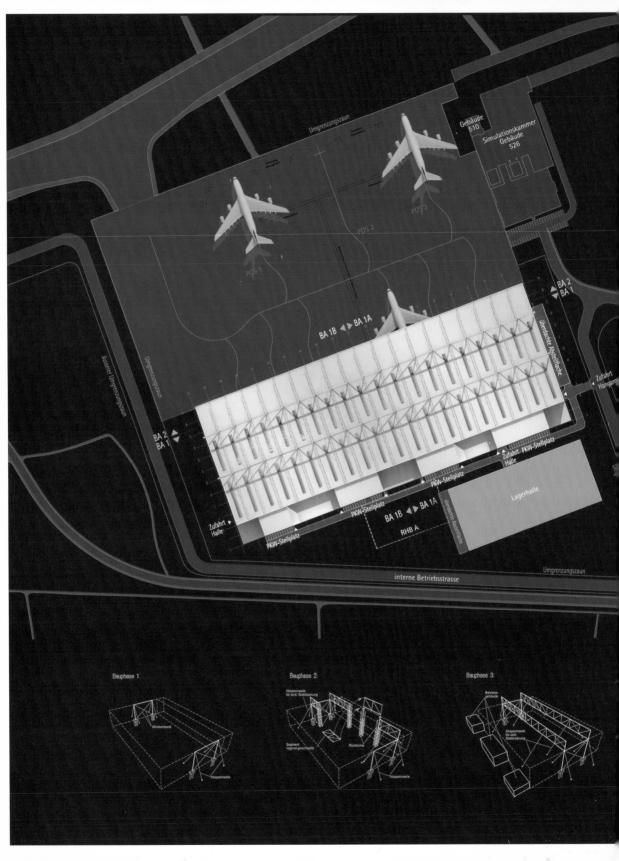

Umgrenzungszaun

Gebäude 510

Simulationskammer
Gebäude 526

POS 3

POS 2

POS 1

äusserer Umgrenzungszaun

Umgrenzungszaun

BA 2
BA 1

BA 1B ◀ ▶ BA 1A

Überdachte Abstellfläche

Zufahrt
Hangar

BA 2
BA 1

Zufahrt PKW-Stellplatz
Halle

PKW-Stellplatz

Lagerhalle

Zufahrt ▶
Halle

PKW-Stellplatz

BA 1B ◀ ▶ BA 1A

Überdachte Abstellfläche

PKW-Stellplatz

RHB A

interne Betriebsstrasse

Umgrenzungszaun

Bauphase 1:

Windverband

Abspannseile

Bauphase 2:

Abspannseile
für seitl. Stabilisierung

Rüsttürme

Segment
liegend geschweißt

Abspannseile

Bauphase 3:

Betriebs-
gebäude

Abspannseile
für seitl.
Stabilisierung

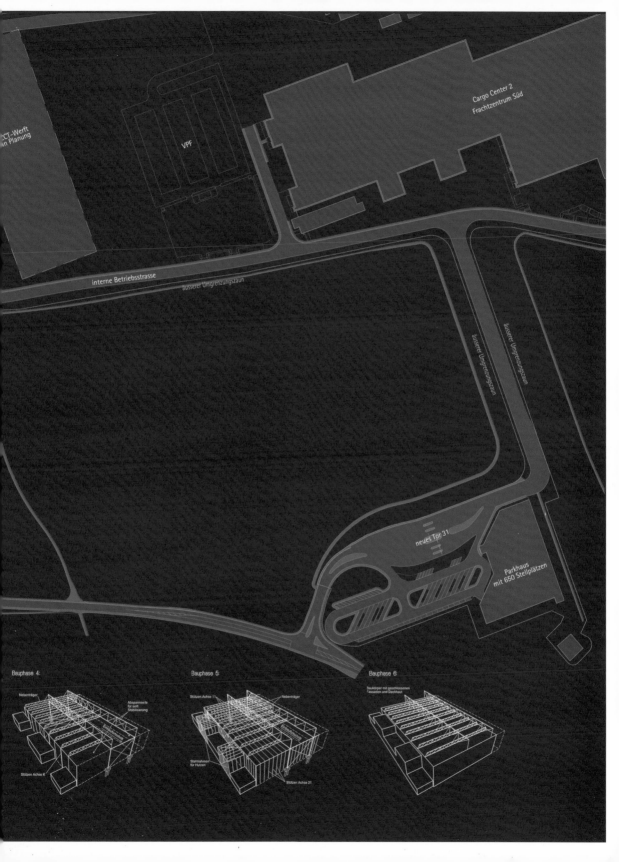

CCT-Werft
in Planung

VPF

Cargo Center 2
Frachtzentrum Süd

interne Betriebsstrasse
äusserer Umgrenzungszaun

äusserer Umgrenzungszaun

äusserer Umgrenzungszaun

neues Tor 31

Parkhaus
mit 650 Stellplätzen

Bauphase 4:

Nebenträger

Abspannseile
für seitl.
Stabilisierung

Stützen Achse K

Bauphase 5:

Stützen Achse 11

Nebenträger

Stahlrahmen
für Hutzen

Stützen Achse 21

Bauphase 6:

Baukörper mit geschlossenen
Fassaden und Dachhaut

LUFTHANSA FIRST CLASS TERMINAL AT FRANKFURT AIRPORT | FRANKFURT, GERMANY
www.fraport.de
Hollen und Radowske | Frankfurt, 2004

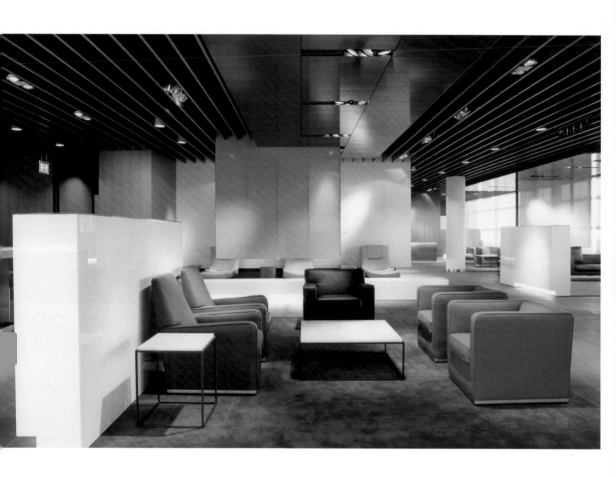

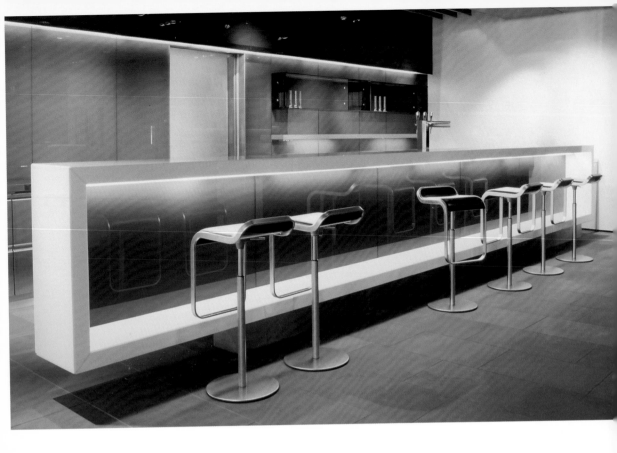

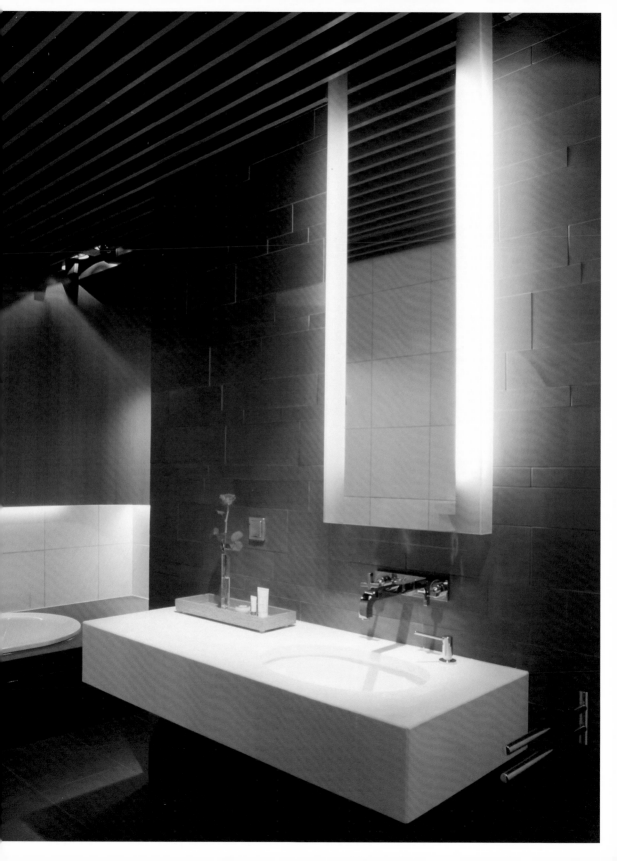

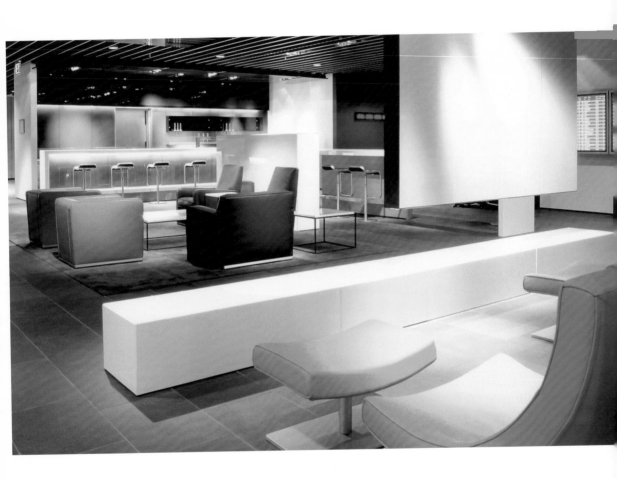

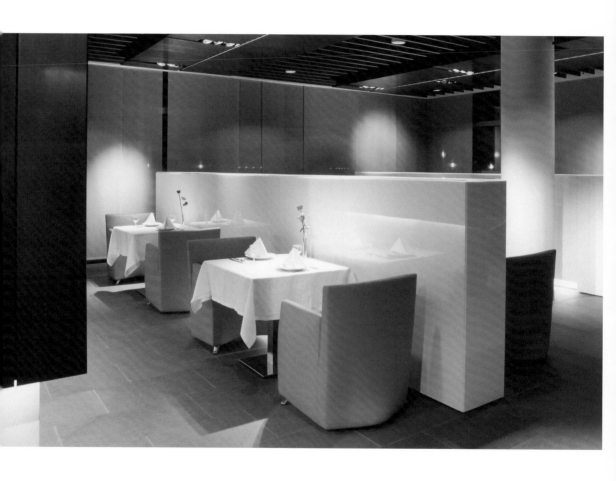

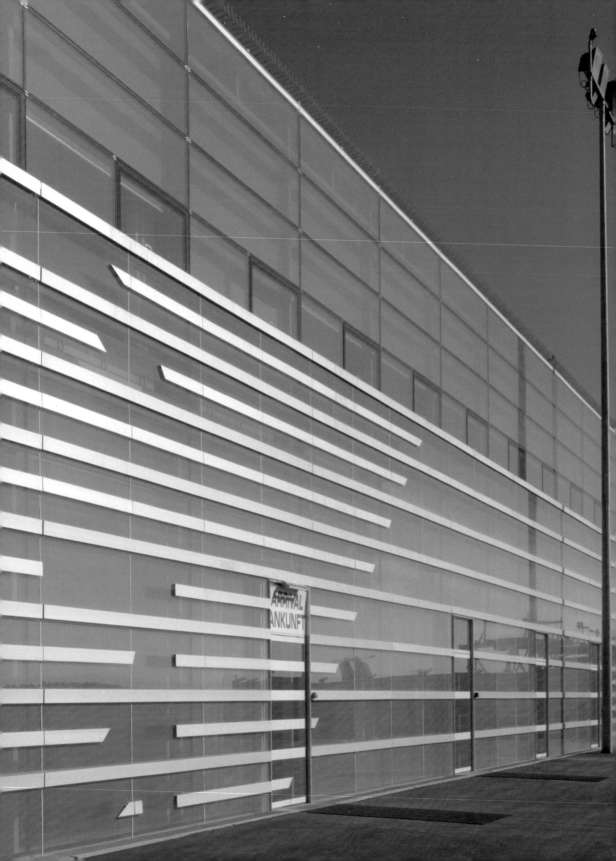

AIRPORT GRAZ | GRAZ, AUSTRIA
www.flughafen-graz.at
Riegler Riewe Architekten | Graz, 1998

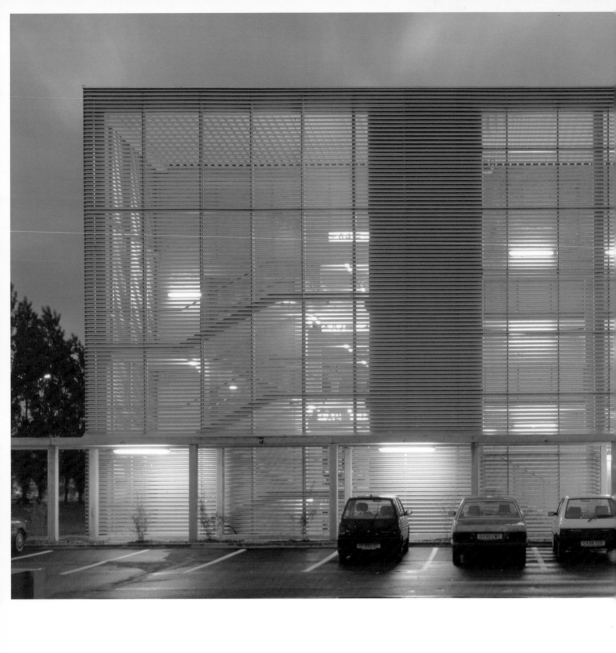

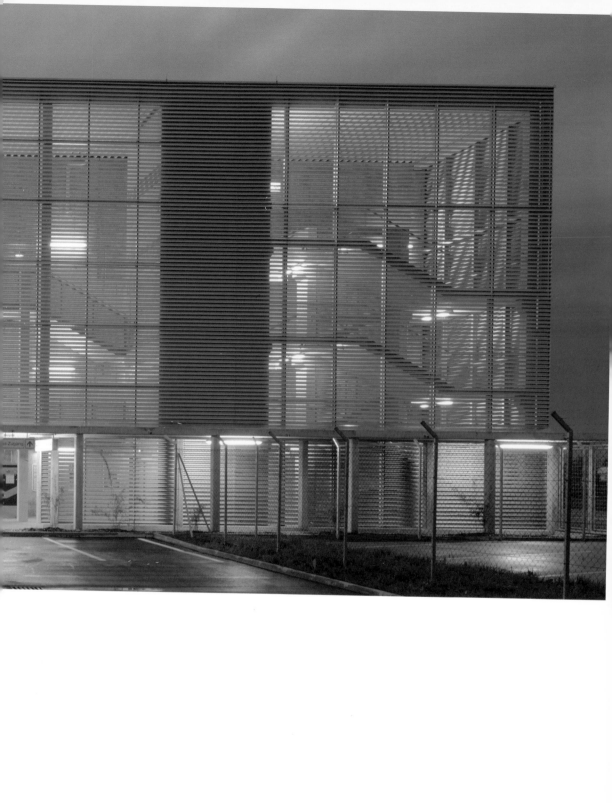

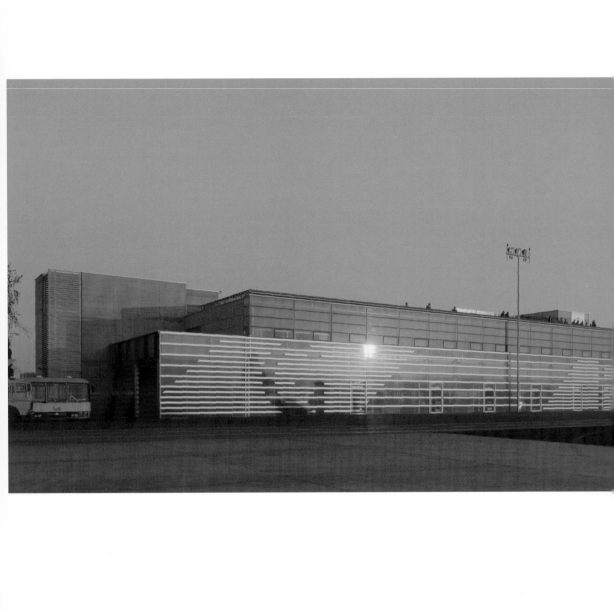

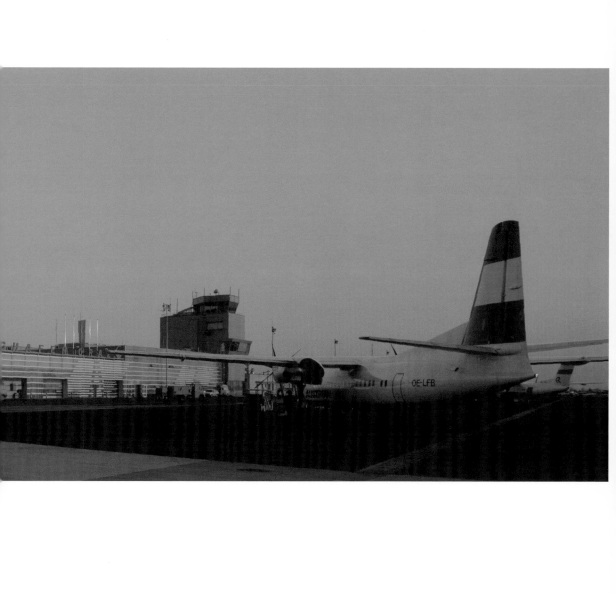

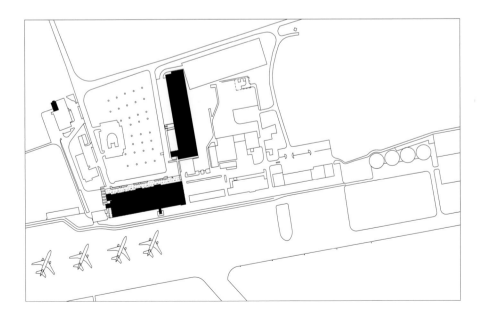

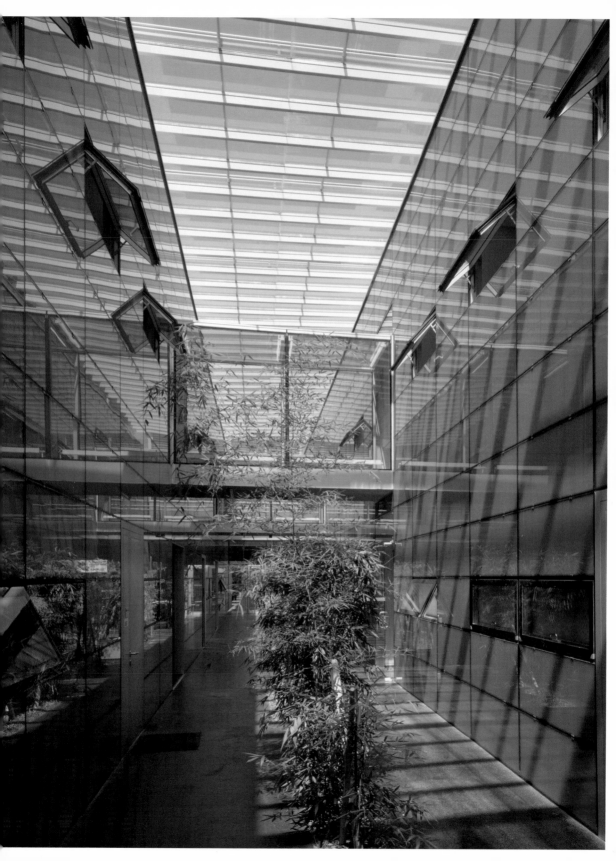

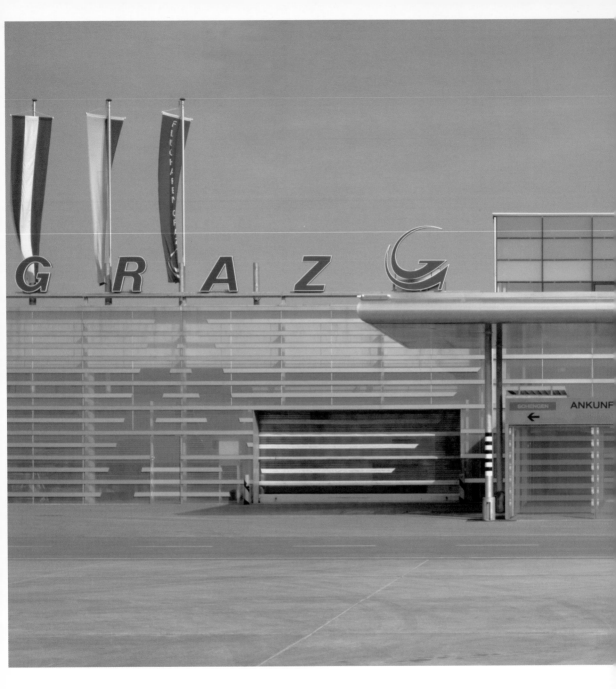

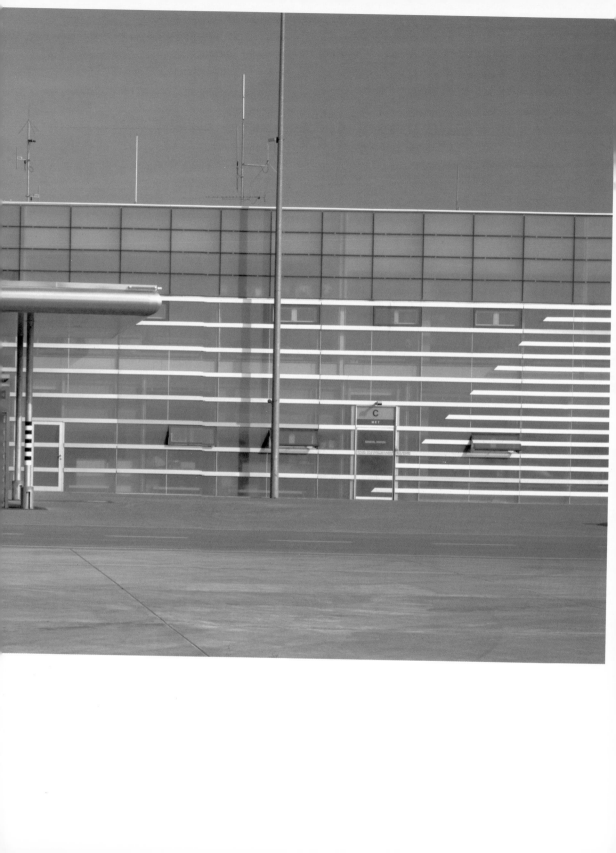

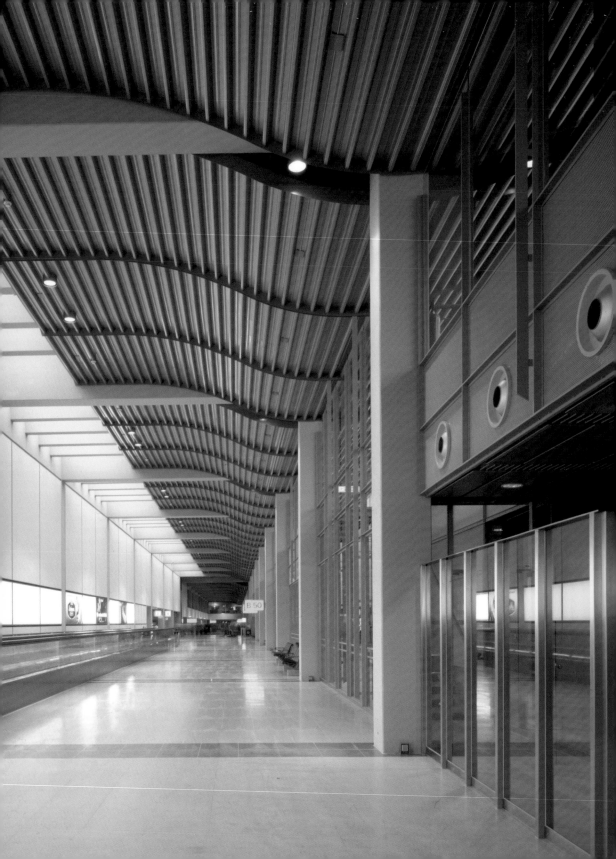

TERMINALS 4 UND 2 AT HAMBURG AIRPORT | **HAMBURG, GERMANY**
www.ham.airport.de
gmp – Architekten von Gerkan, Marg und Partner | Hamburg, 1993, 2005

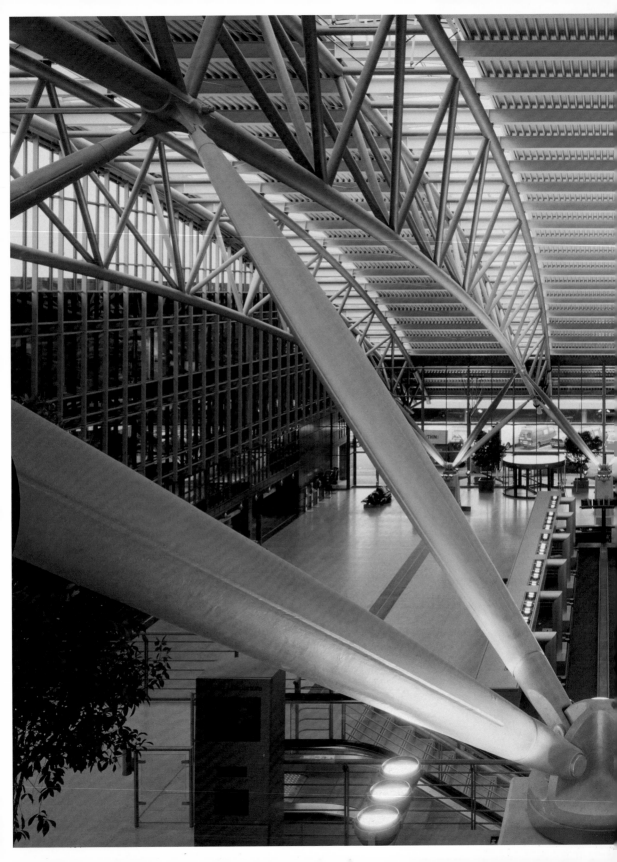

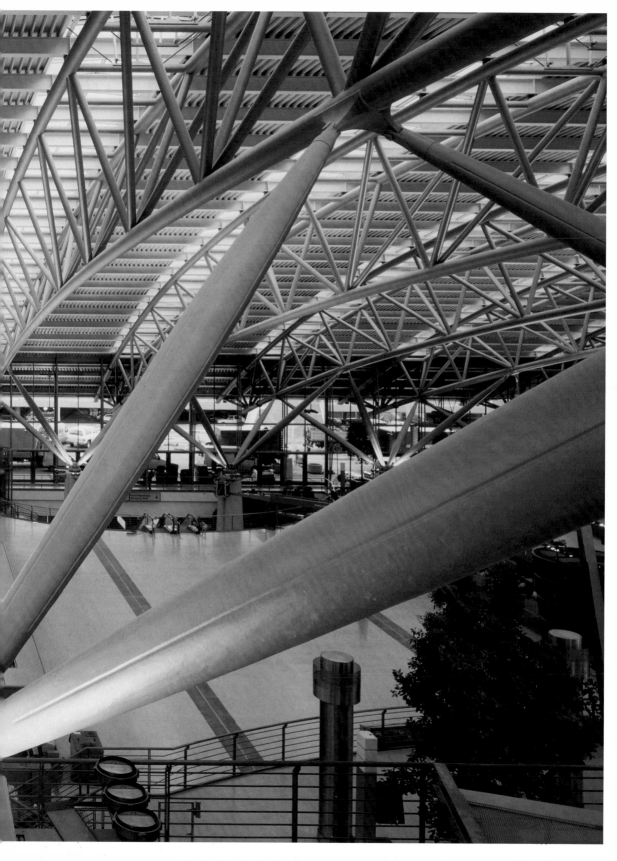

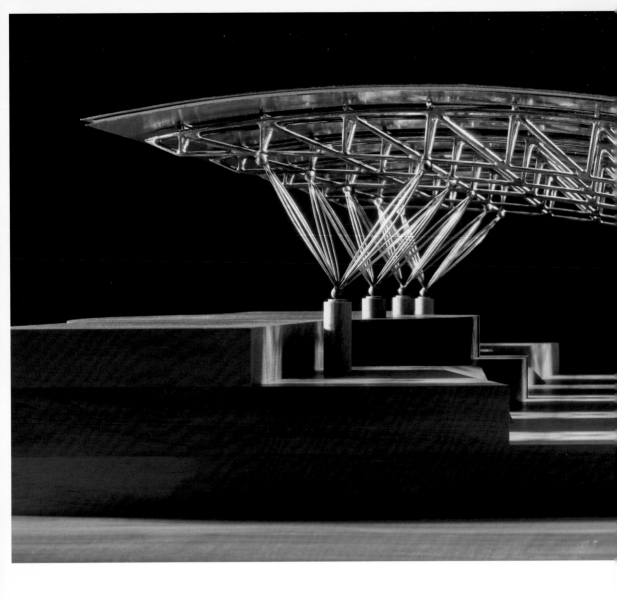

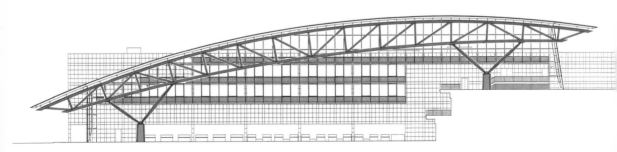

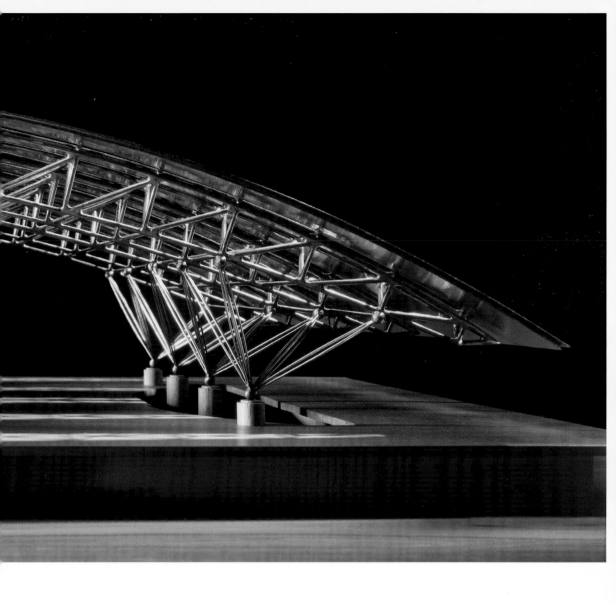

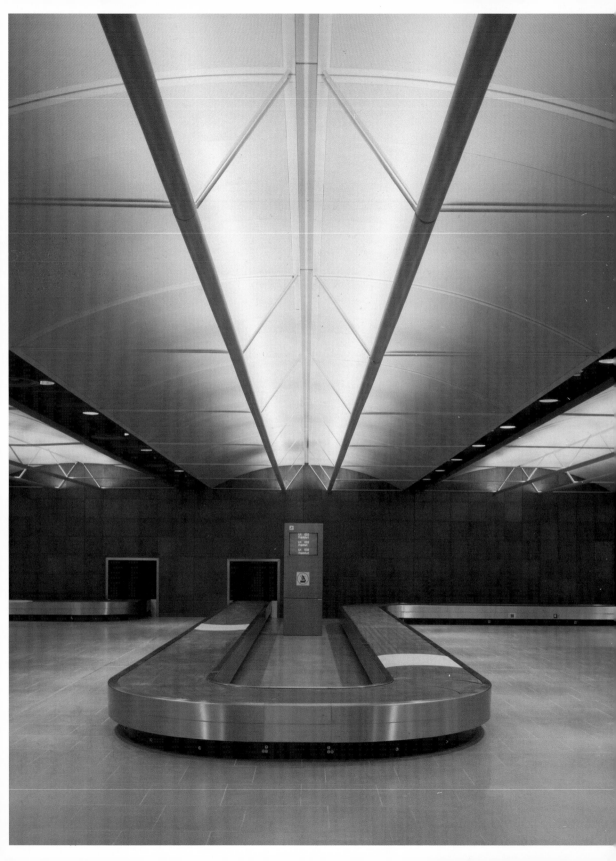

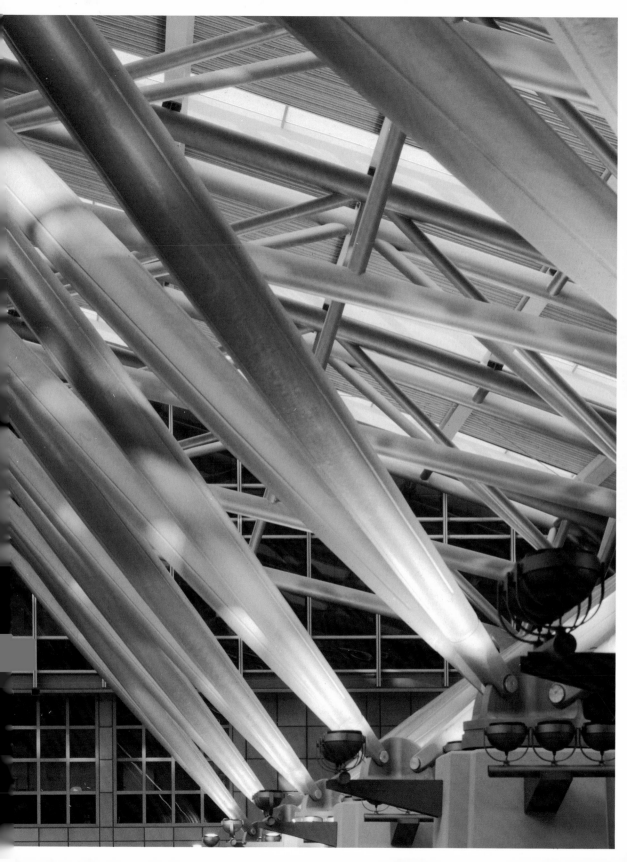

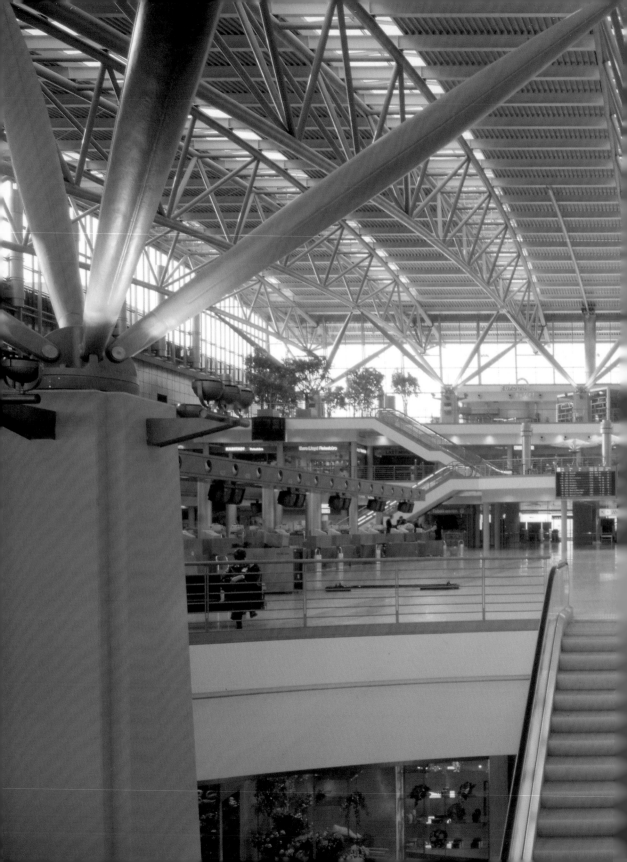

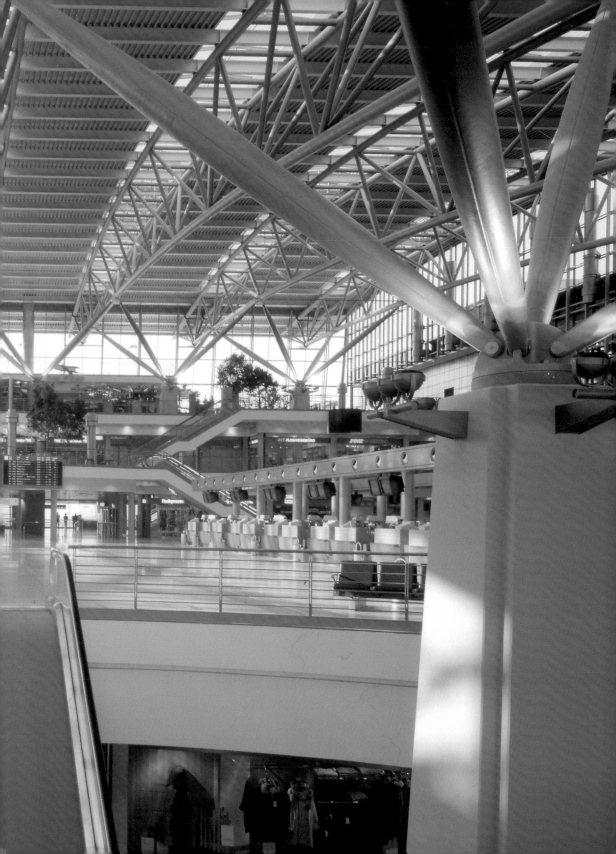

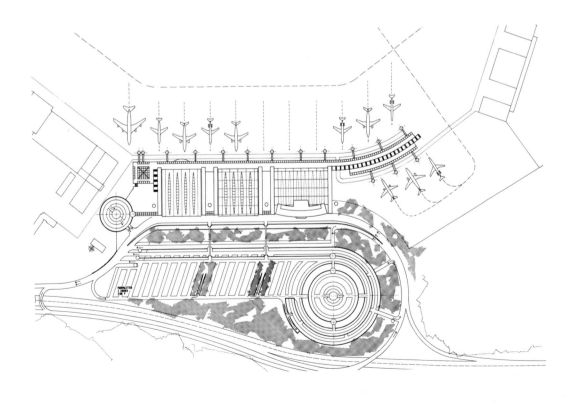

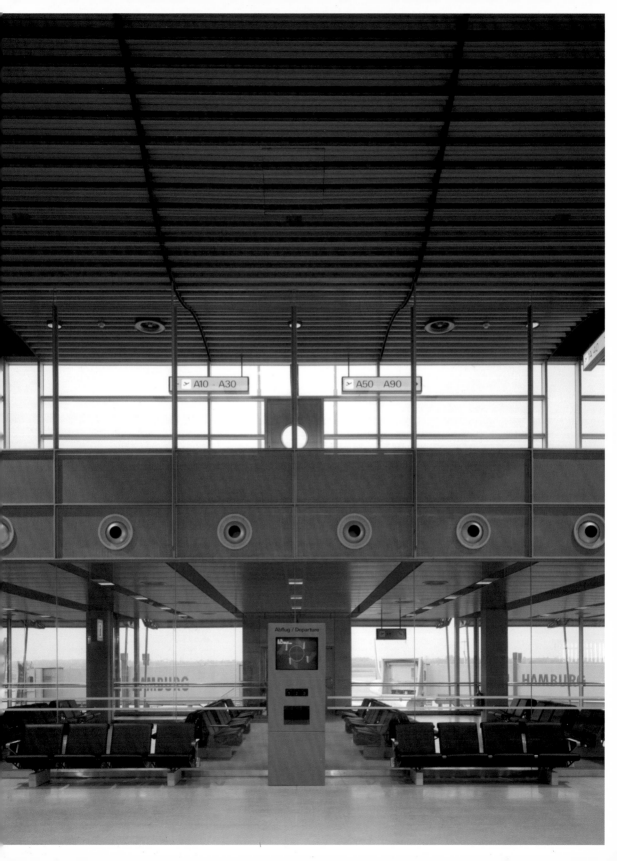

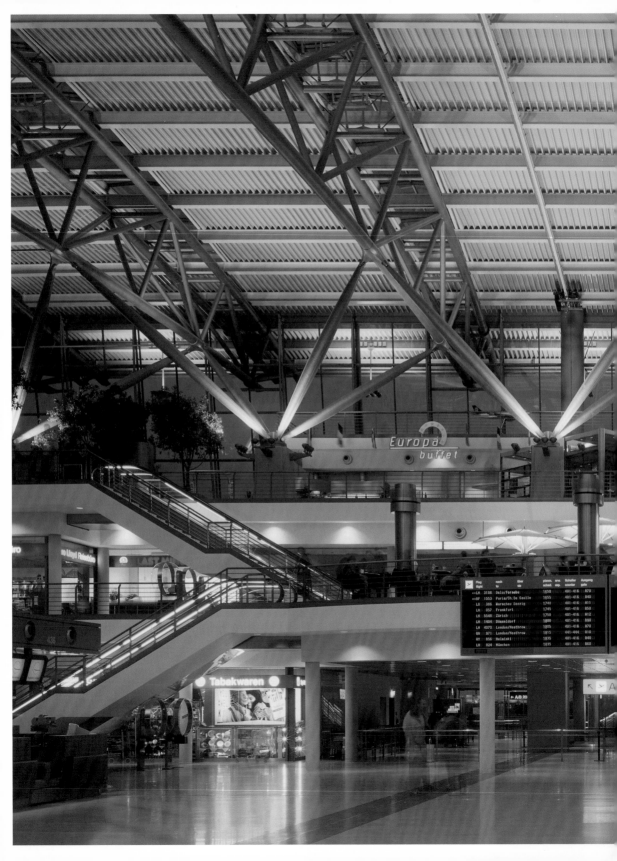

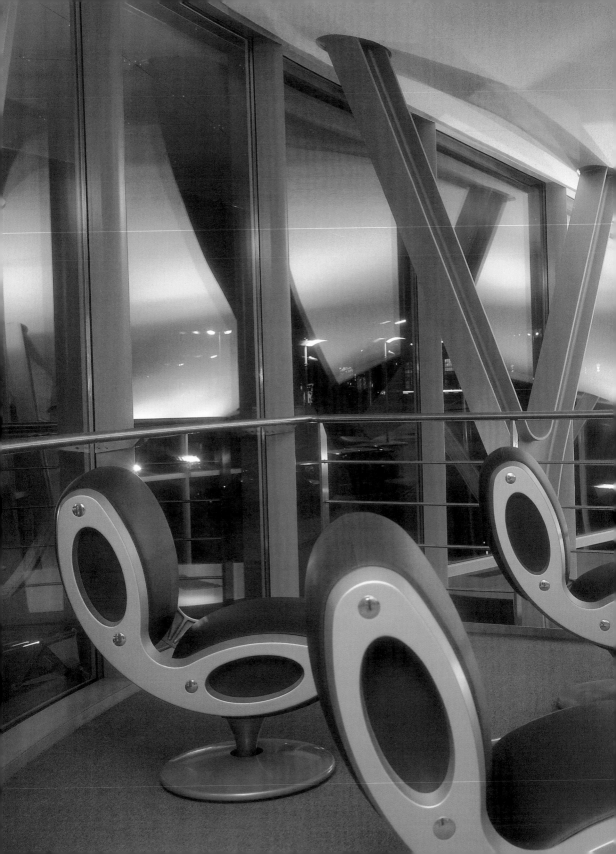

EMPFANGSGEBÄUDE LUFTHANSA TECHNIK AG AT HAMBURG AIRPORT | HAMBURG, GERMANY
www.ham.airport.de
Renner Hainke Wirth Architekten | Hamburg, 1999

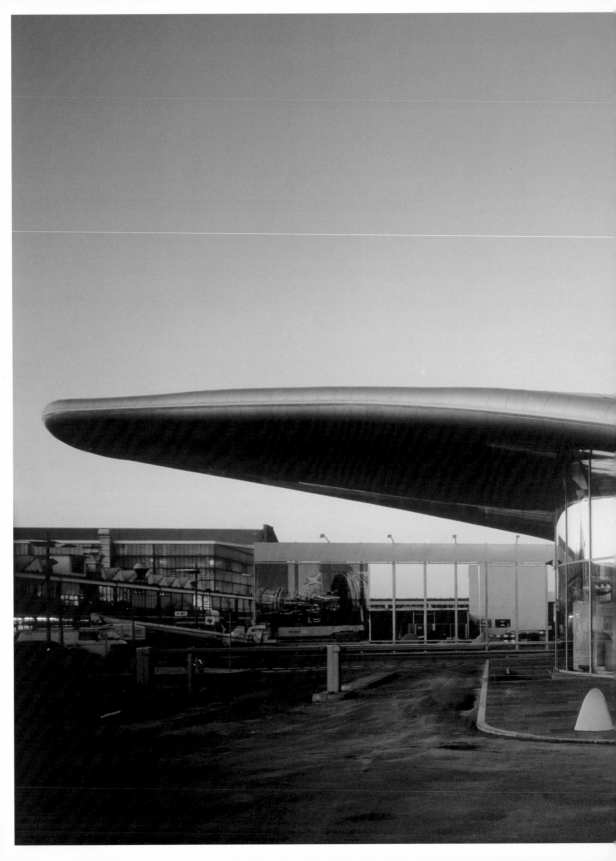

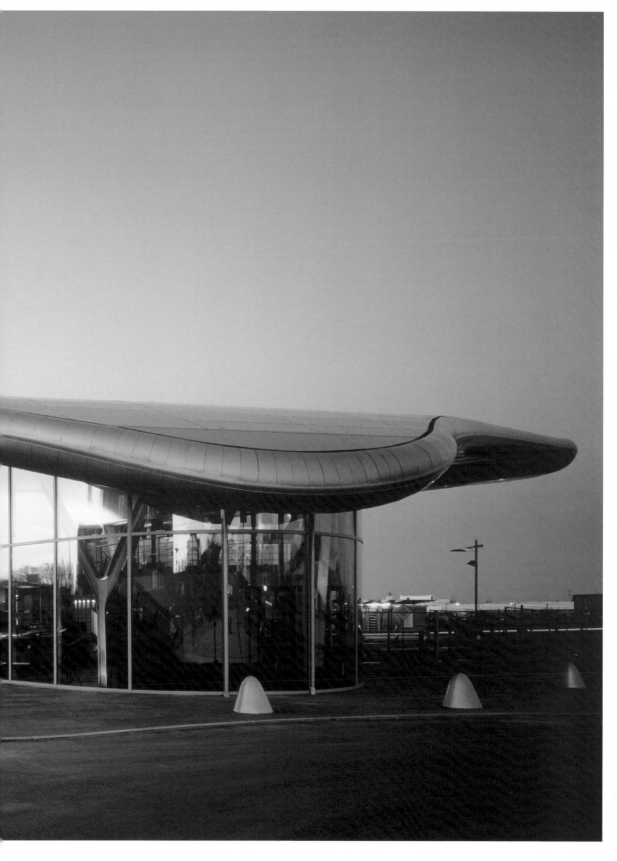

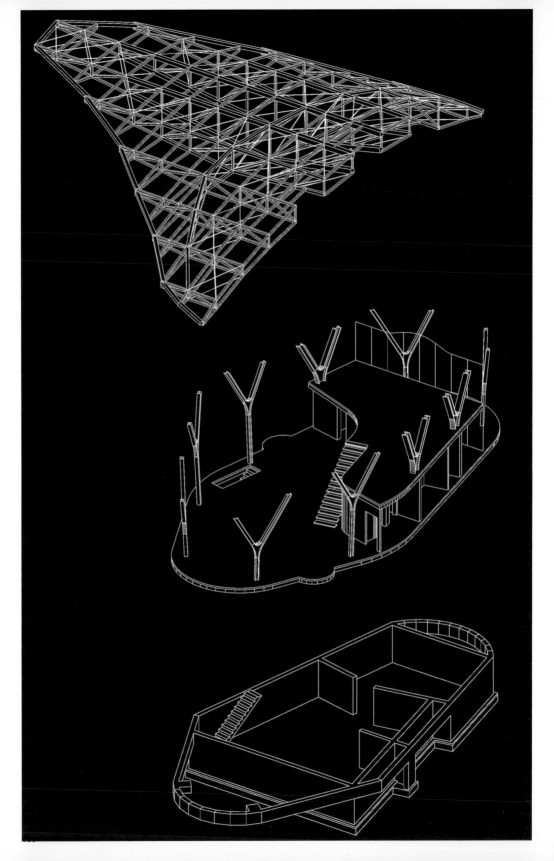

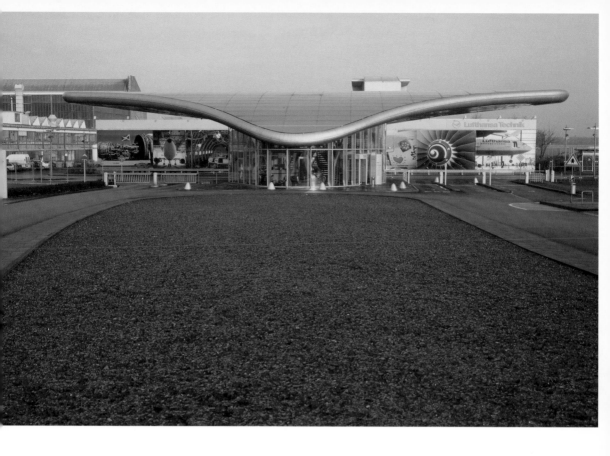

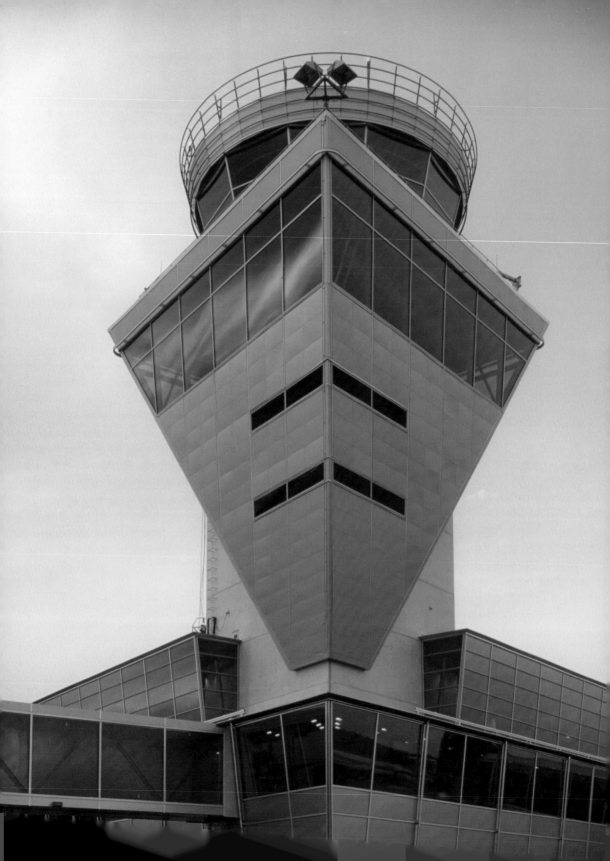

HELSINKI-VANTAA | **HELSINKI, FINLAND**
www.helsinki-vantaa.fi
Pekka Salminen Architects | Helsinki, 1999

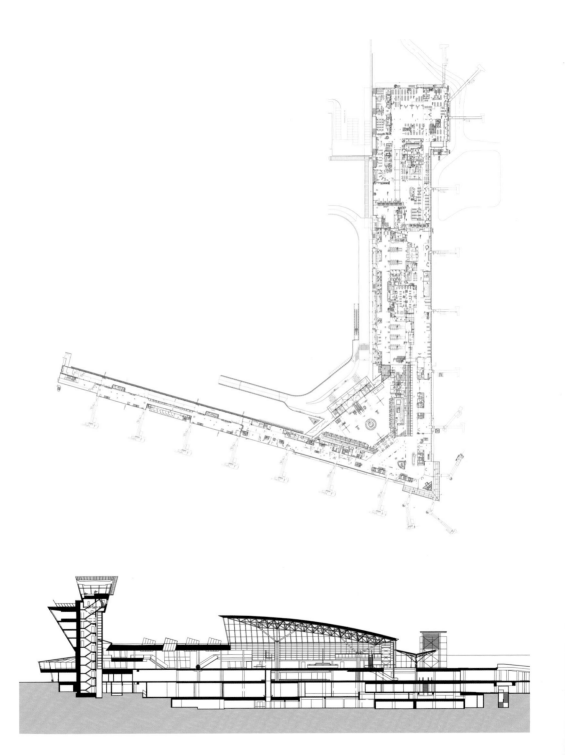

184

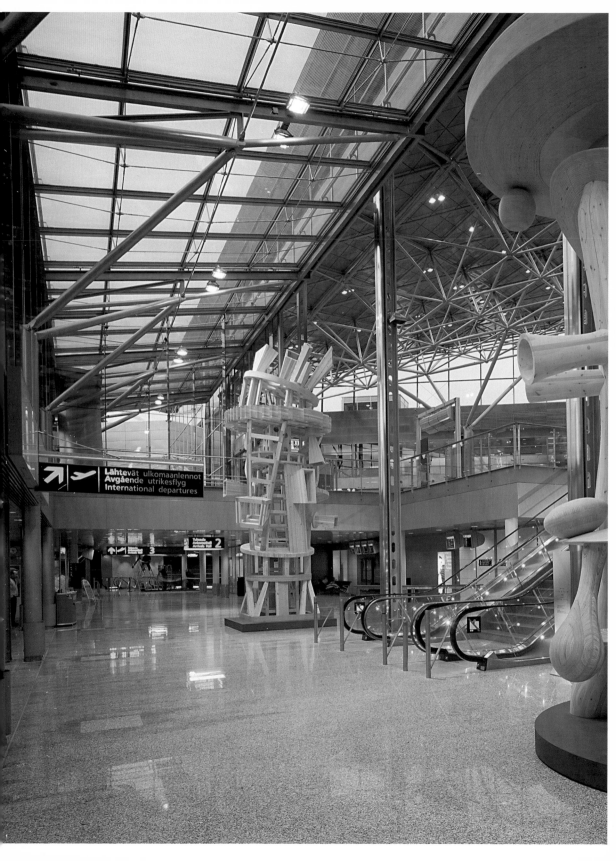

Lähtevät ulkomaanlennot
Avgående utrikesflyg
International departures

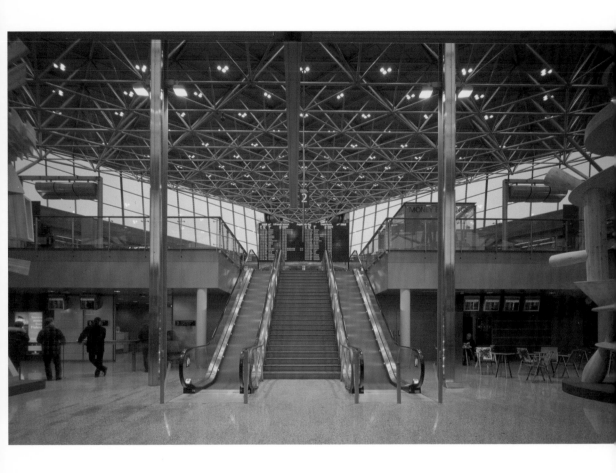

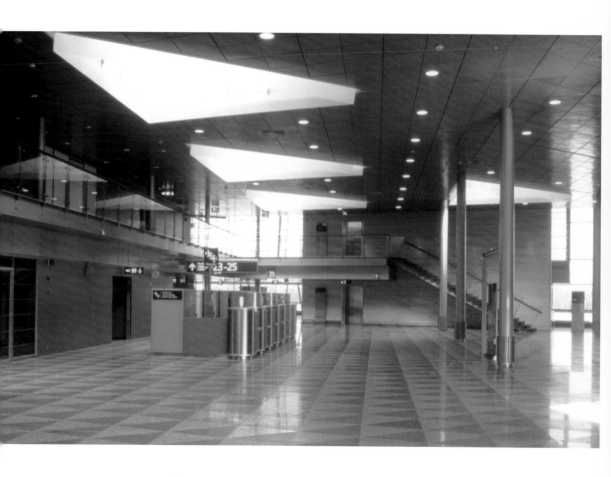

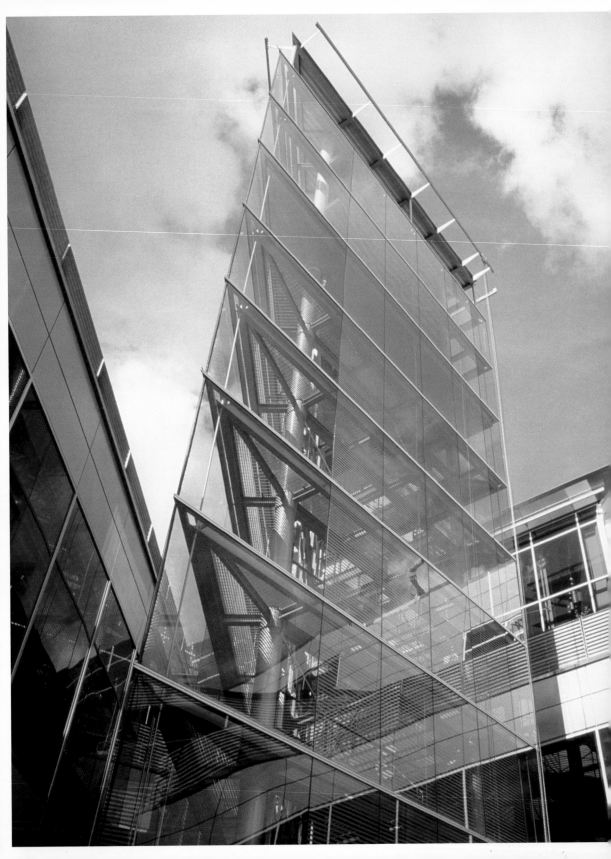

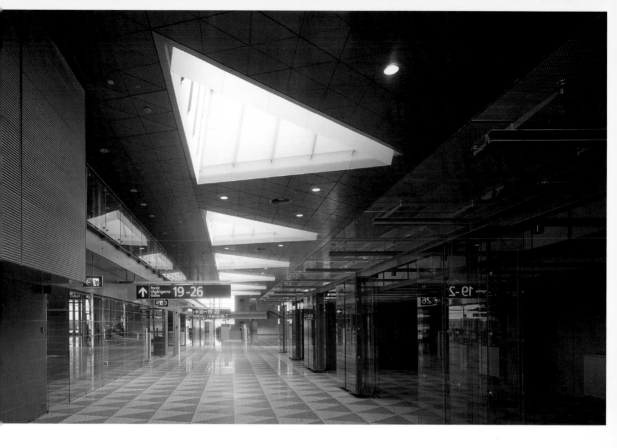

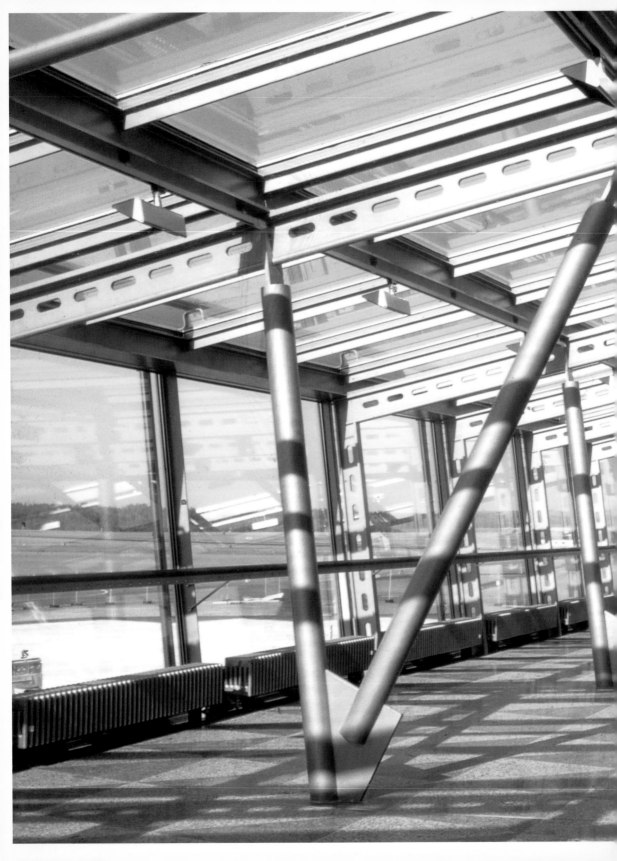

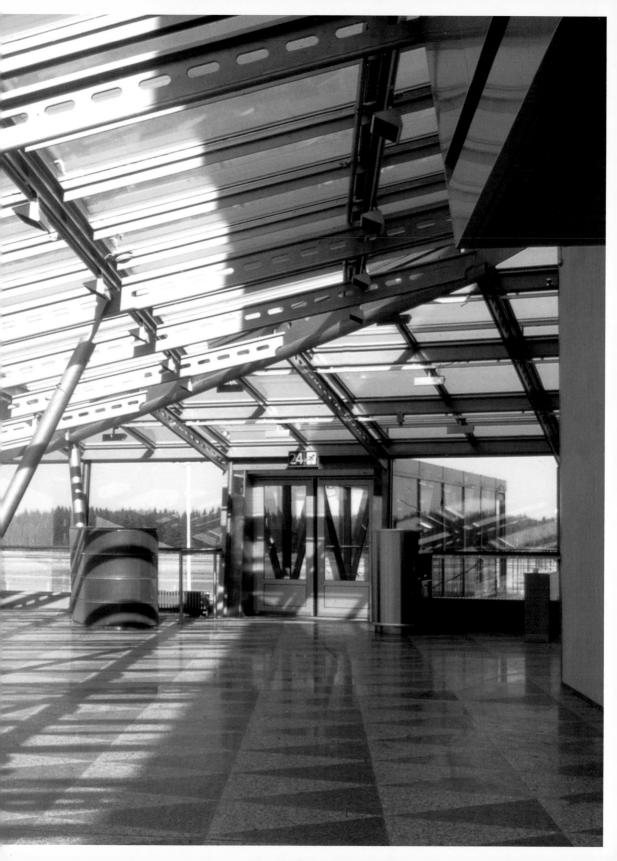

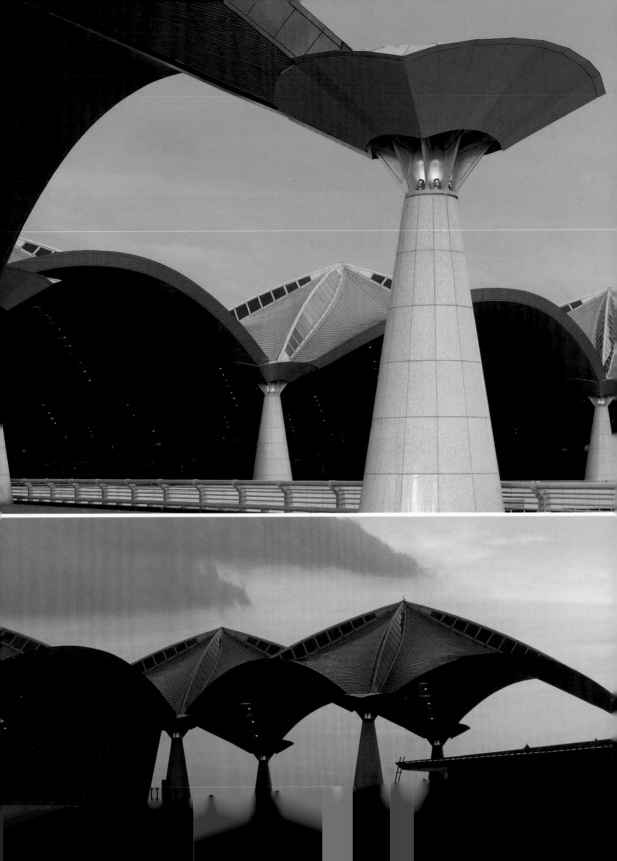

KL INTERNATIONAL AIRPORT | SEPANG, MALAYSIA
www.klia.com.my
Kisho Kurokawa Architect & Associates | Tokyo, 1998

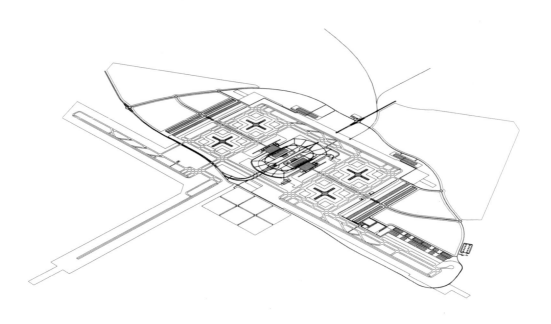

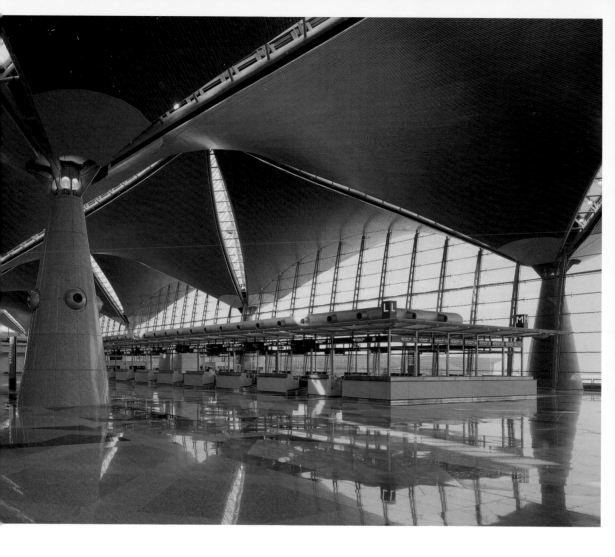

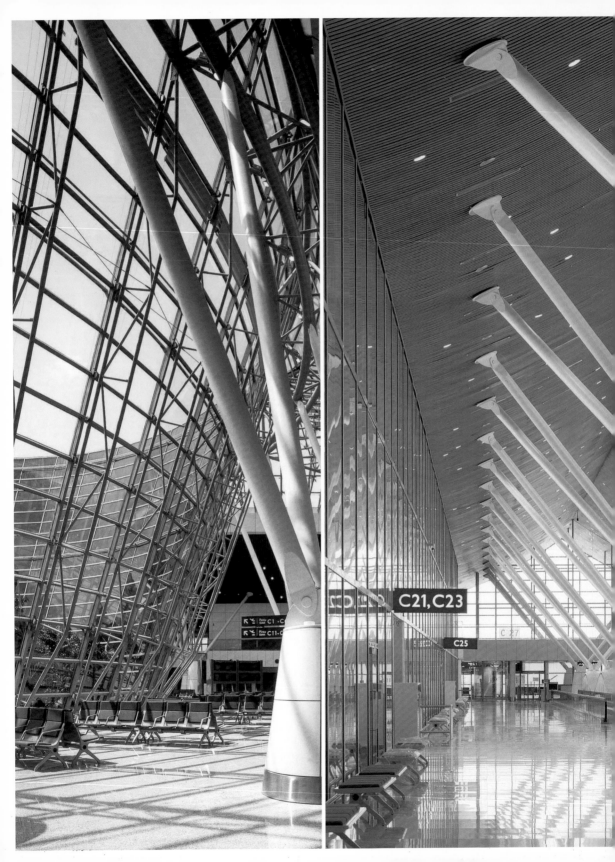

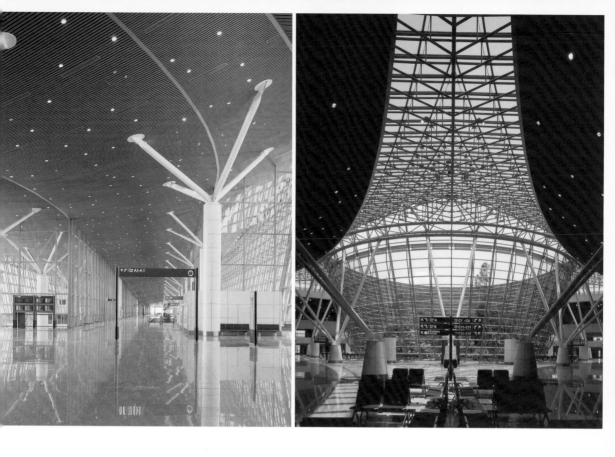

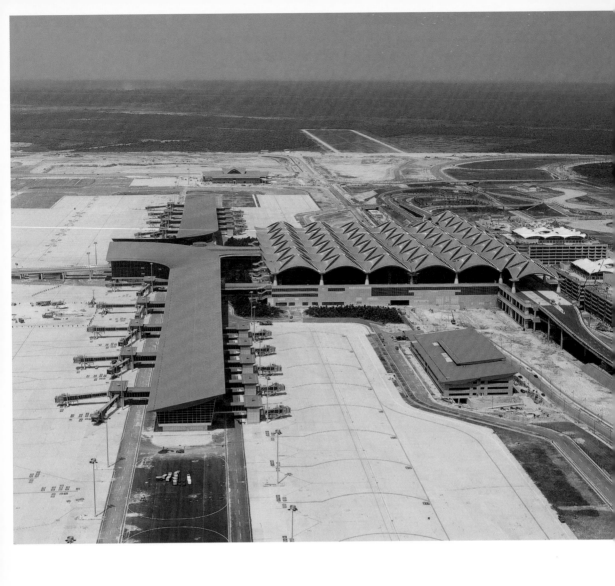

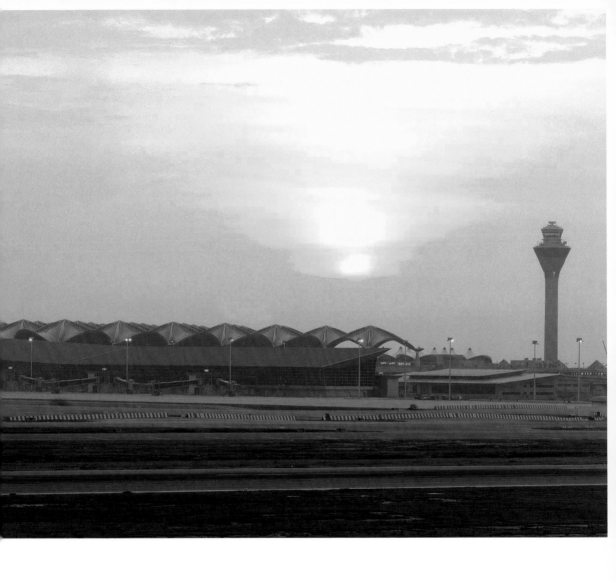

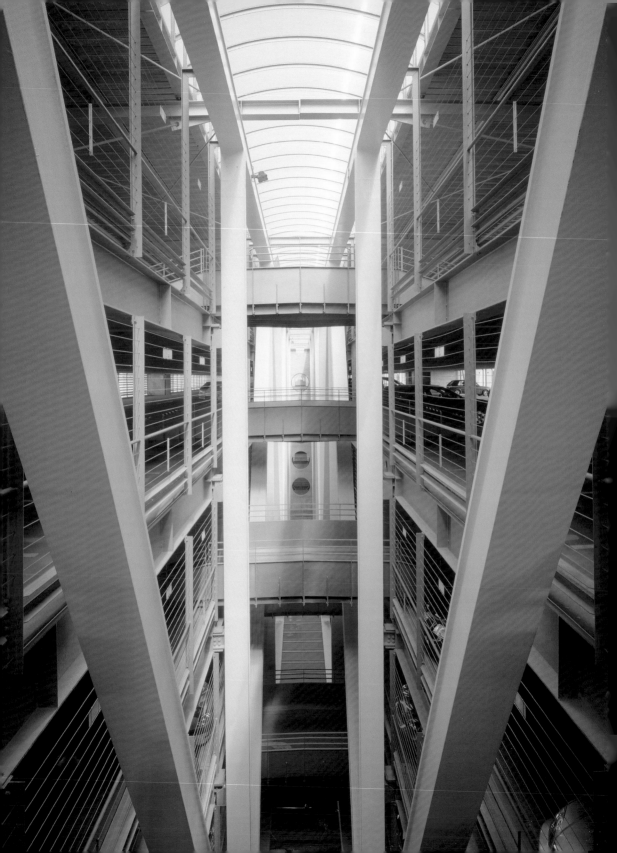

PARKING GARAGE AT LEIPZIG/HALLE AIRPORT | LEIPZIG SCHKEUDITZ, GERMANY
www.leipzig-halle-airport.de
Brunnert und Partner, Hans-Georg Brunnert, Udo Breiderhoff, Hellmut Schiefer | Stuttgart, 2003

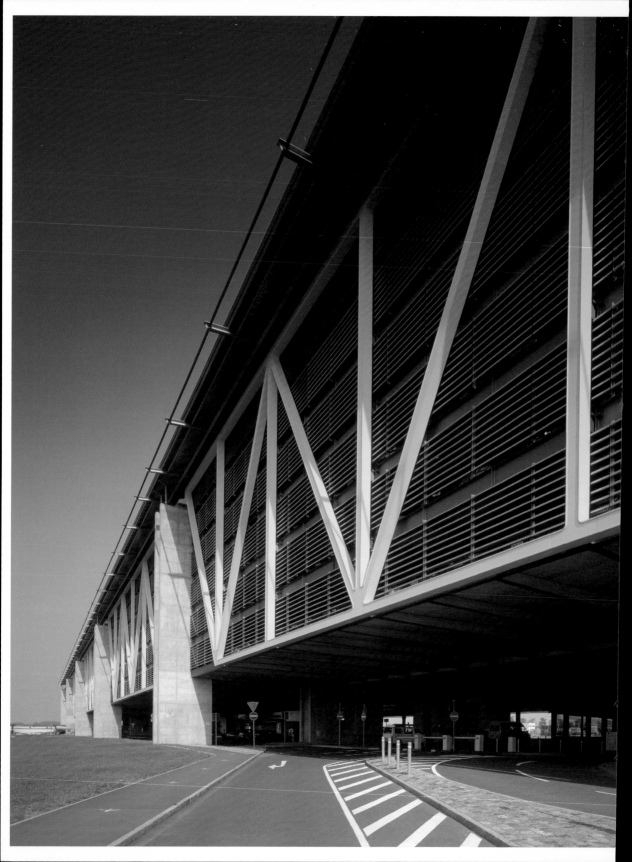

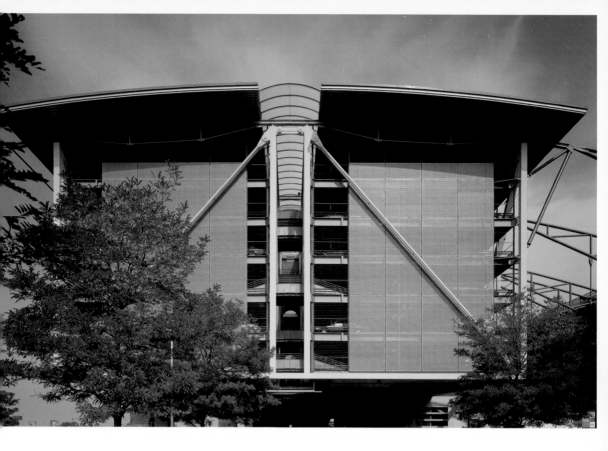

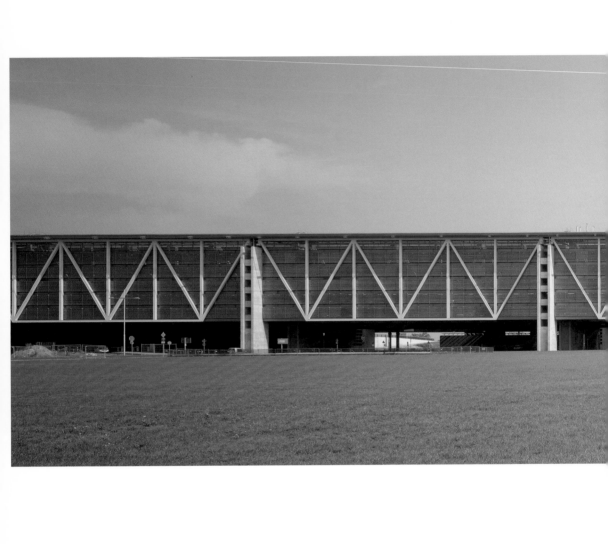

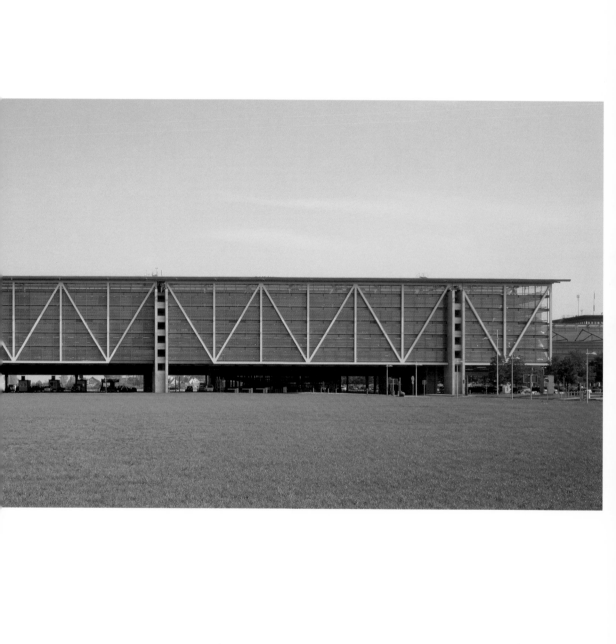

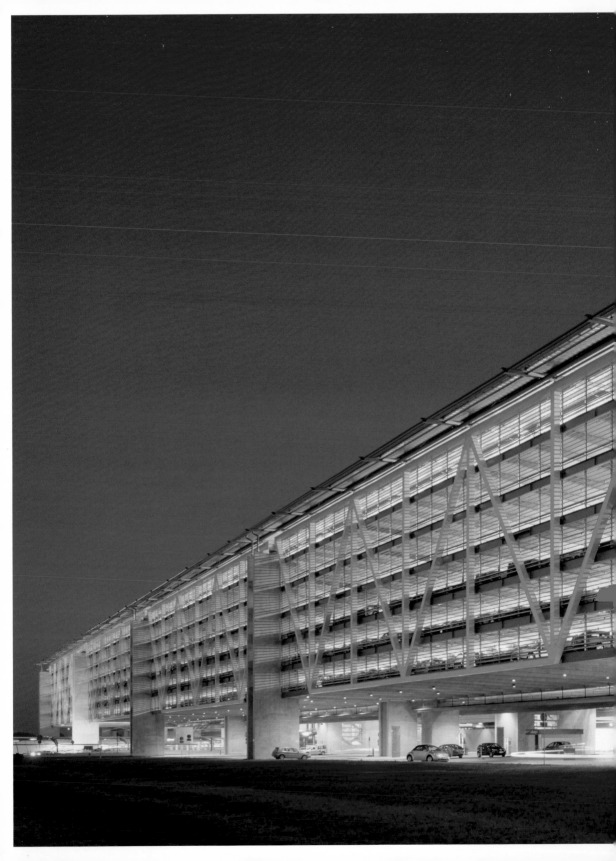

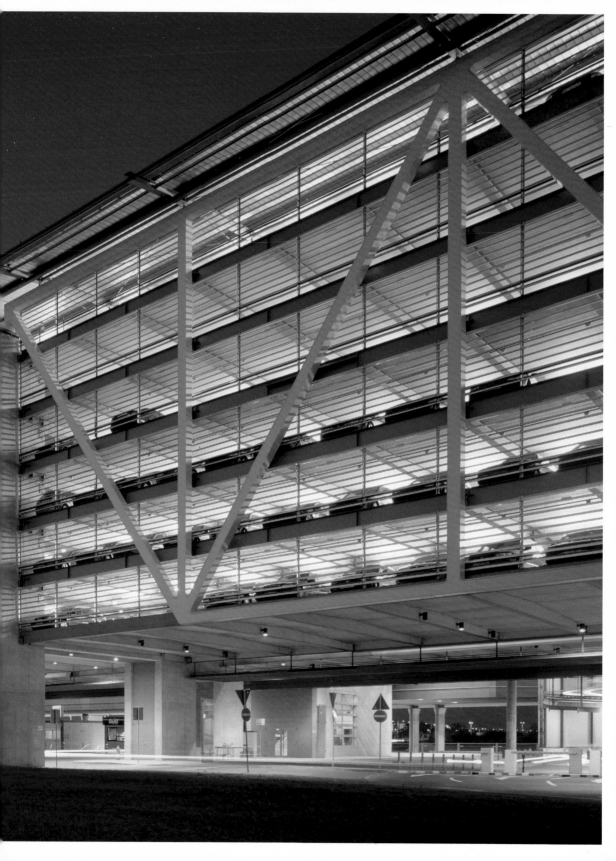

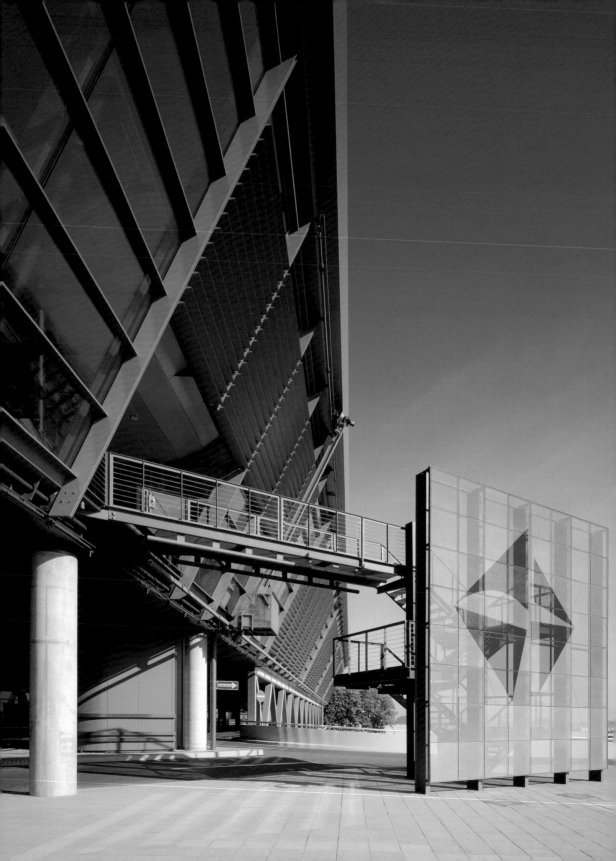

TERMINAL AT LEIPZIG/HALLE AIRPORT | LEIPZIG SCHKEUDITZ, GERMANY
www.leipzig-halle-airport.de
Brunnert und Partner, Hans-Georg Brunnert, Udo Breiderhoff, Hellmut Schiefer | Stuttgart, 2003

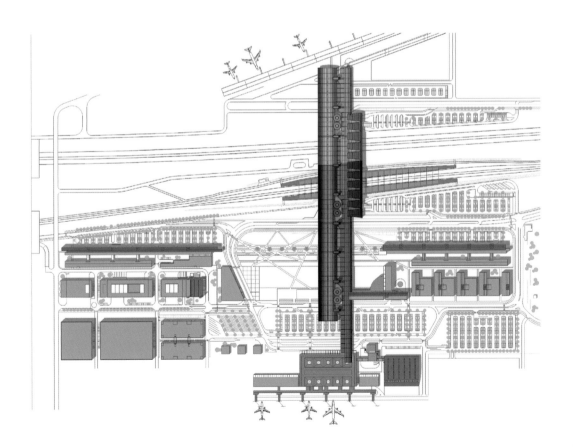

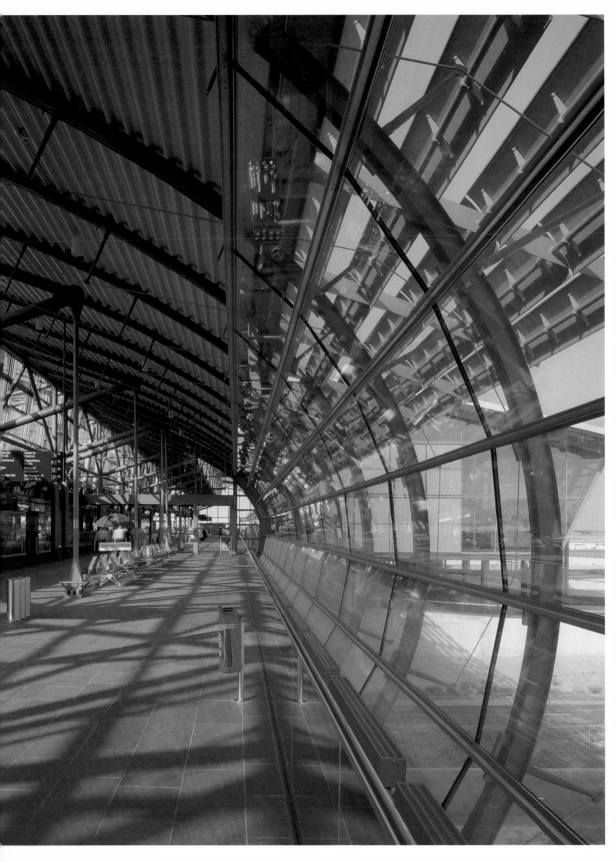

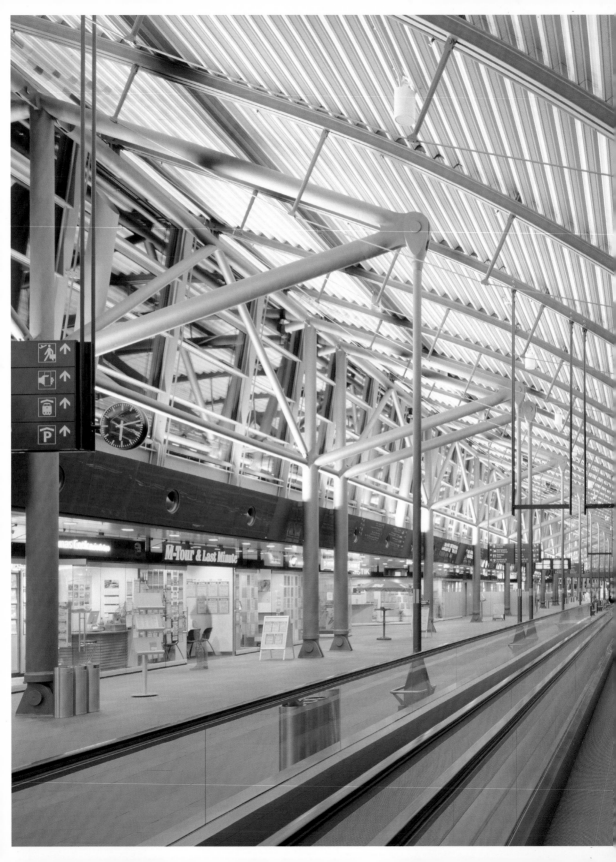

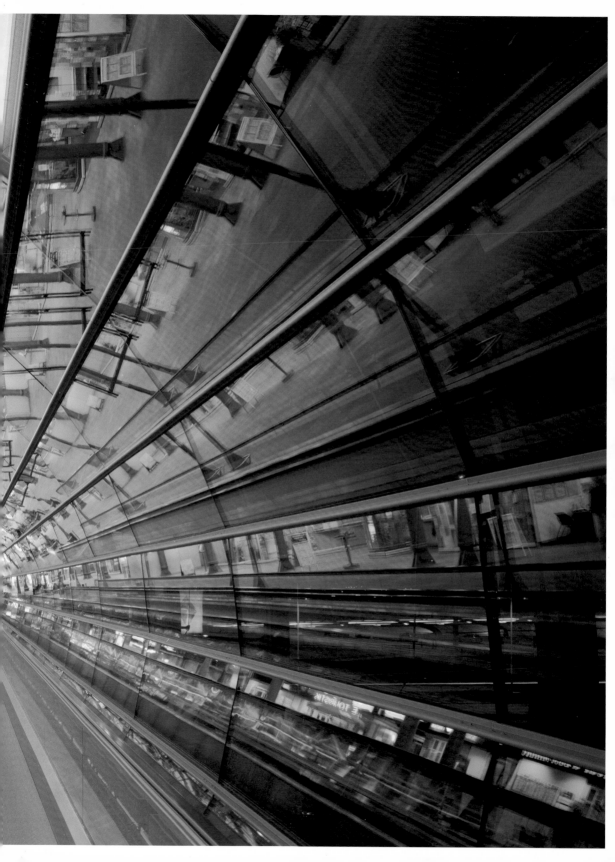

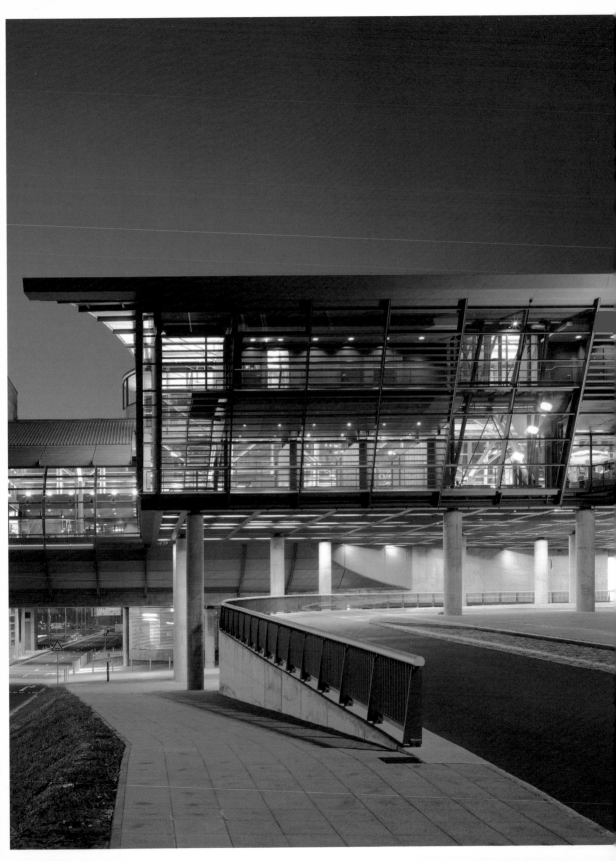

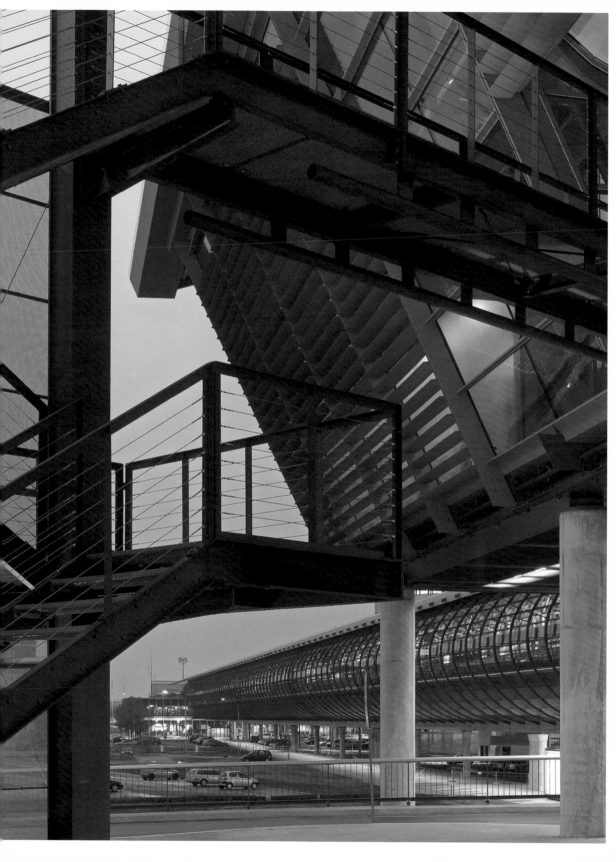

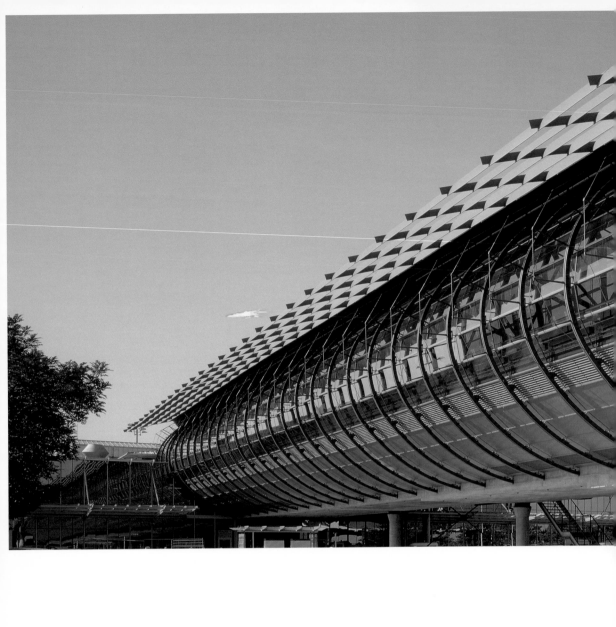

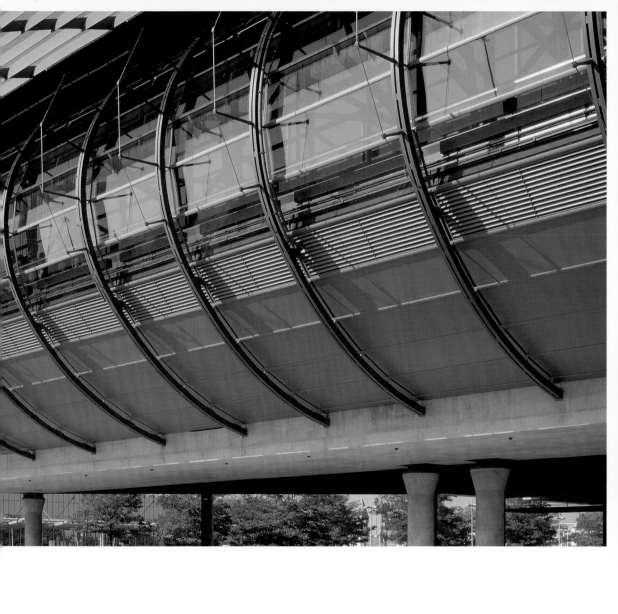

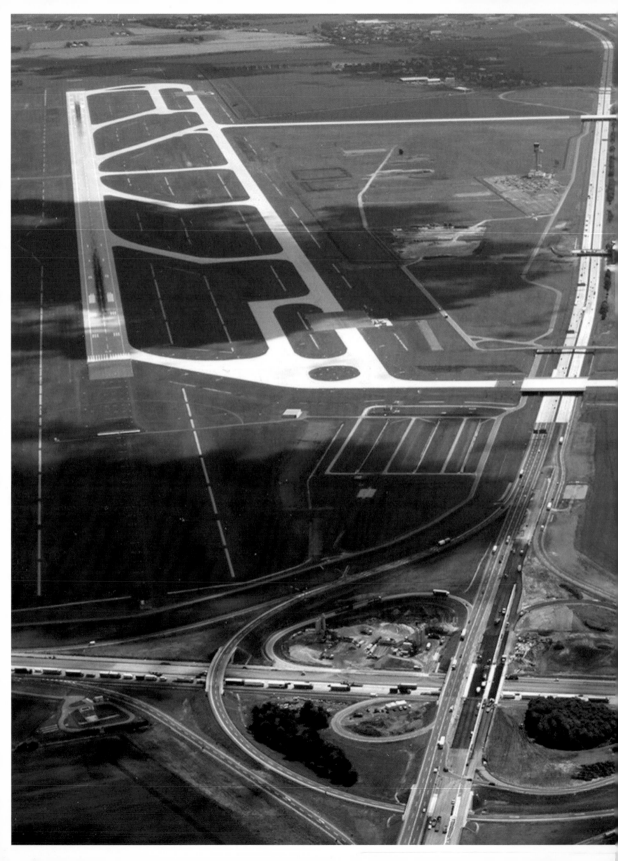

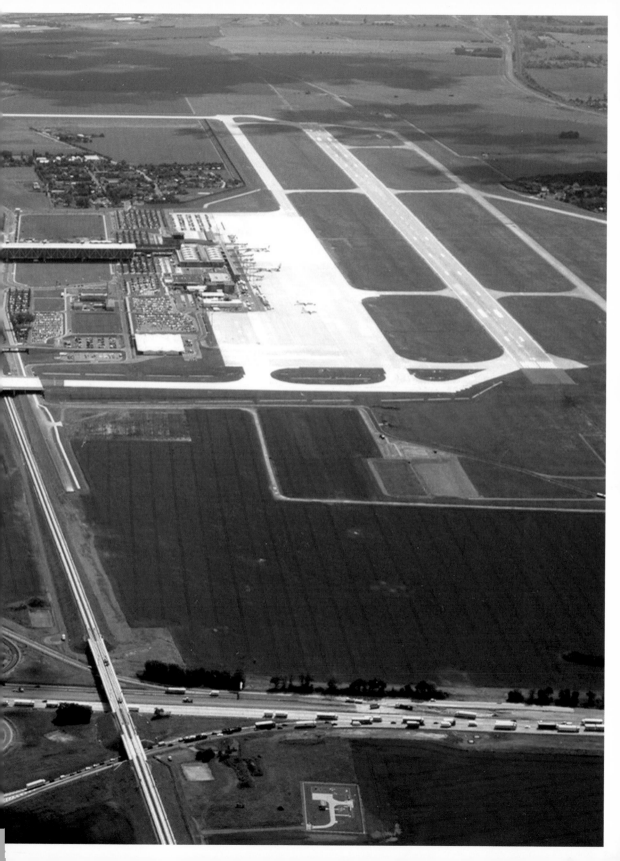

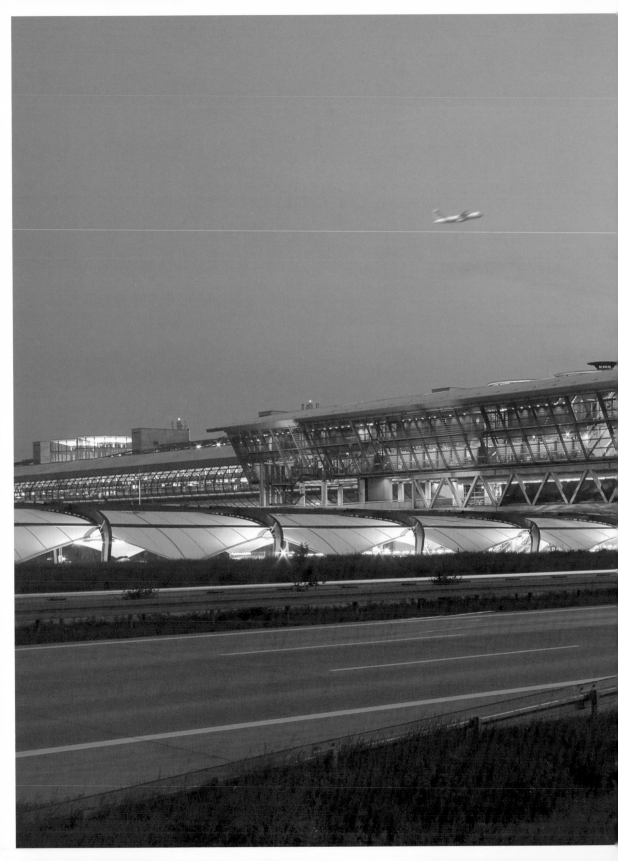

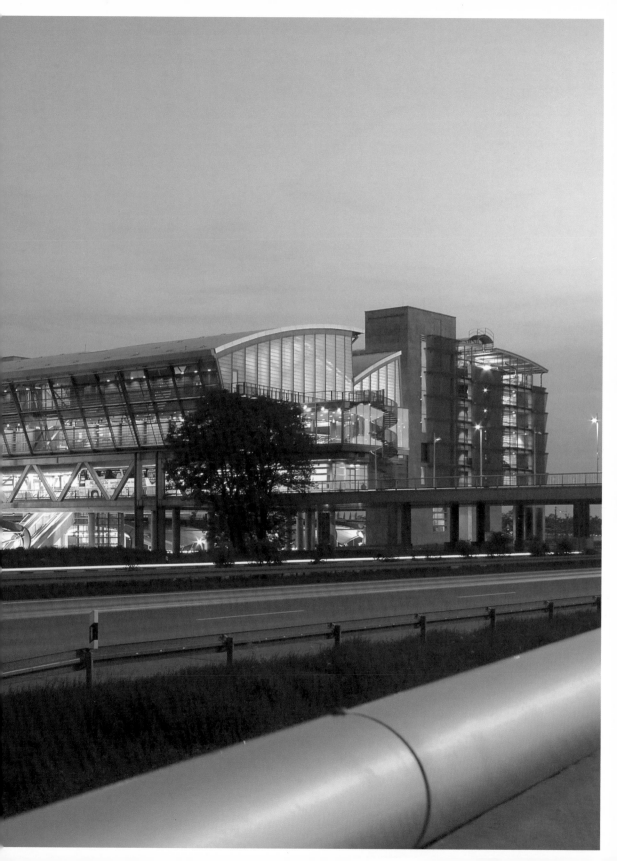

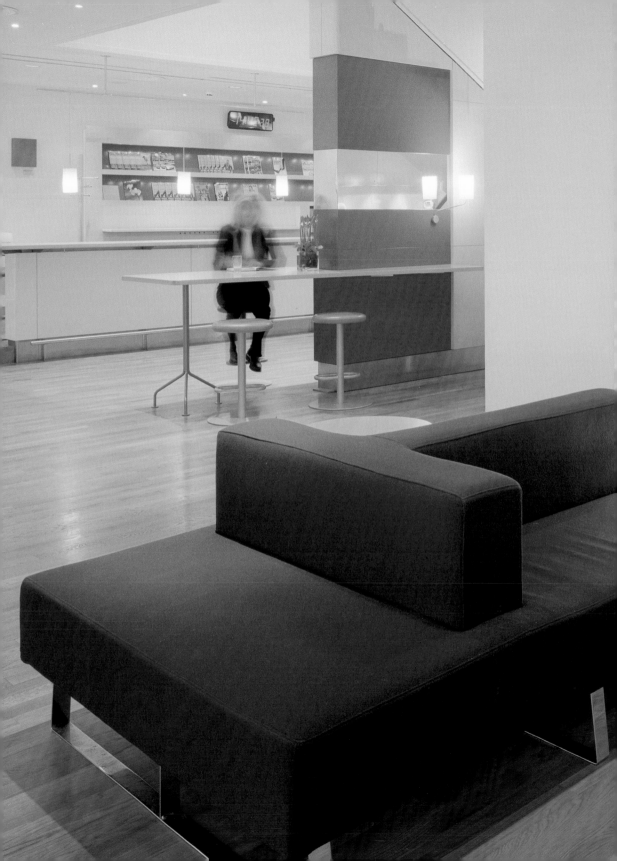

SAS BUSINESS LOUNGE AT HEATHROW AIRPORT | **LONDON, UK**
www.baa.com
Thomas Eriksson Architects, TEArk | Stockholm, 2003

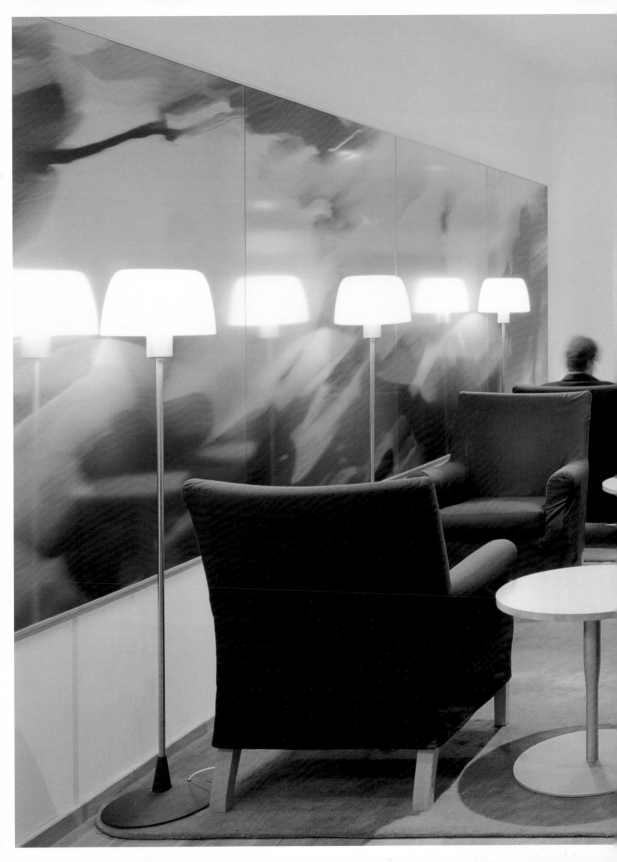

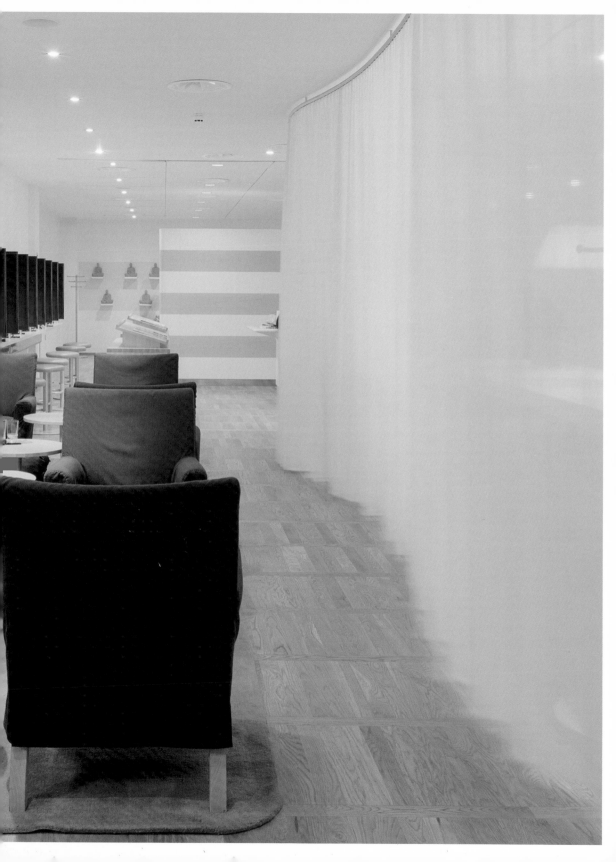

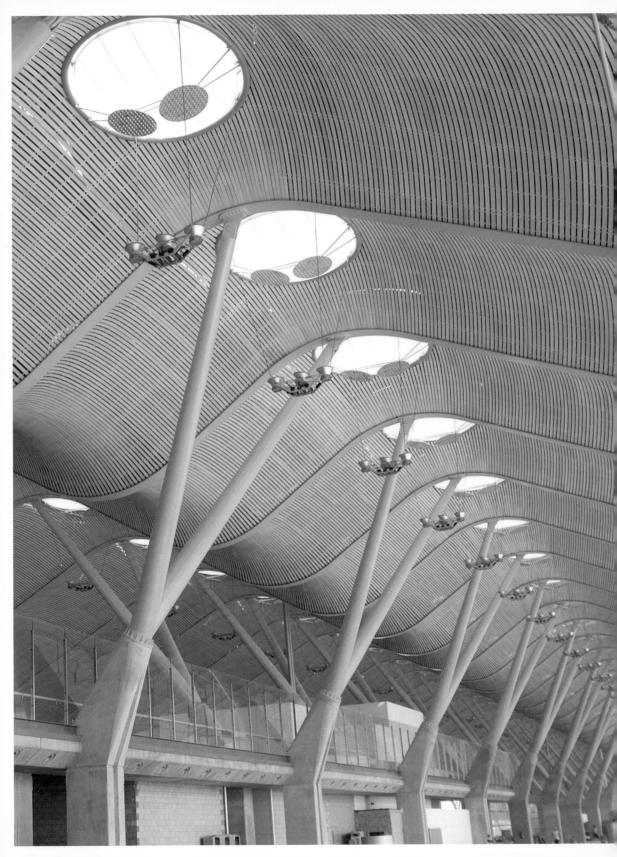

SATELLITE TERMINAL AT NAT BARAJAS INTERNATIONAL AIRPORT | MADRID, SPAIN
www.aena.es
Richard Rogers Partnership and Estudio Lamela | London, 2005

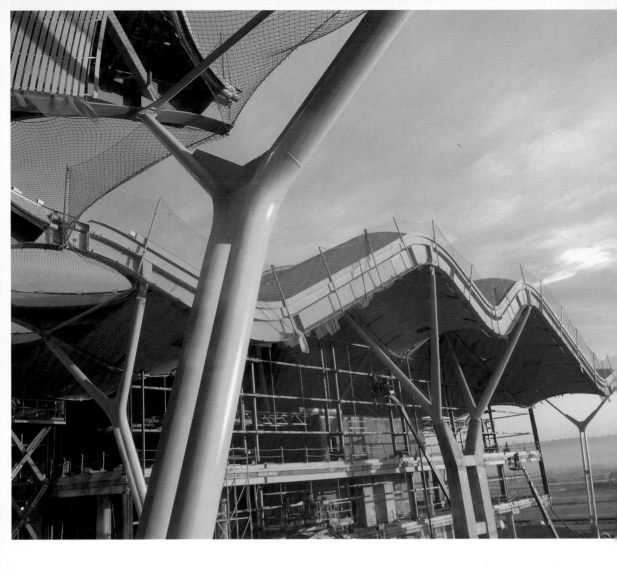

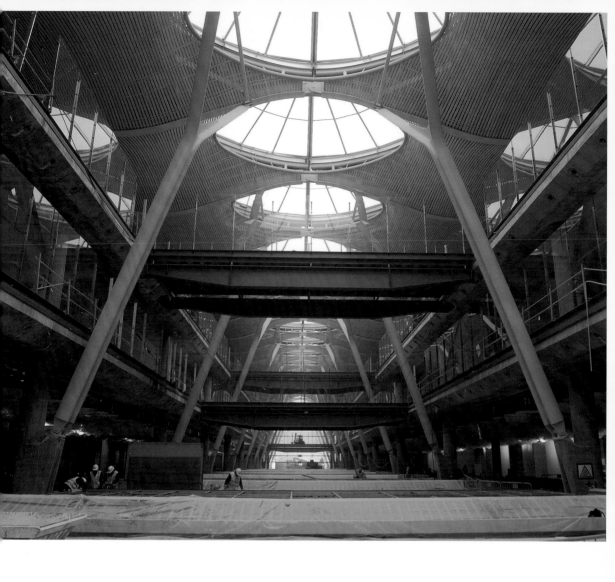

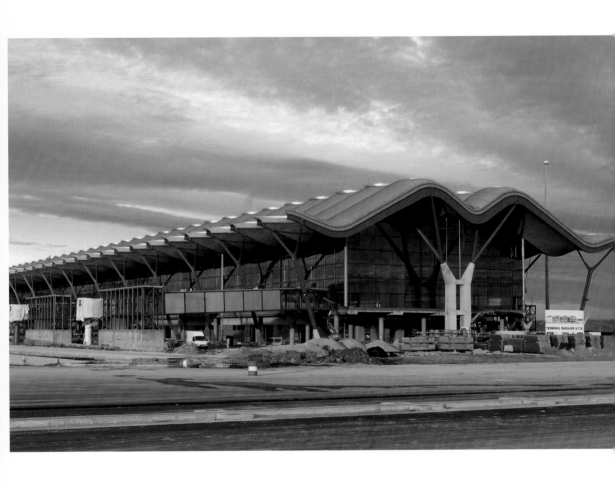

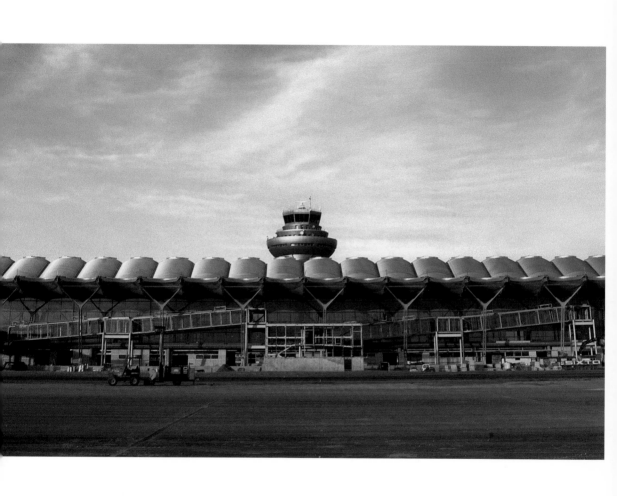

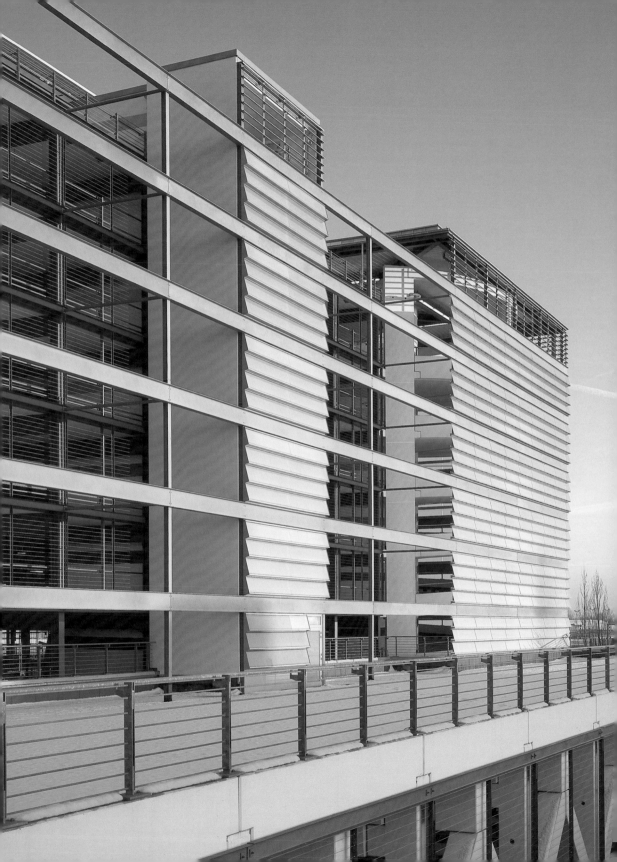

PARKING GARAGE P 20 AT MUNICH AIRPORT INTERNATIONAL | MUNICH, GERMANY
www.munich-airport.de
Koch+Partner Architekten und Stadtplaner, Rainer Schmidt Landschaftsarchitekten | Munich, 2003

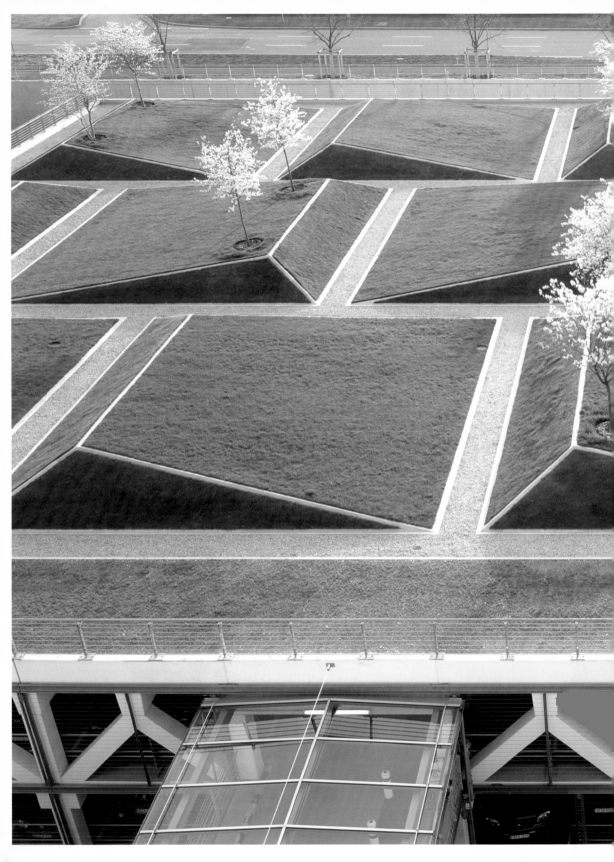

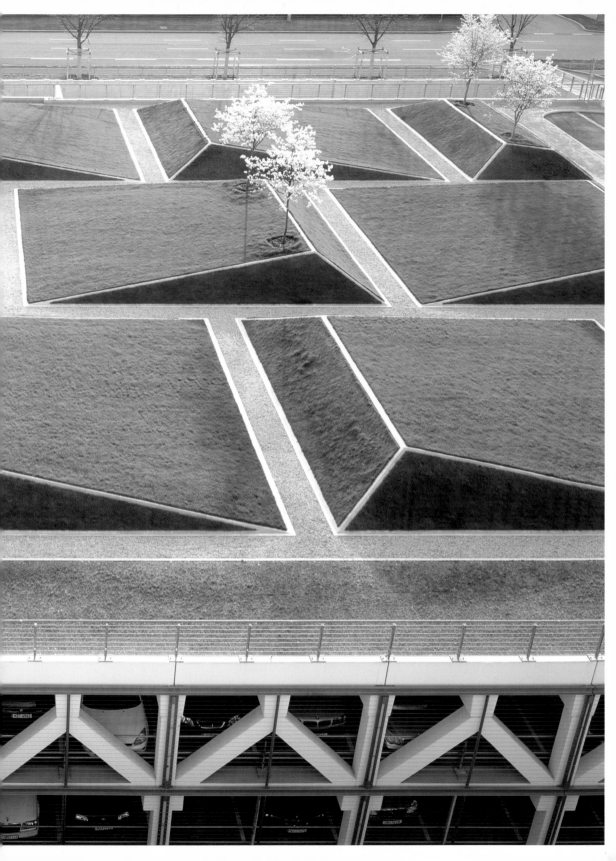

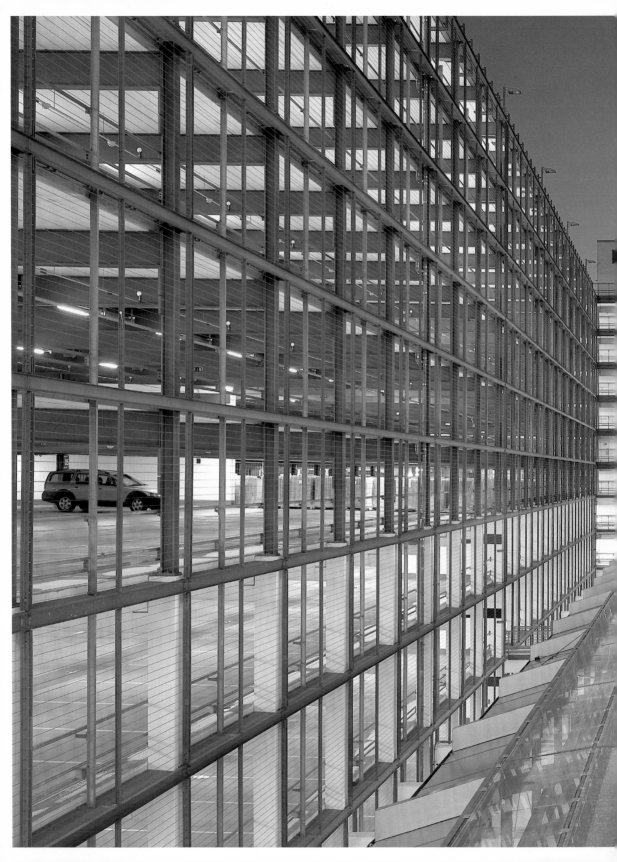

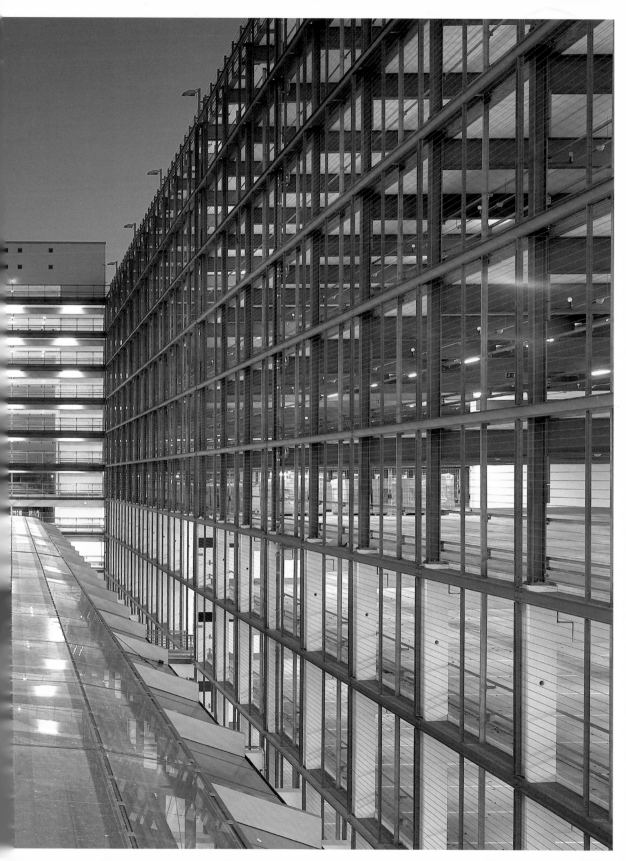

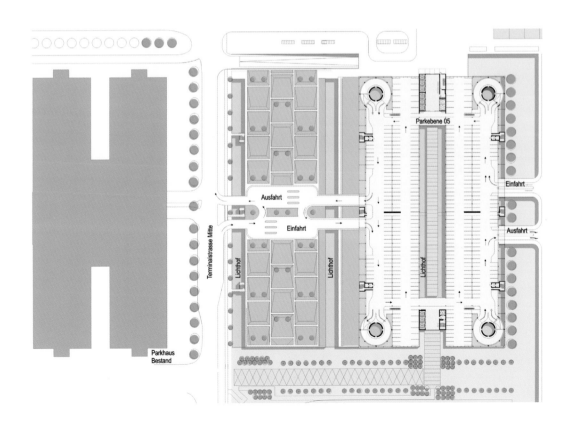

Einfahrt

Parkebene 05

Ausfahrt

Einfahrt

Ausfahrt

Terminalstrasse Mitte

Lichthof

Lichthof

Lichthof

Parkhaus
Bestand

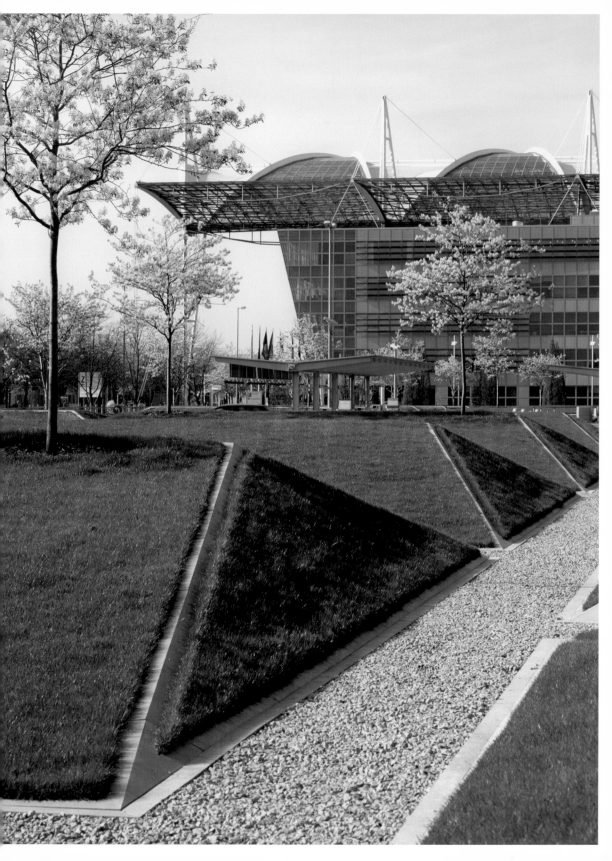

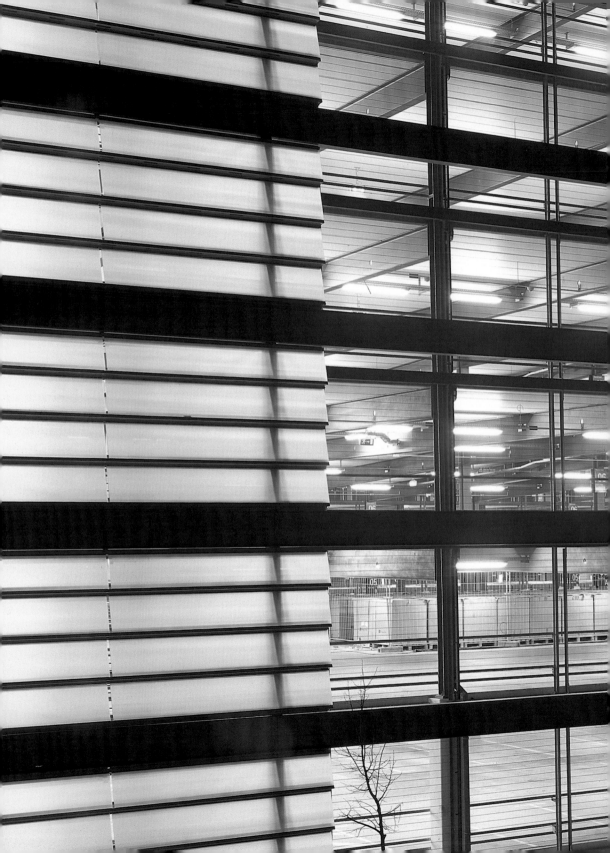

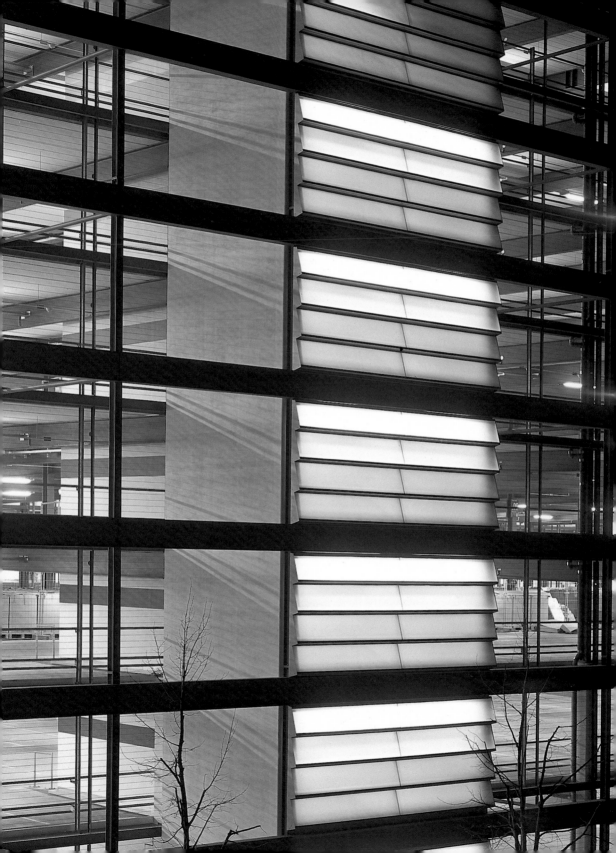

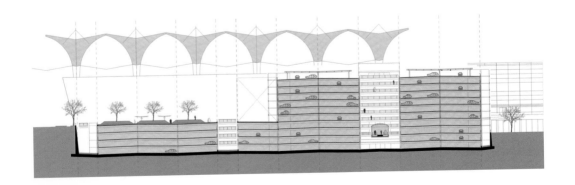

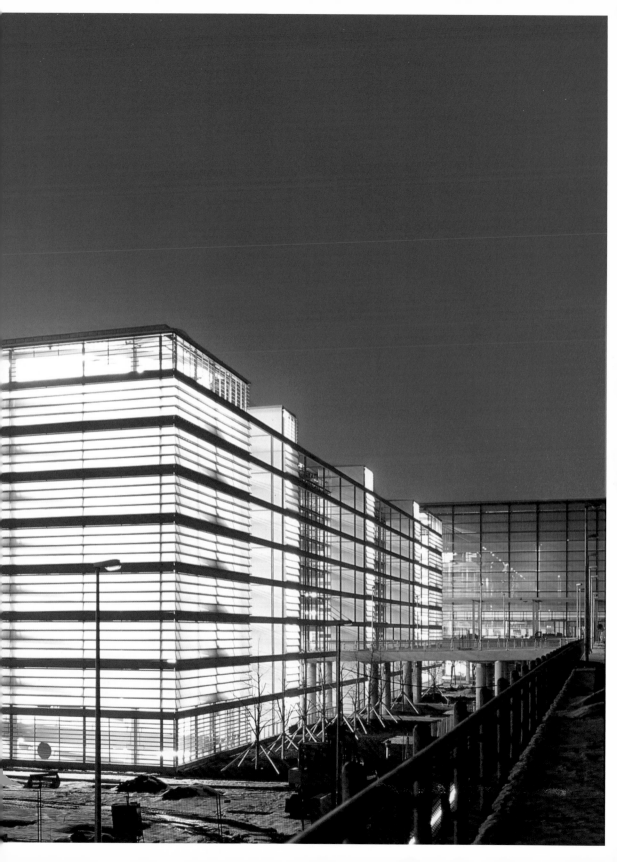

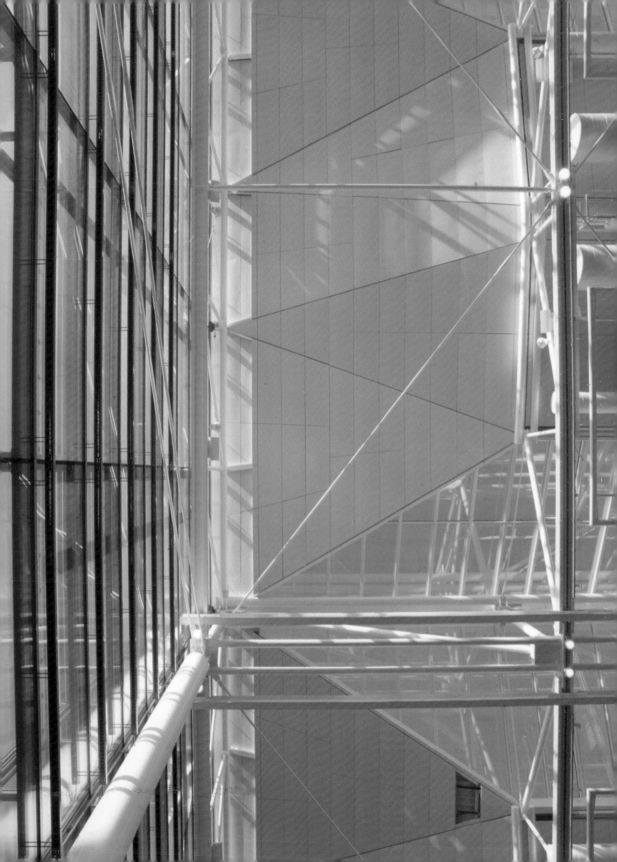

TERMINAL 2 AT MUNICH AIRPORT INTERNATIONAL I MUNICH, GERMANY
www.munich-airport.de
Koch+Partner Architekten und Stadtplaner I München, 2003

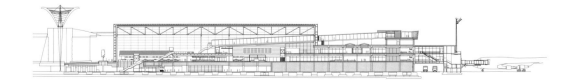

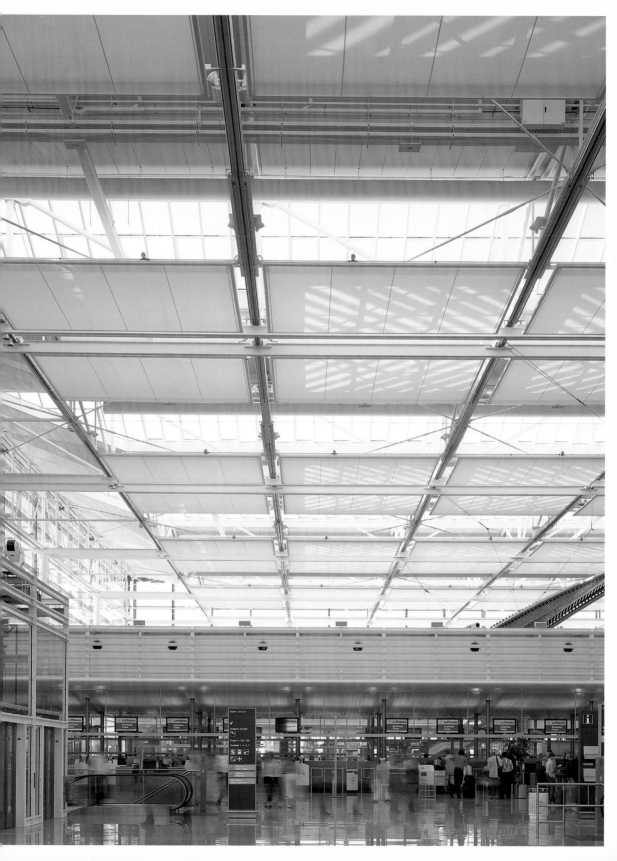

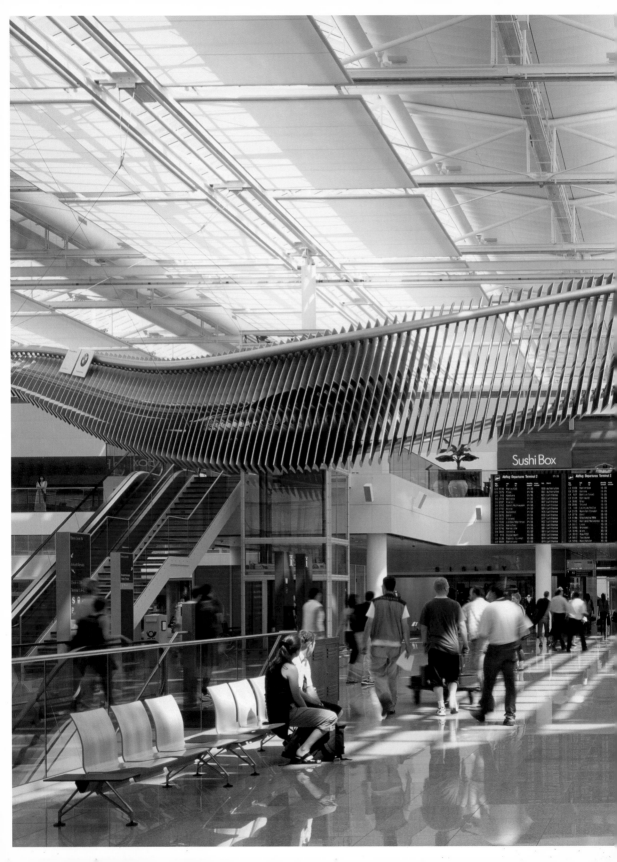

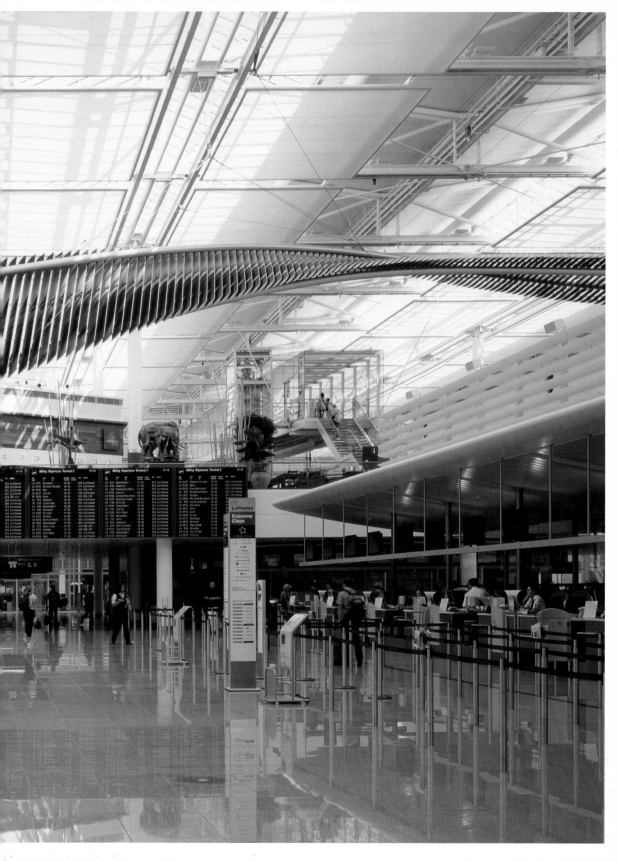

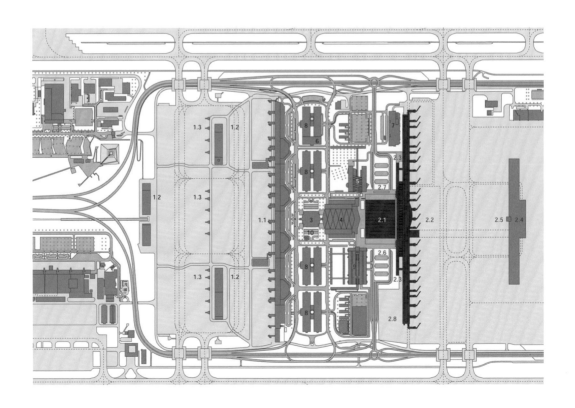

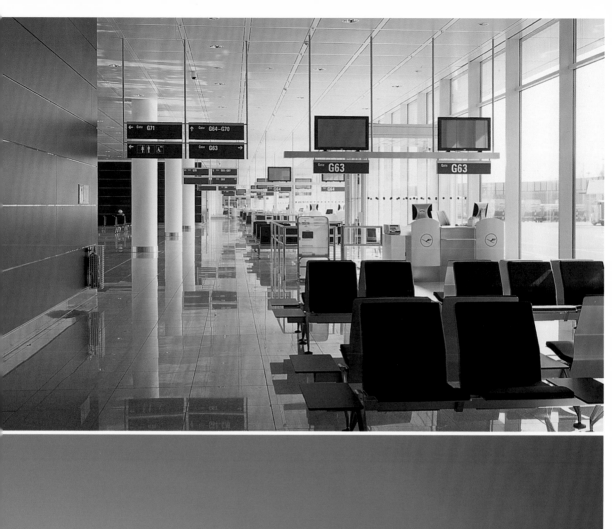

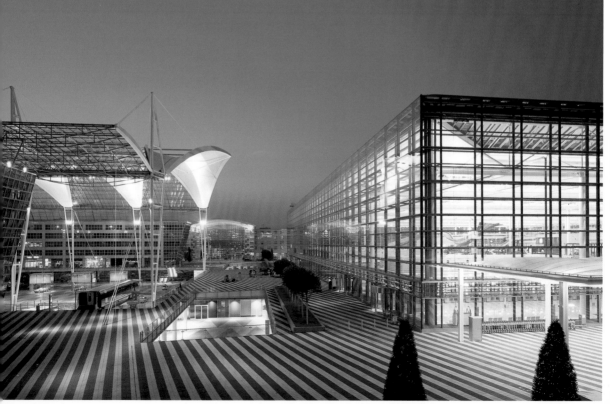

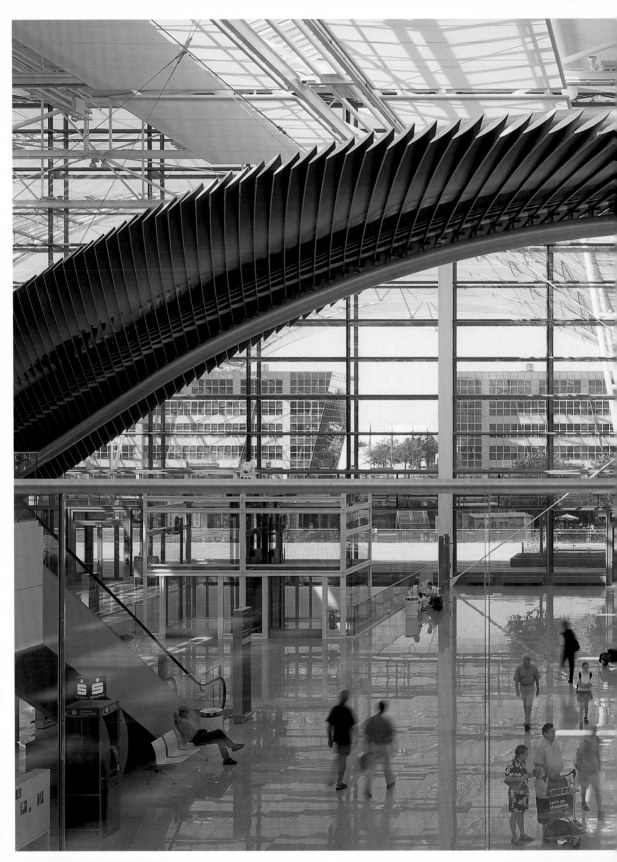

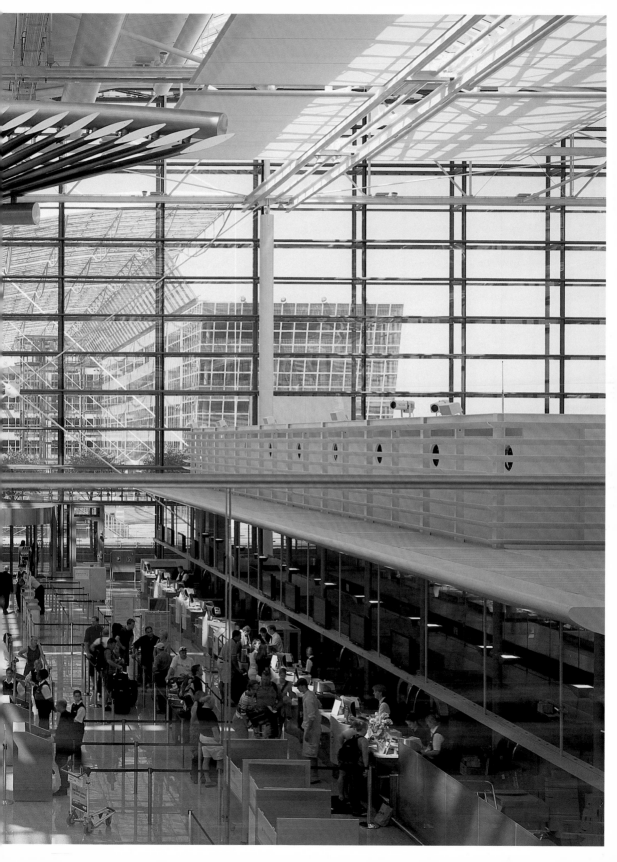

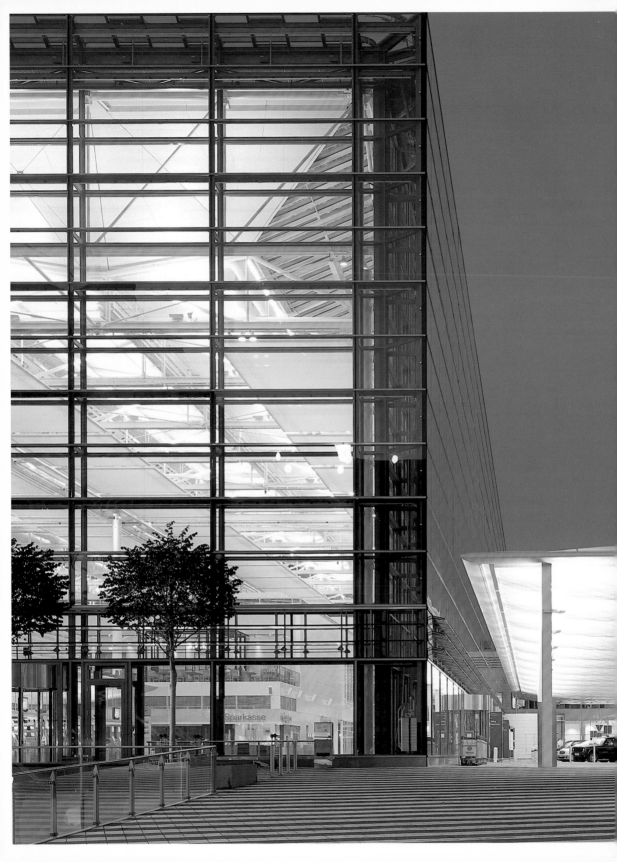

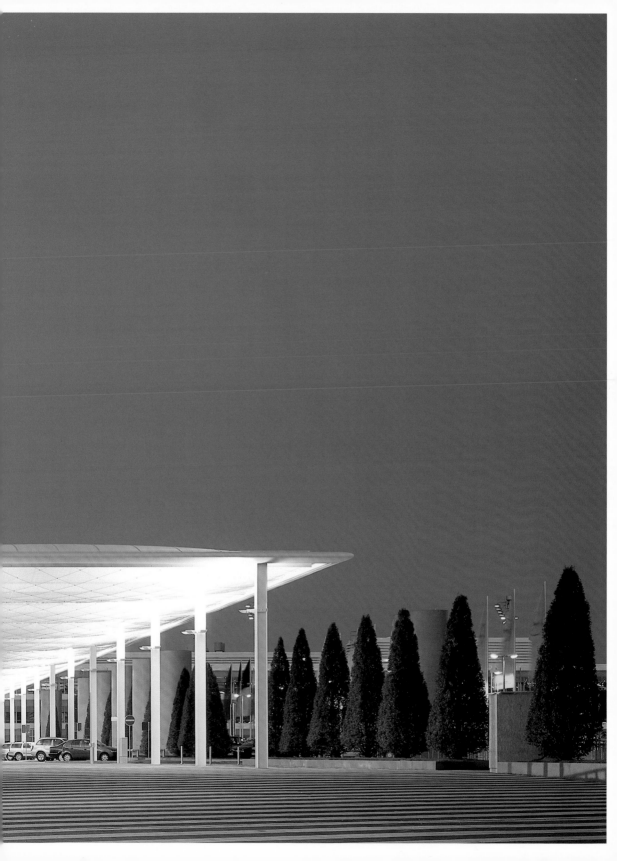

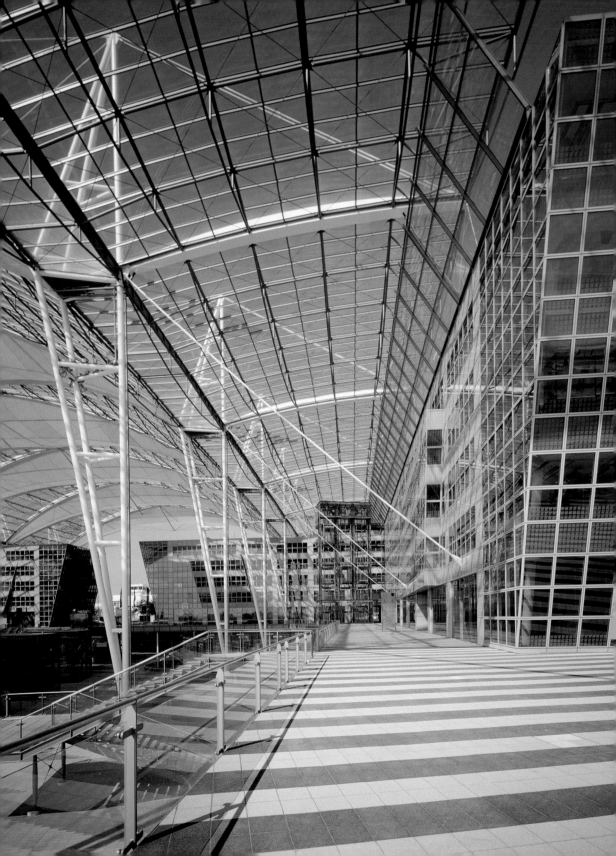

MUNICH AIRPORT CENTER AT MUNICH AIRPORT INTERNATIONAL | MUNICH, GERMANY
www.munich-airport.de
Murphy / Jahn | Chicago, 1999

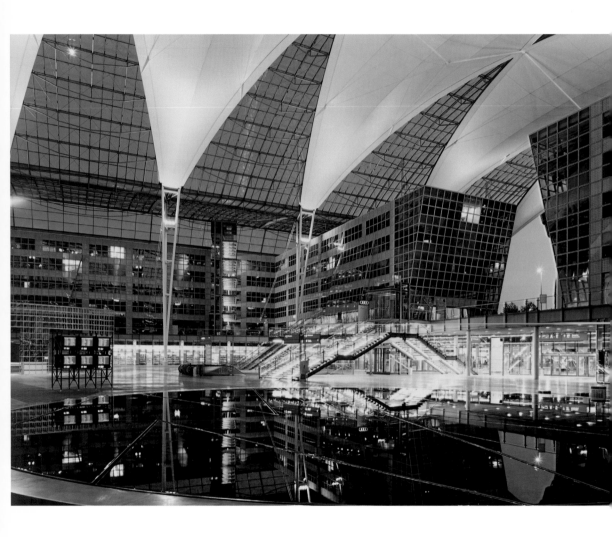

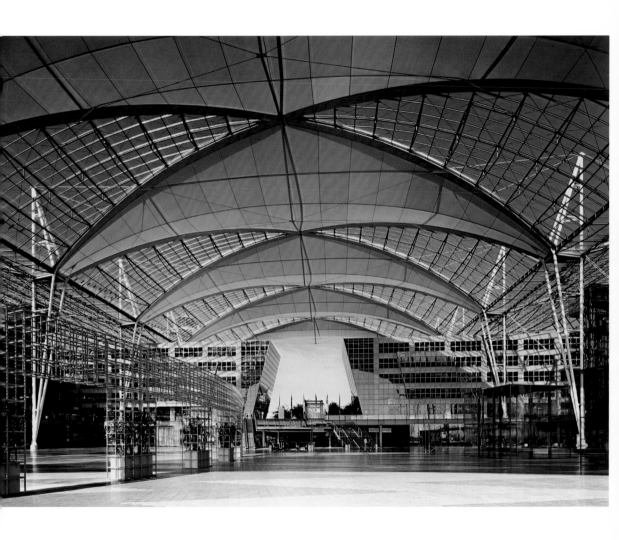

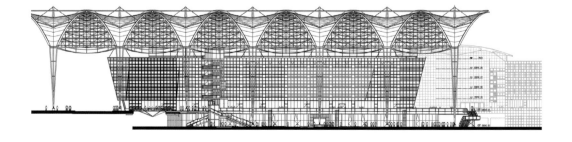

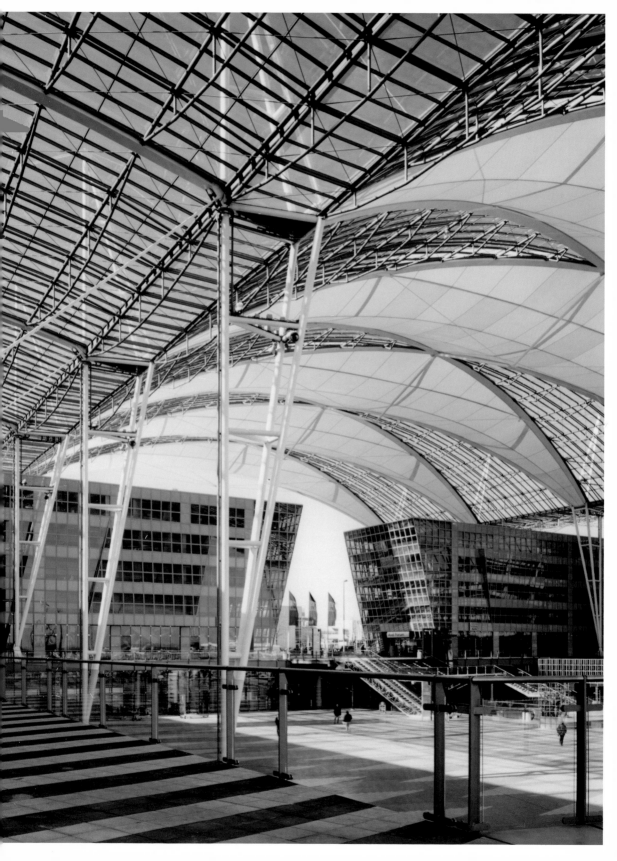

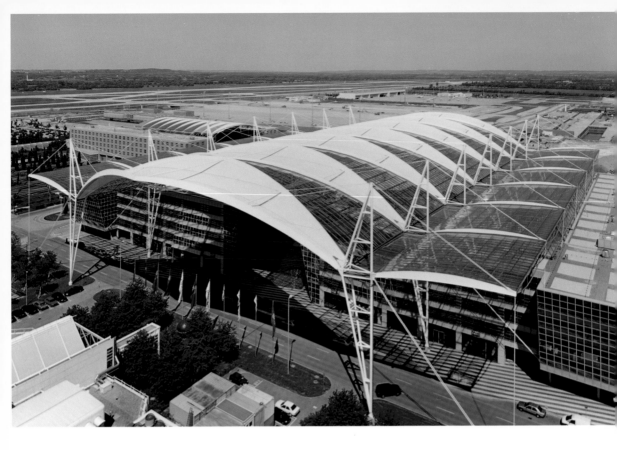

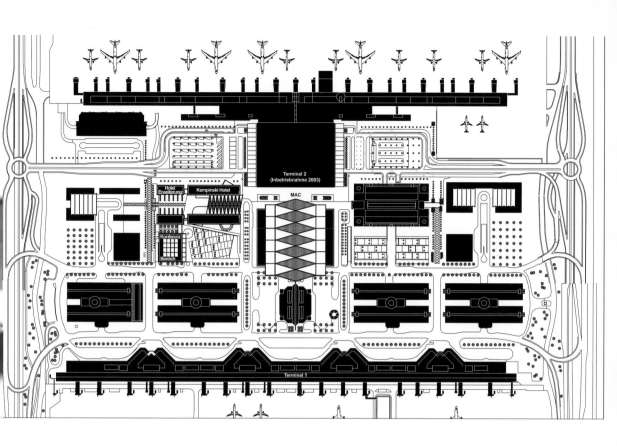

Terminal 2
(Inbetriebnahme 2003)

MAC

Hotel
Erweiterung: Kempinski Hotel

Konferenz
Bereich

Terminal 1

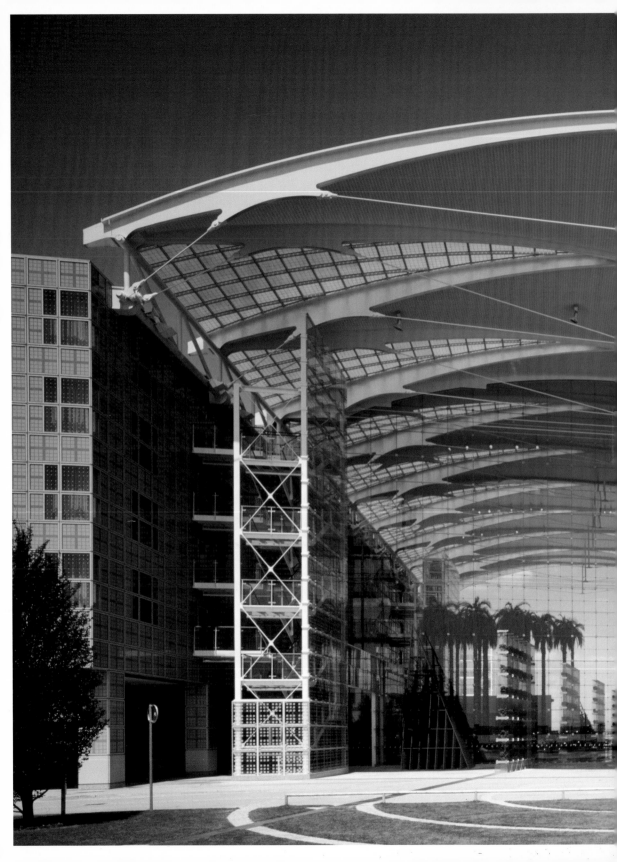

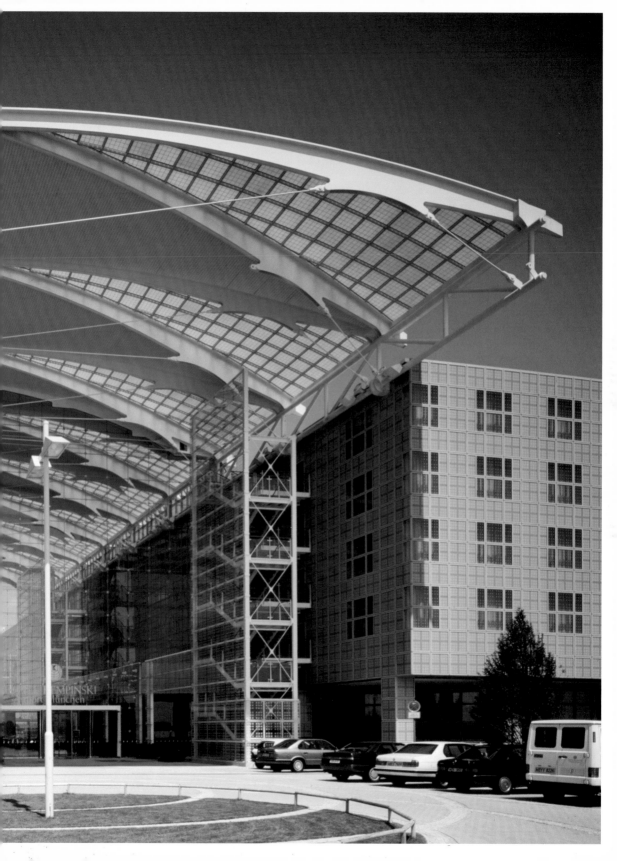

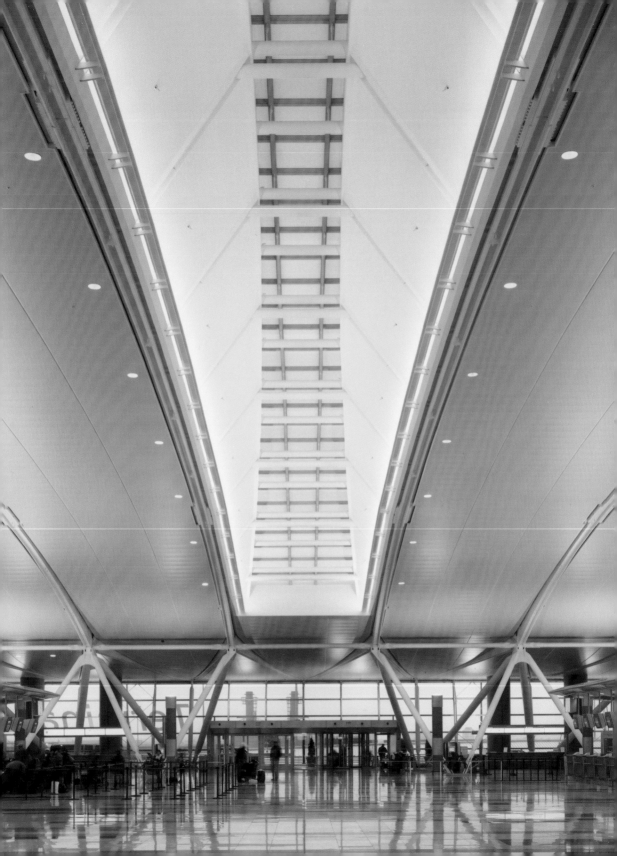

TERMINAL 4 AT JOHN F. KENNEDY INTERNATIONAL AIRPORT | NEW YORK, USA
www.kennedyairport.com
Skidmore, Owings and Merrill LLP | New York, 2001

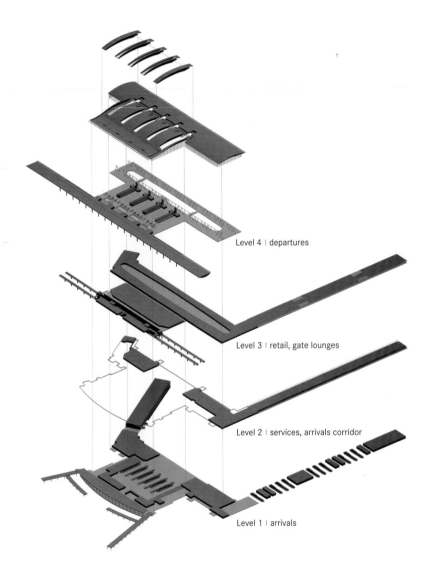

Level 4 I departures

Level 3 I retail, gate lounges

Level 2 I services, arrivals corridor

Level 1 I arrivals

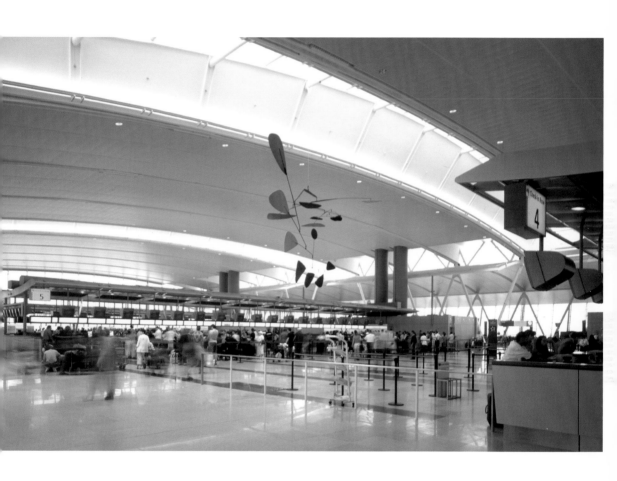

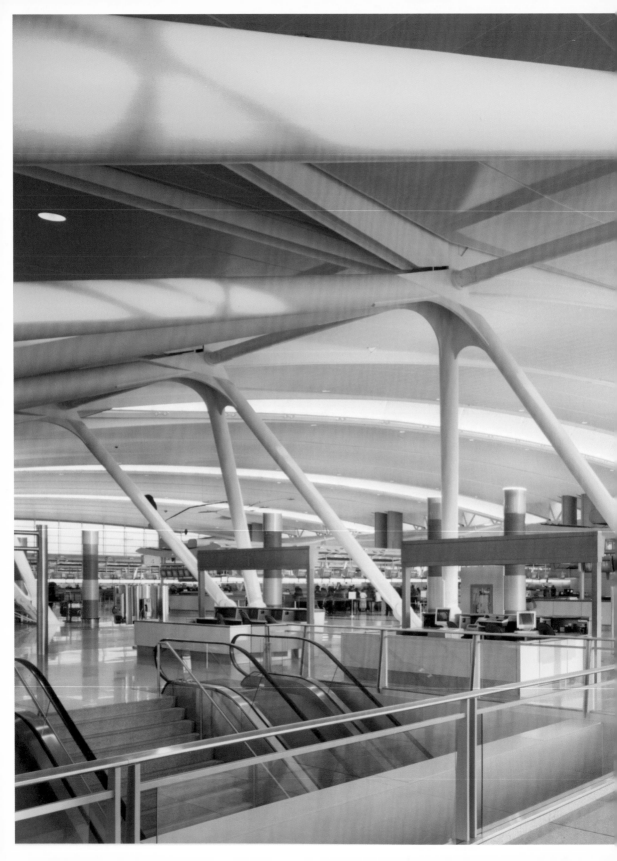

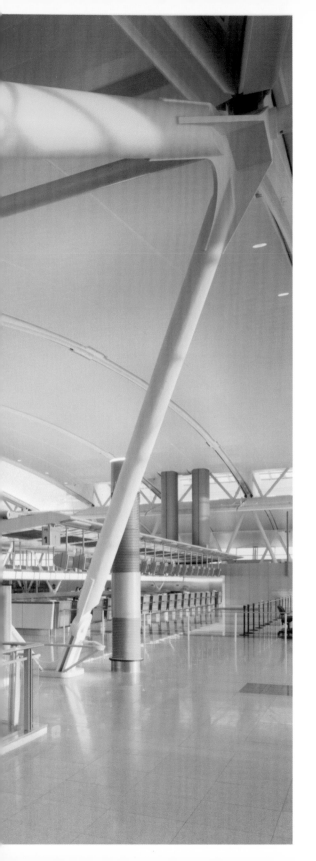

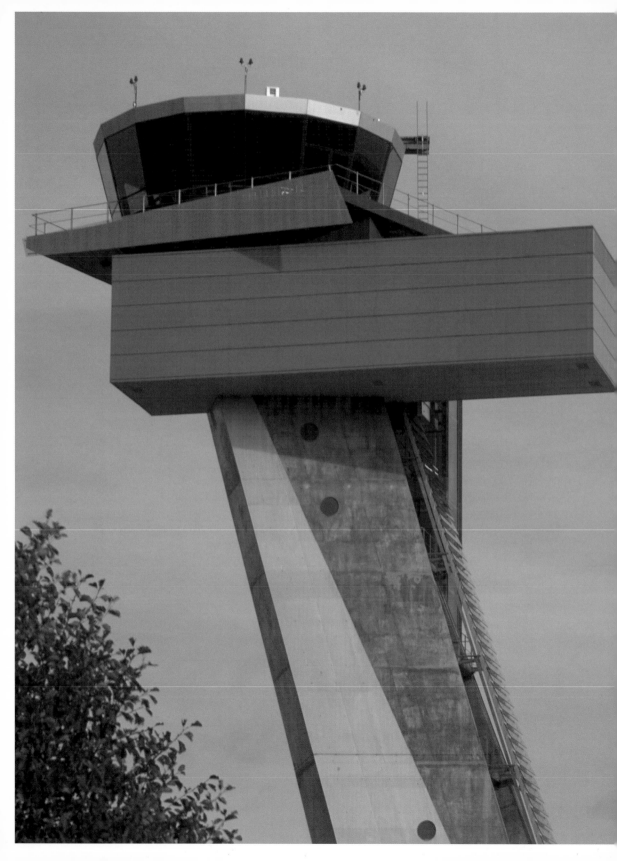

CONTROL TOWER AT NUREMBERG AIRPORT | **NUREMBERG, GERMANY**
www.azfreight.com / nue
Behnisch und Partner | Stuttgart, 1998

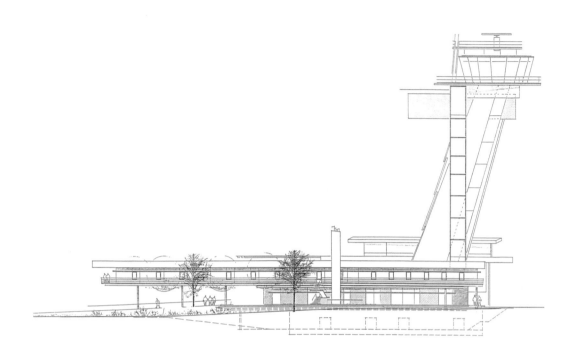

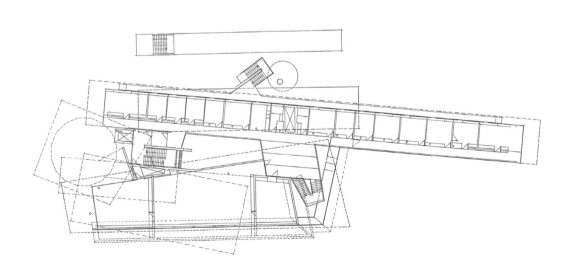

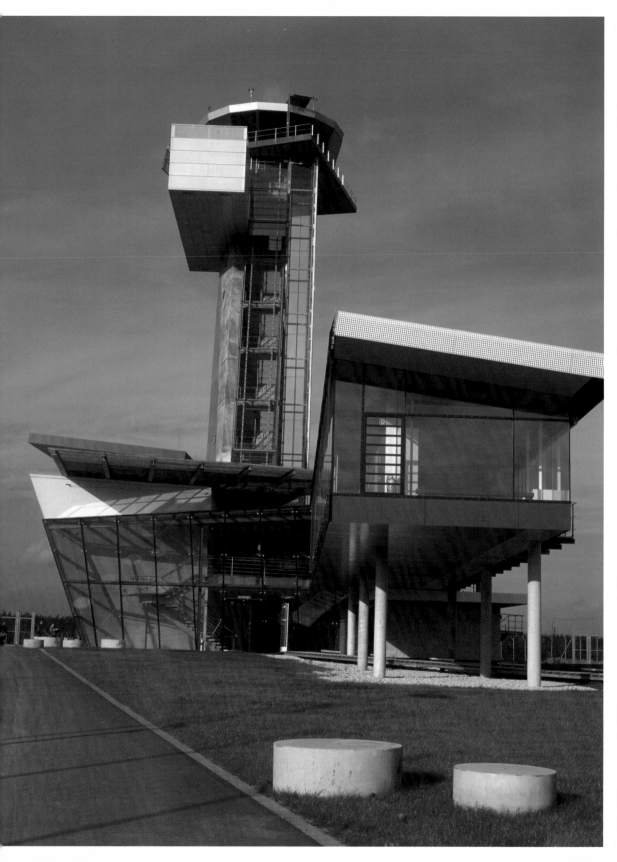

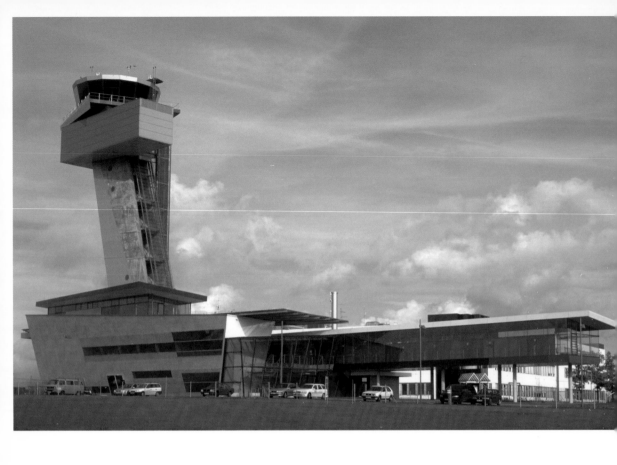

KANSAI INTERNATIONAL AIRPORT | OSAKA, JAPAN
www.kansai-airport.or.jp
Renzo Piano Building Workshop | Genua, 1994

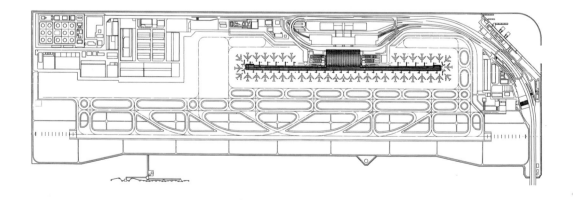

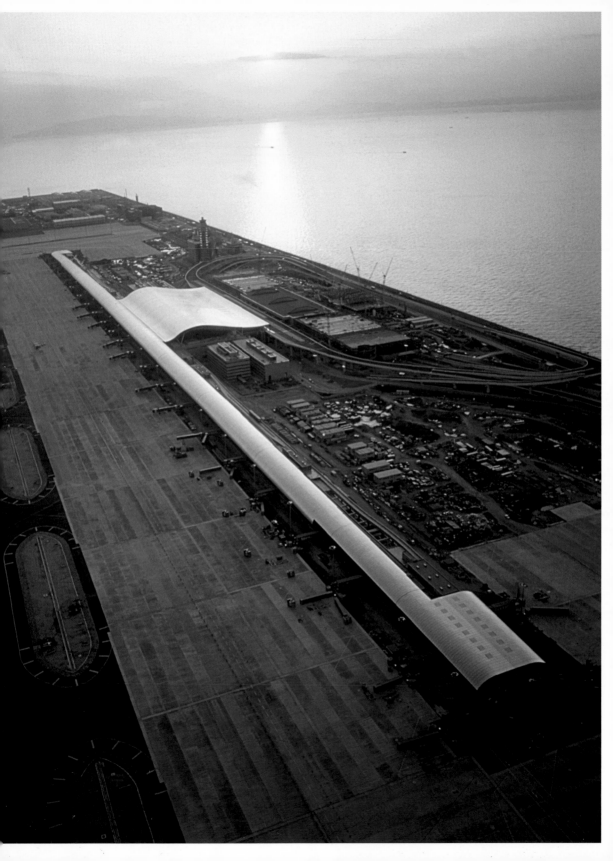

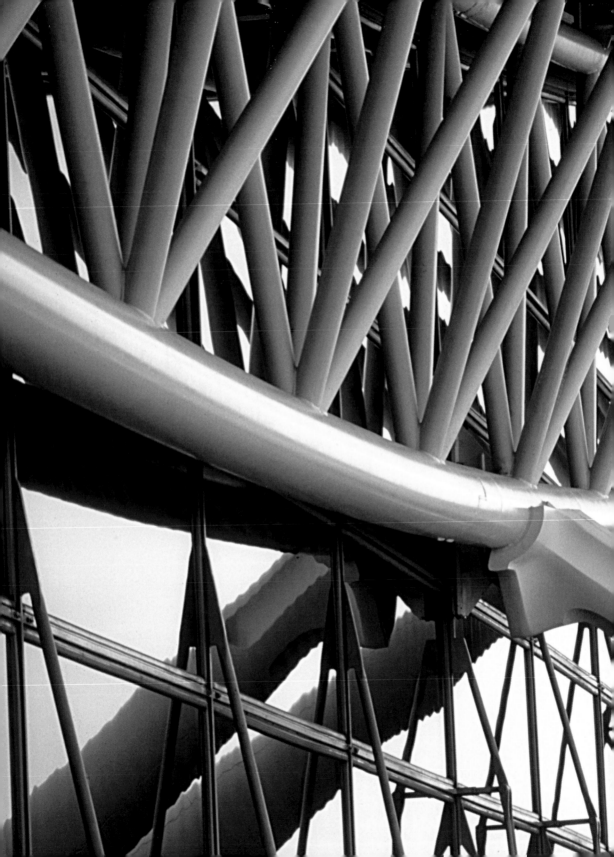

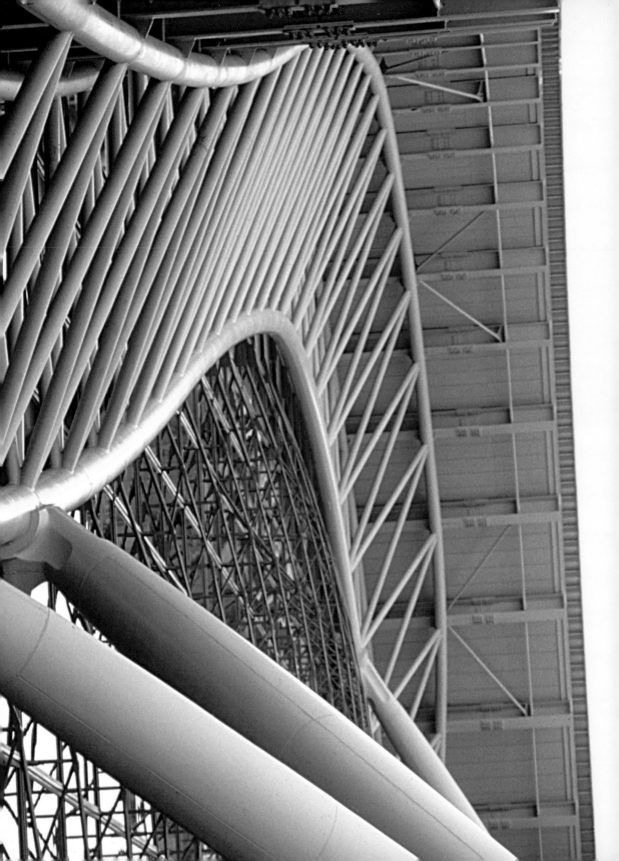

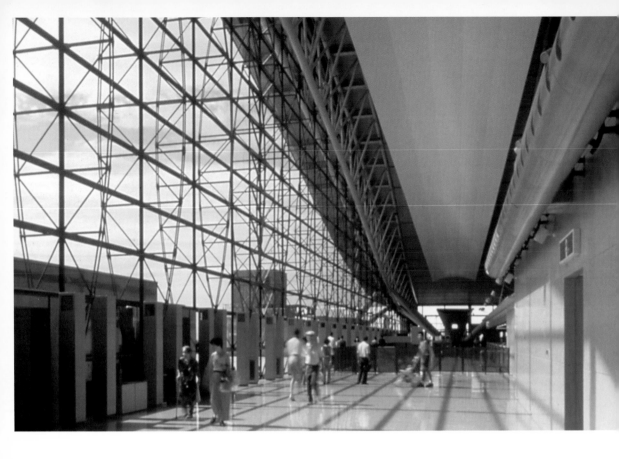

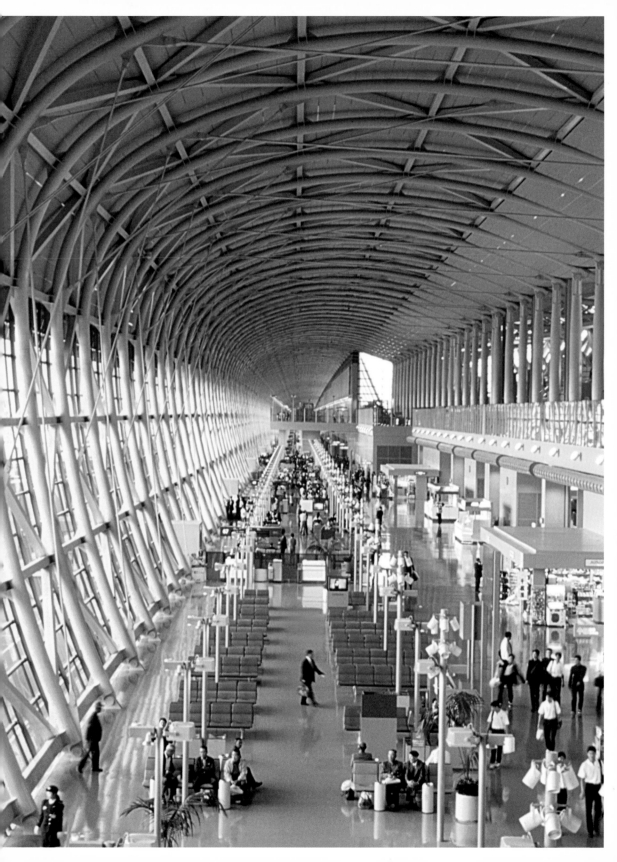

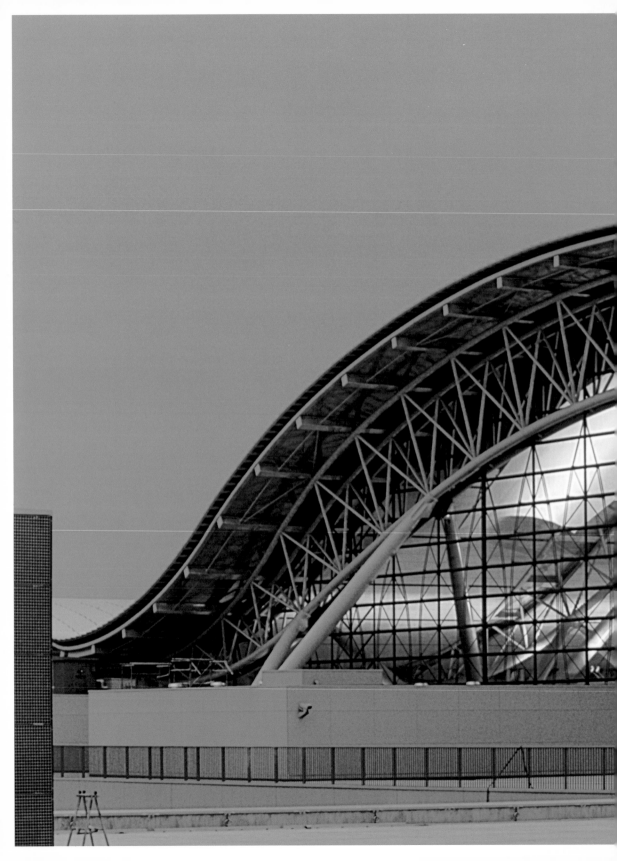

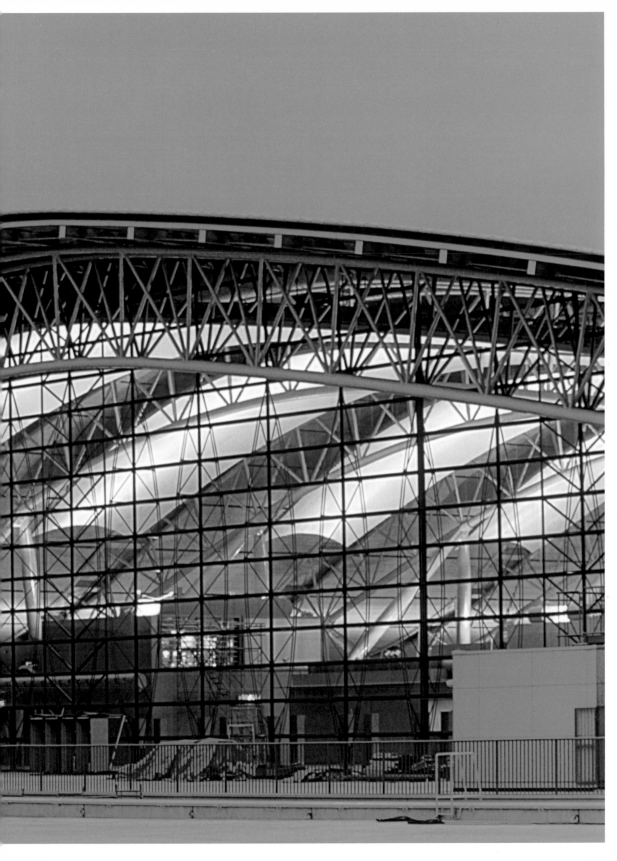

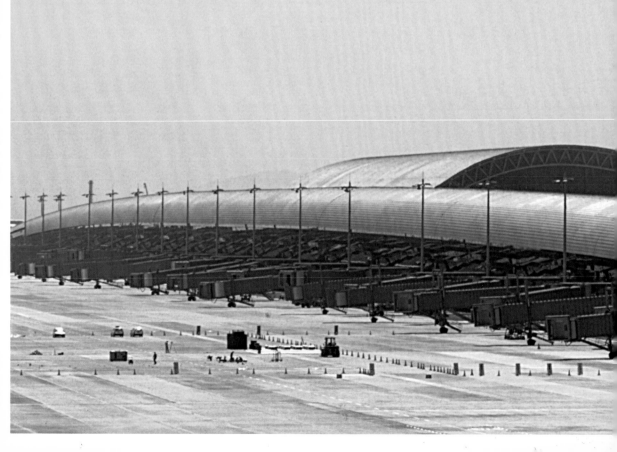

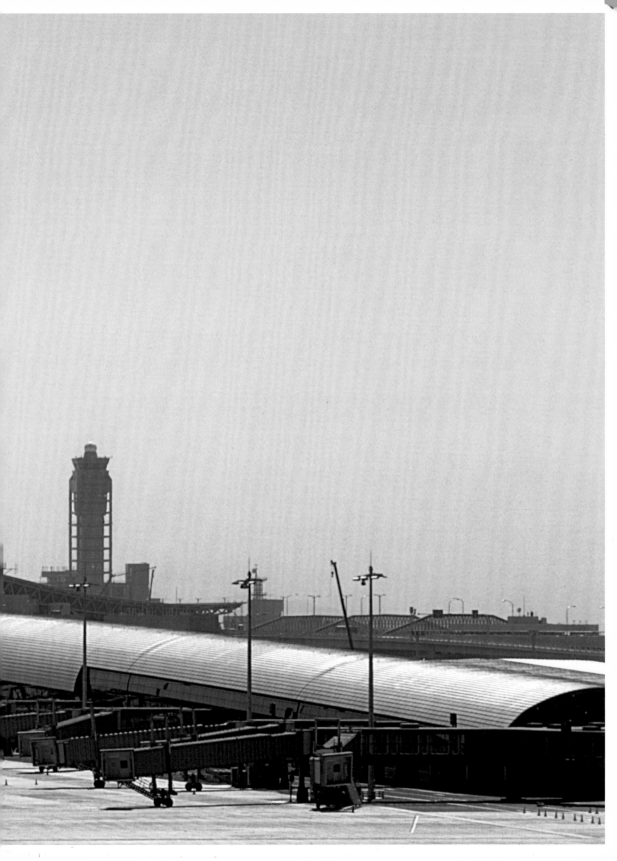

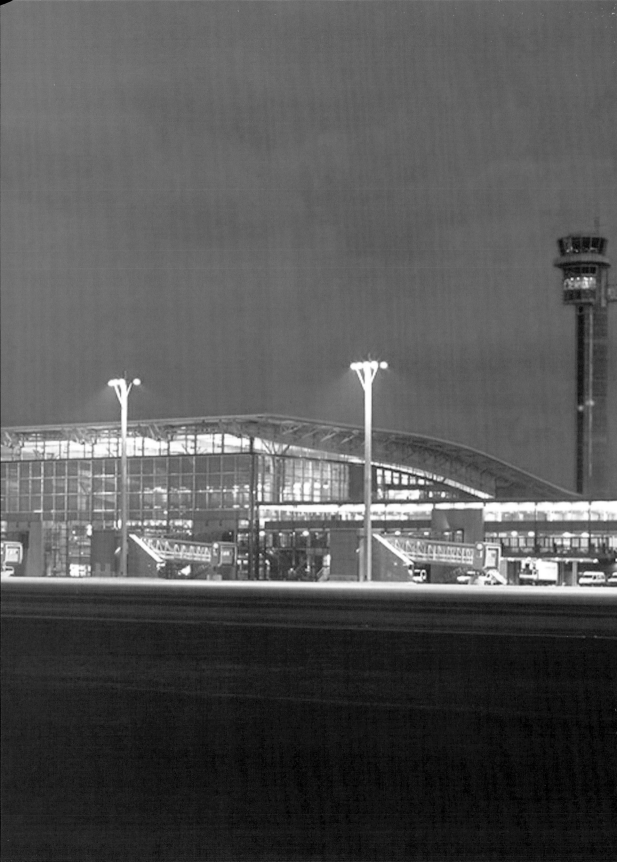

OSLO AIRPORT GARDERMOEN | OSLO, NORWAY
www.osl.no
Aviaplan, Ramstad and Bryn | Oslo, 1998

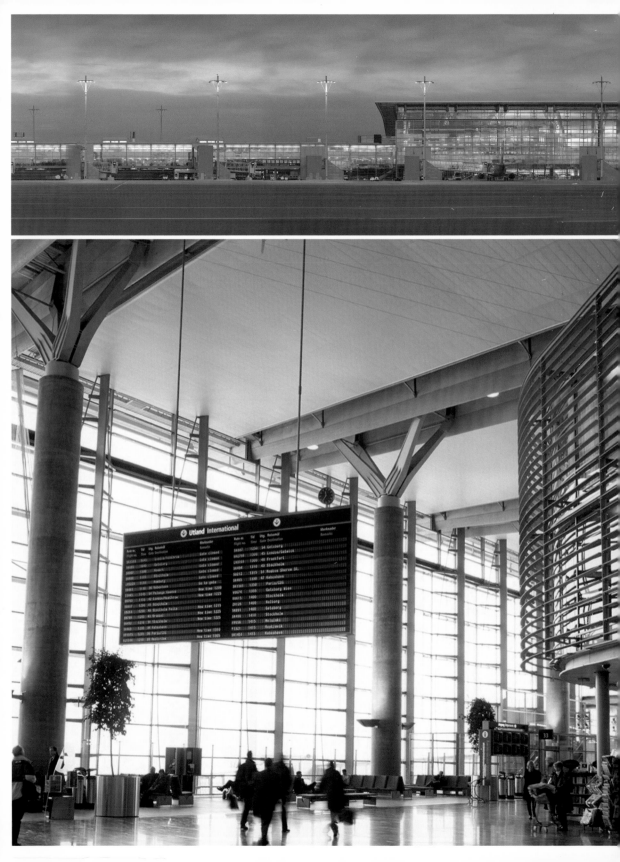

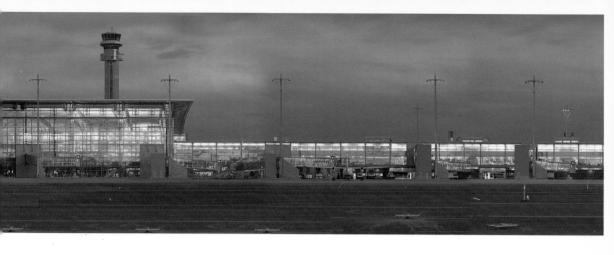

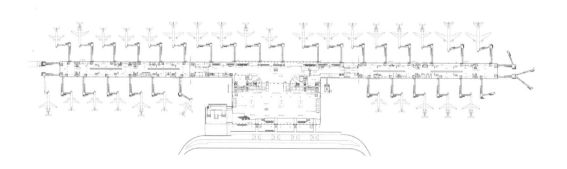

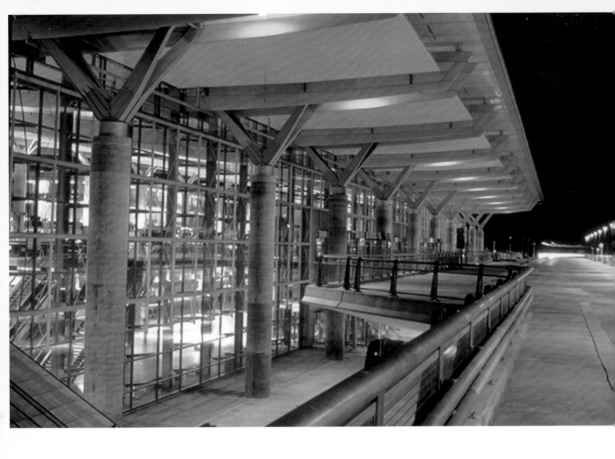

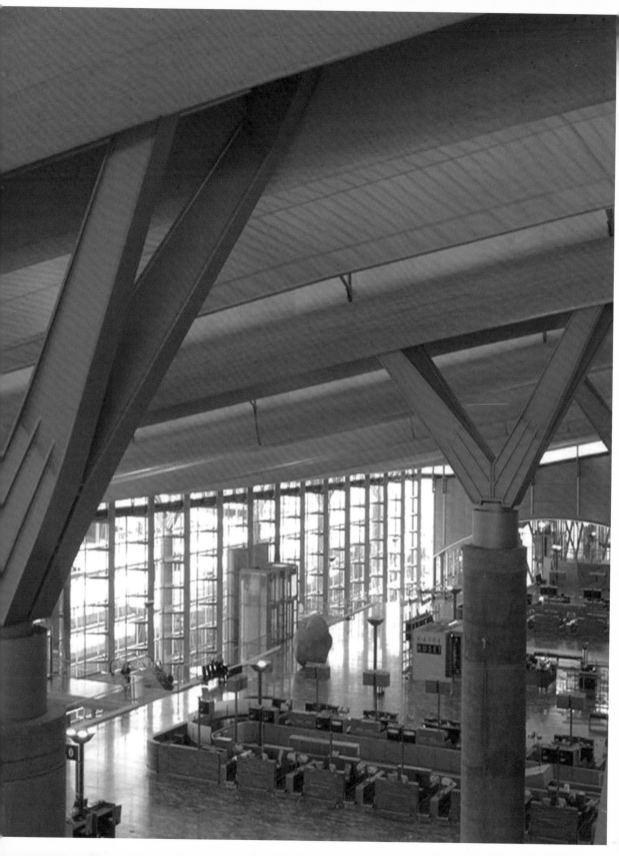

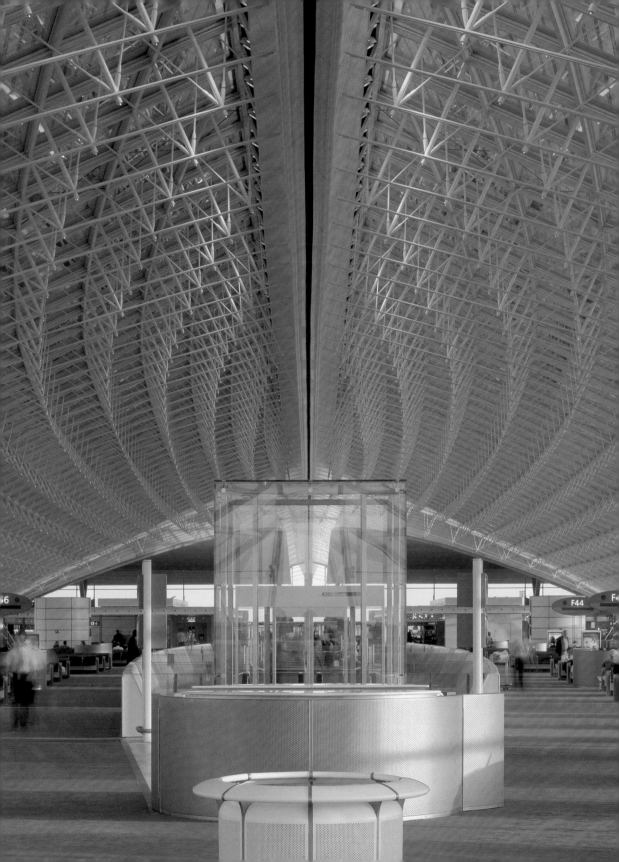

PENINSULA TERMINAL 2F AT CHARLES DE GAULLE AIRPORT | PARIS, FRANCE
www.adp.fr
Paul Andreu | Paris, 2003

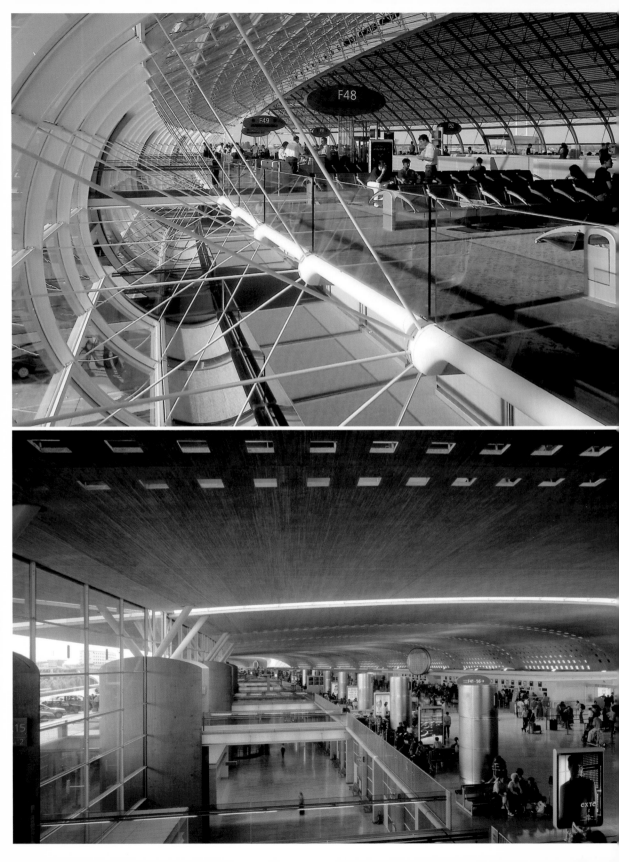

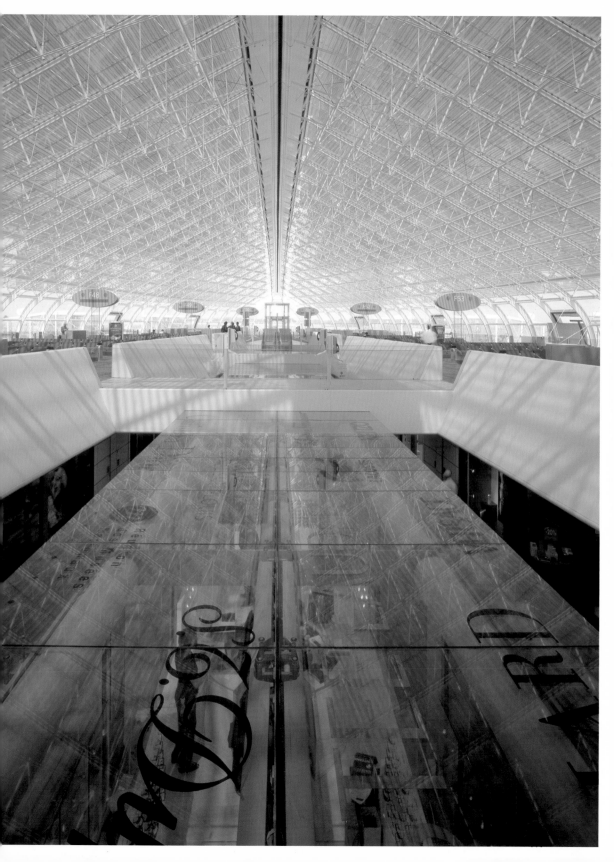

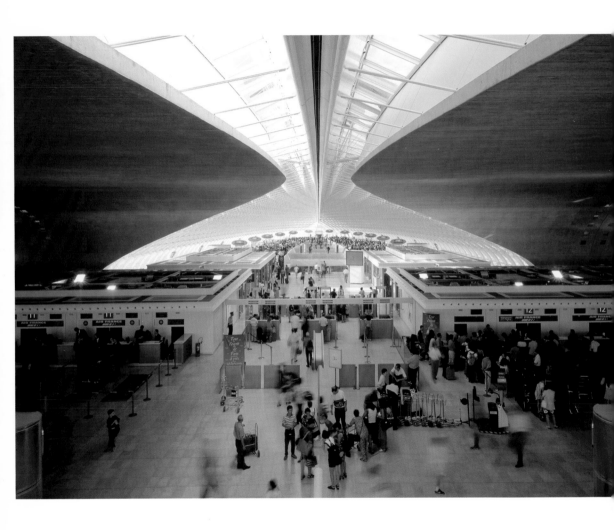

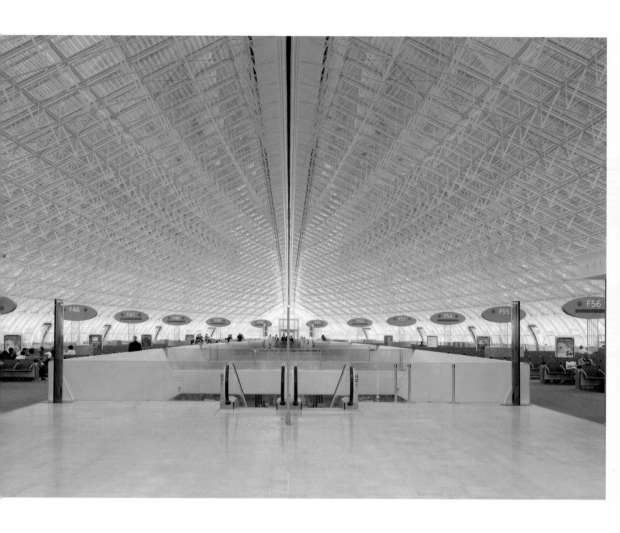

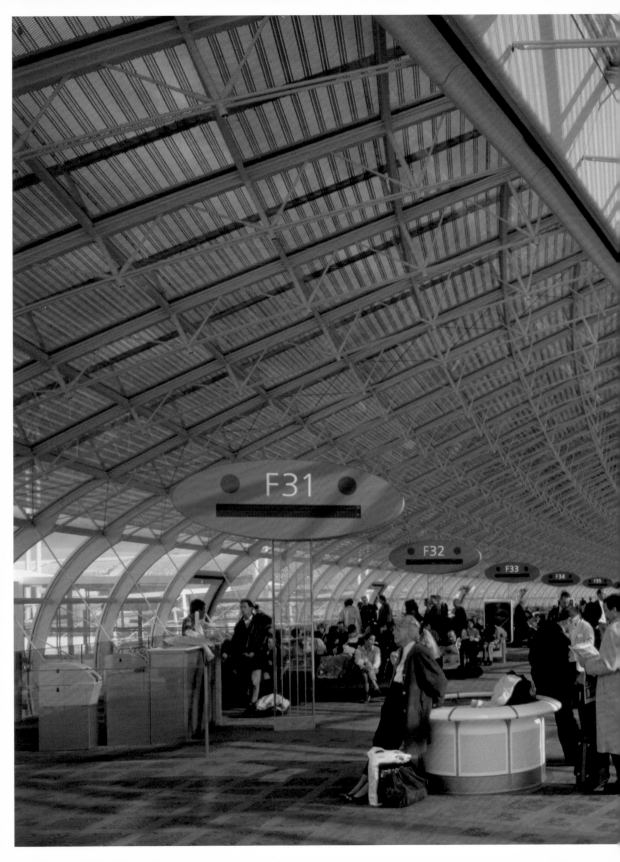

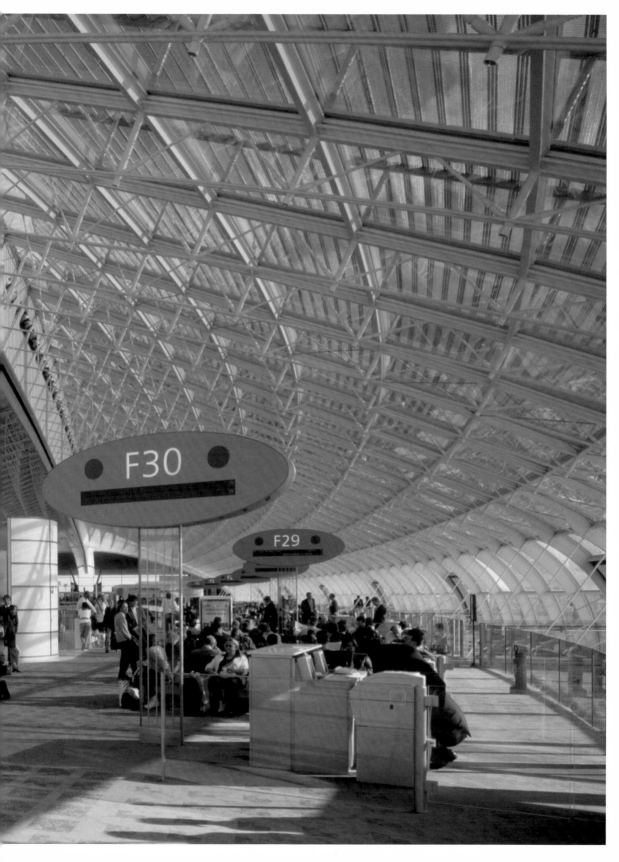

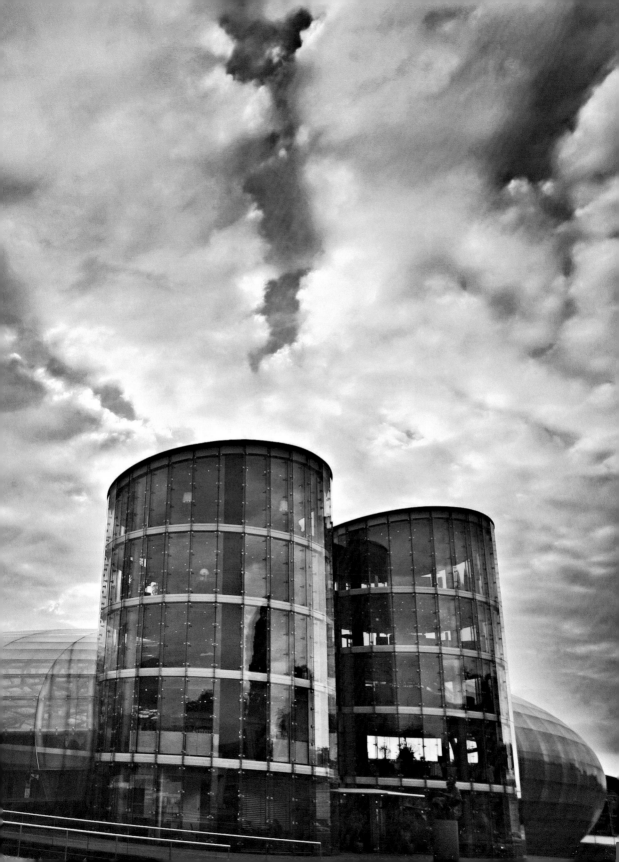

RED BULL HANGAR 7 AT SALZBURG AIRPORT W.A MOZART | SALZBURG, AUSTRIA
www.hangar-7.com, www.salzburg-airport.com
Atelier Volkmar Burgstaller | Salzburg, 2003

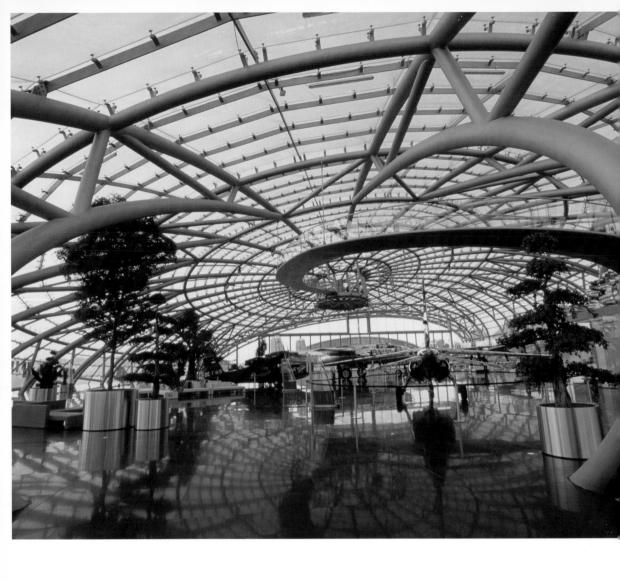

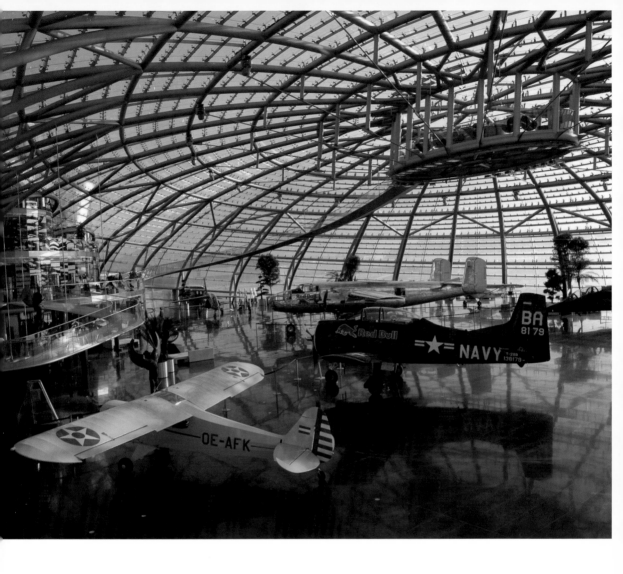

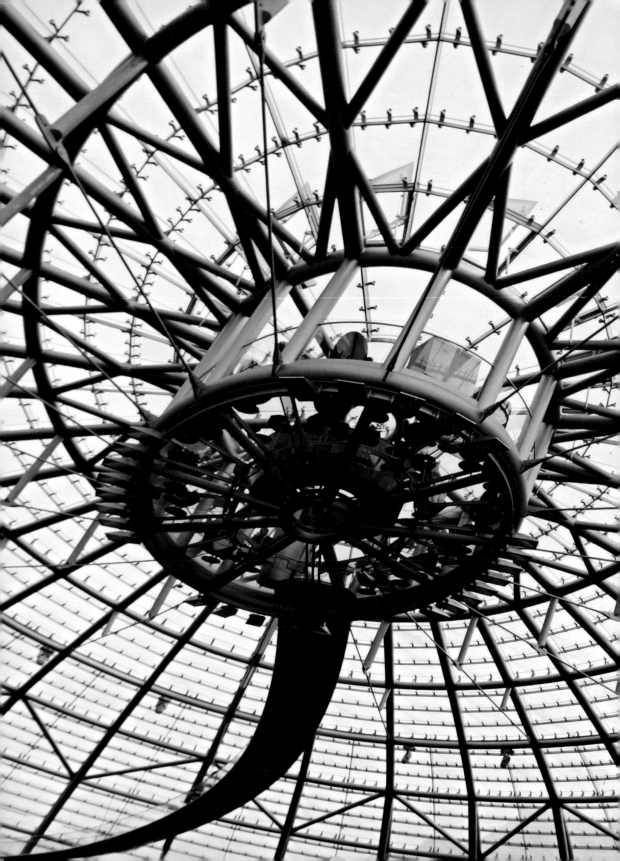

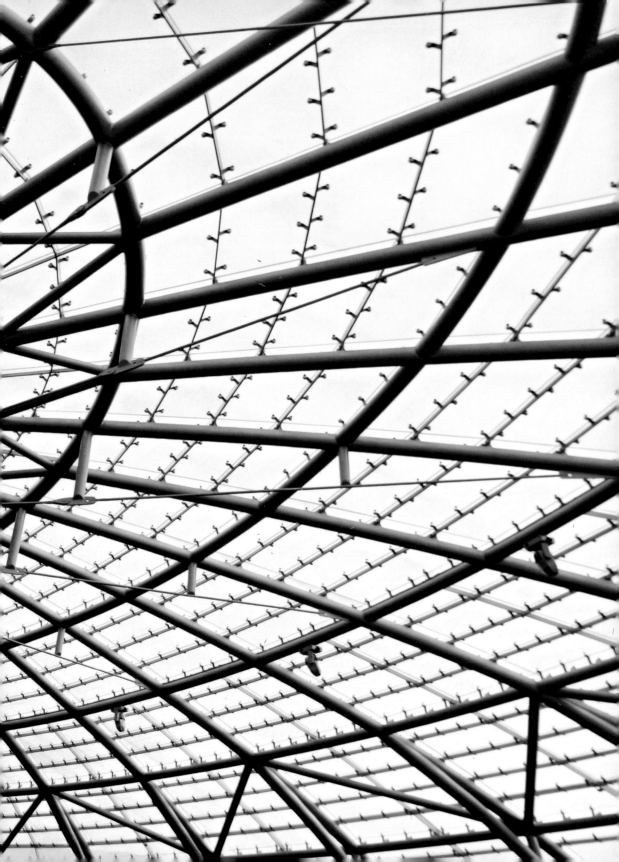

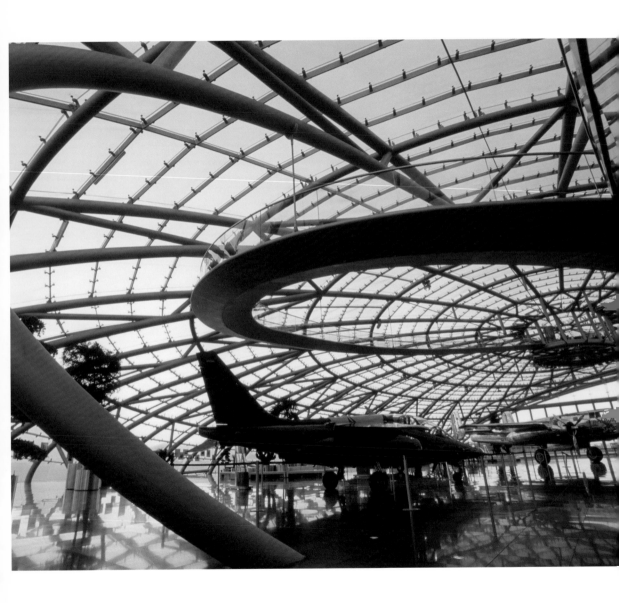

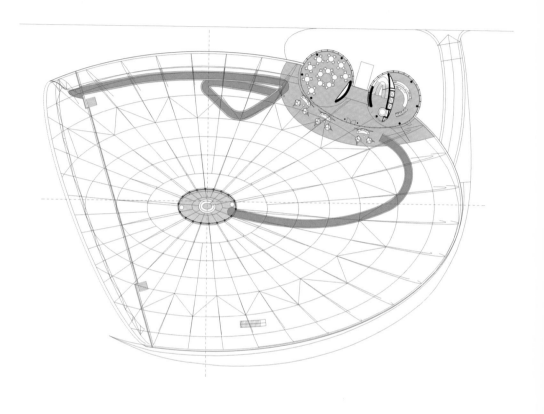

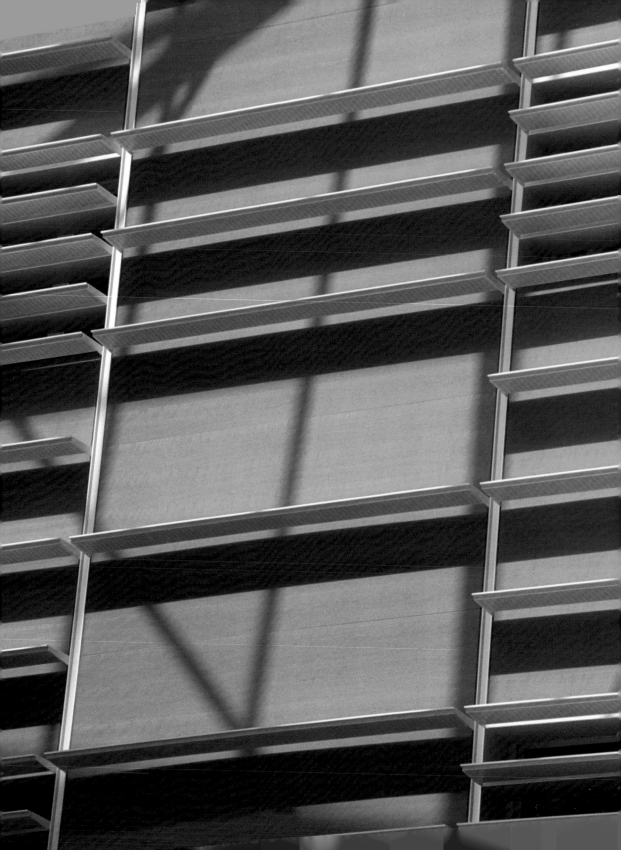

SAN FRANCISCO INTERNATIONAL AIRPORT | SAN FRANCISCO, USA
www.flysfo.com
Skidmore, Owings and Merill LLP | New York, 2001

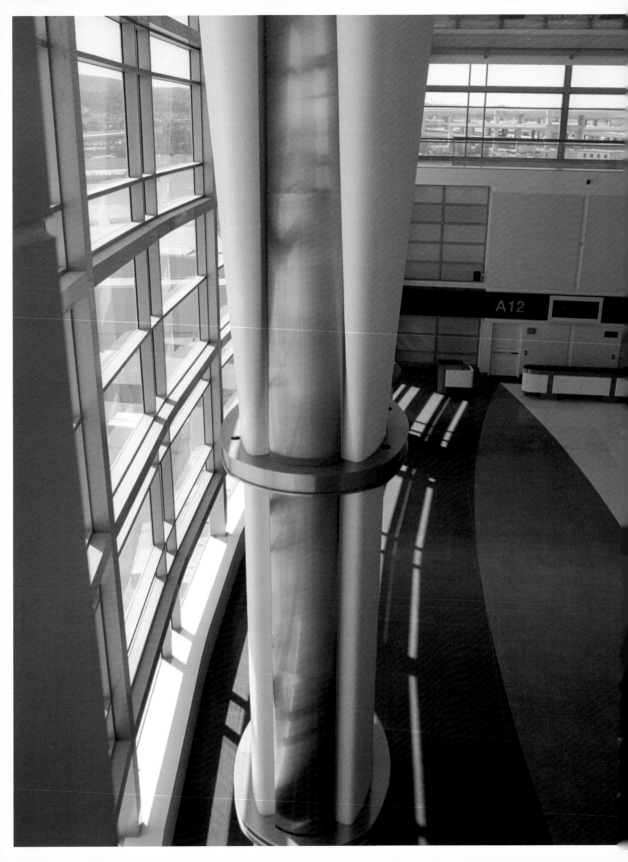

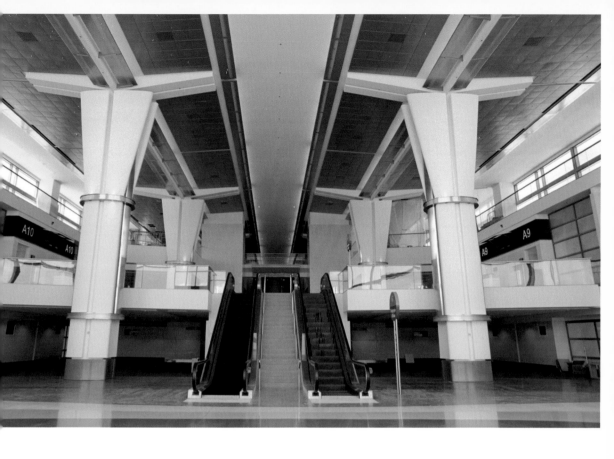

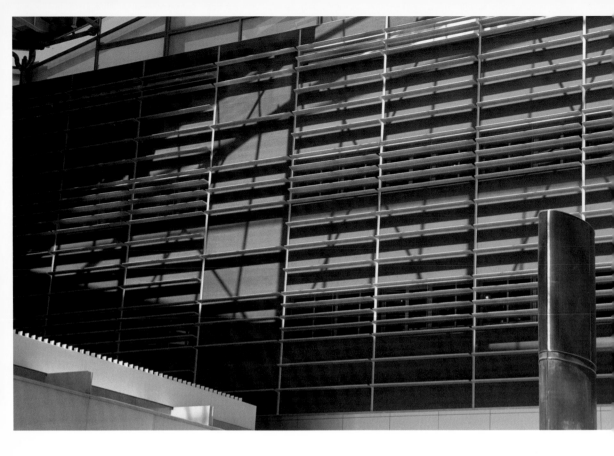

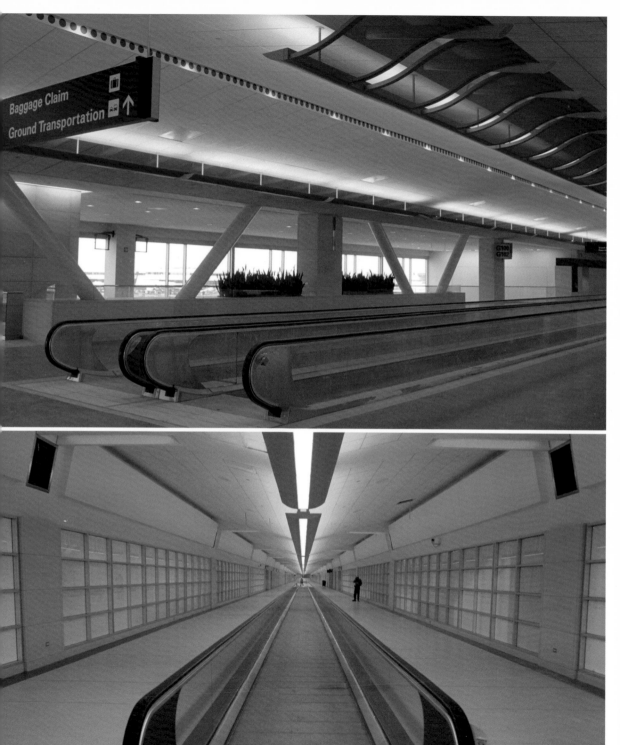

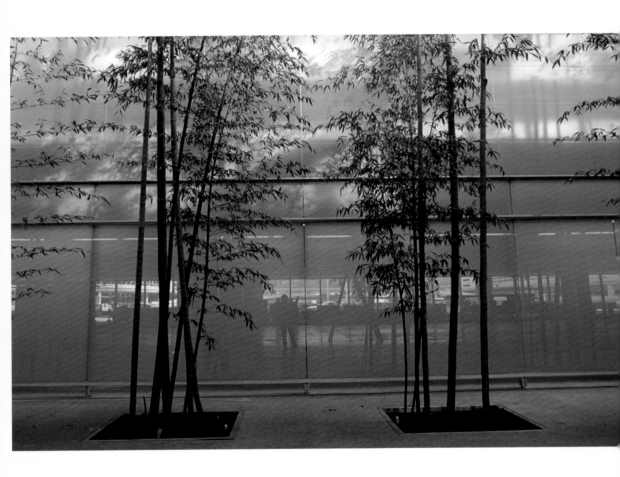

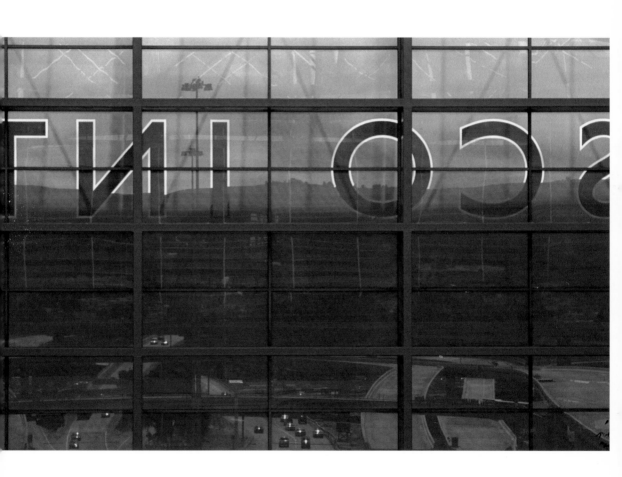

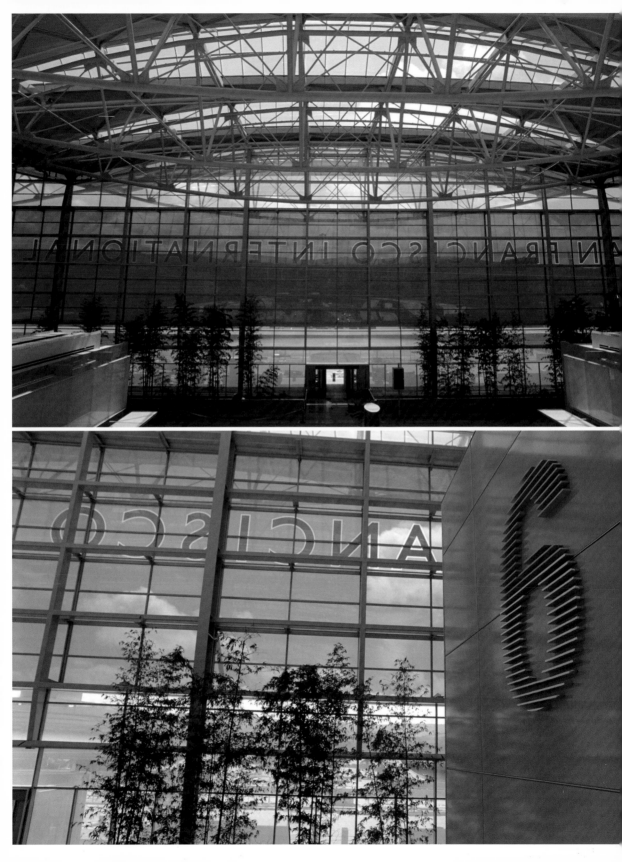

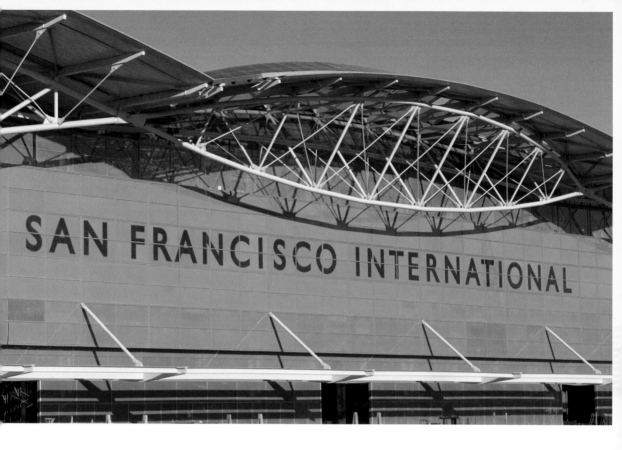

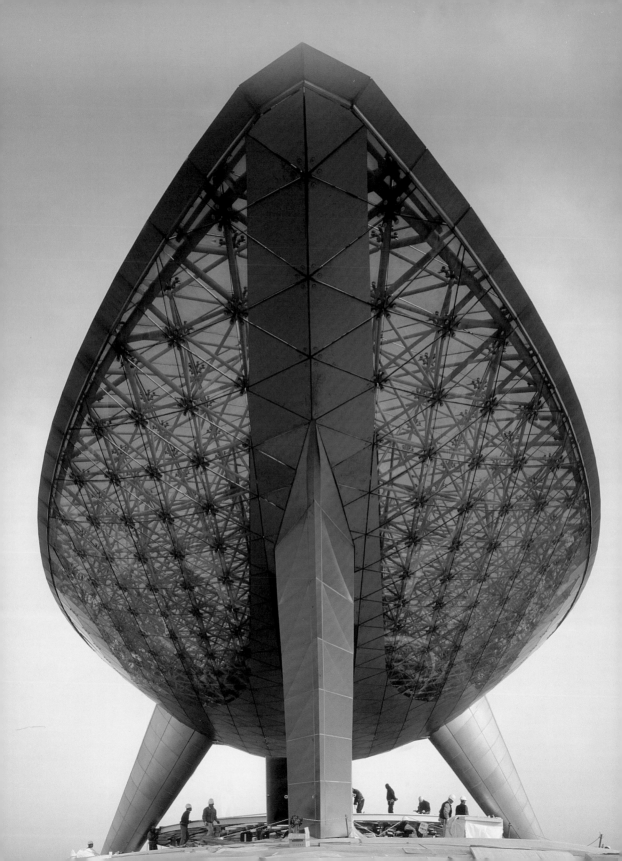

INTEGRATED TRANSPORTATION CENTER
AT INCHEON INTERNATIONAL AIRPORT | SEOUL, SOUTH KOREA
www.airport.or.kr
Terry Farrell and Partners | London, 2001

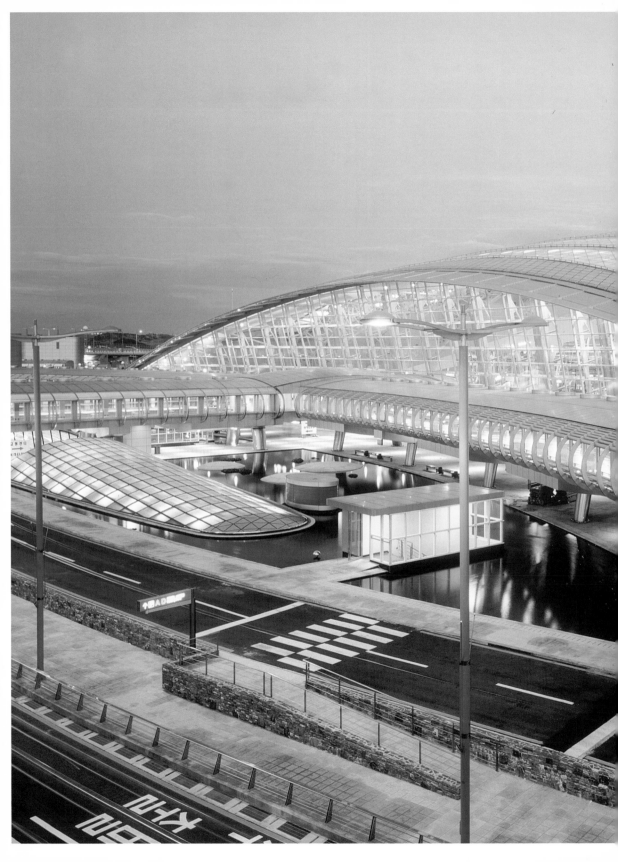

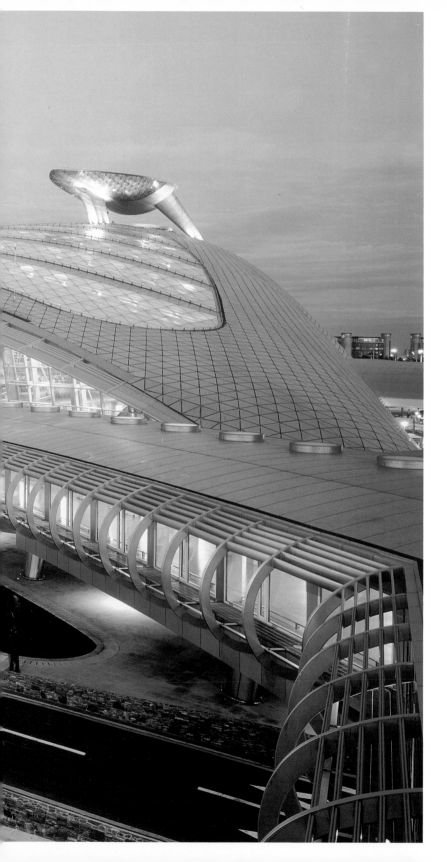

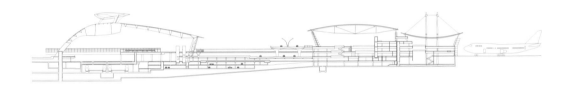

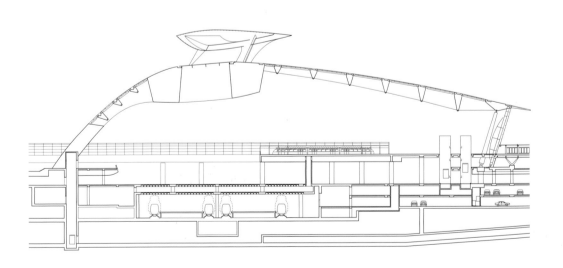

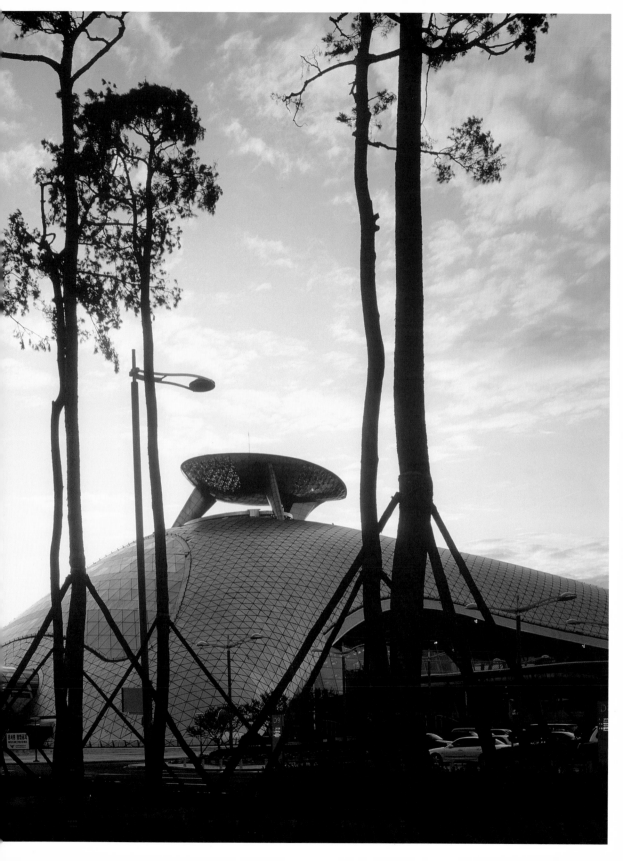

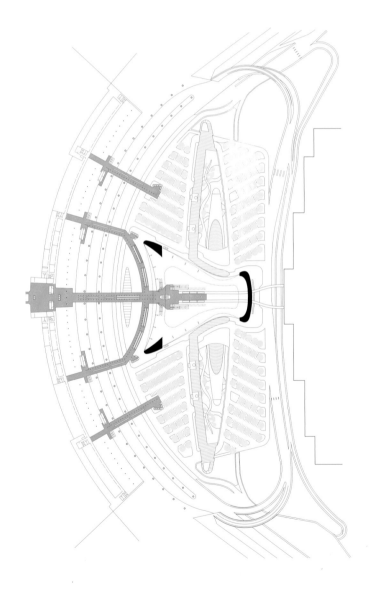

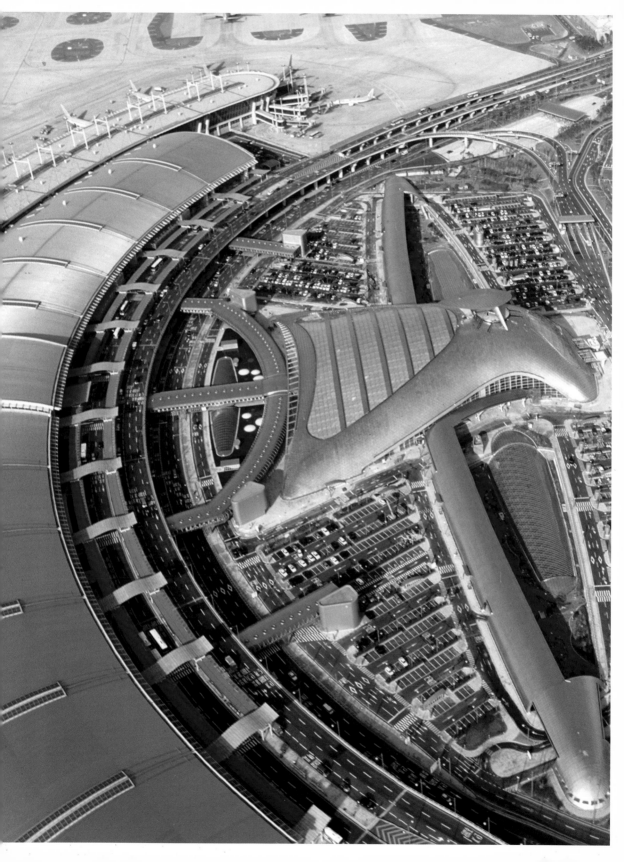

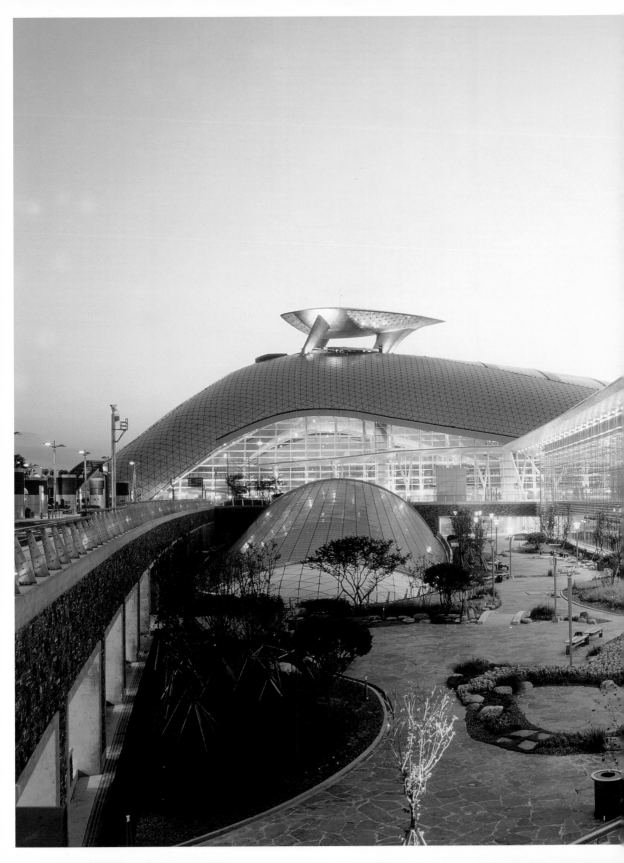

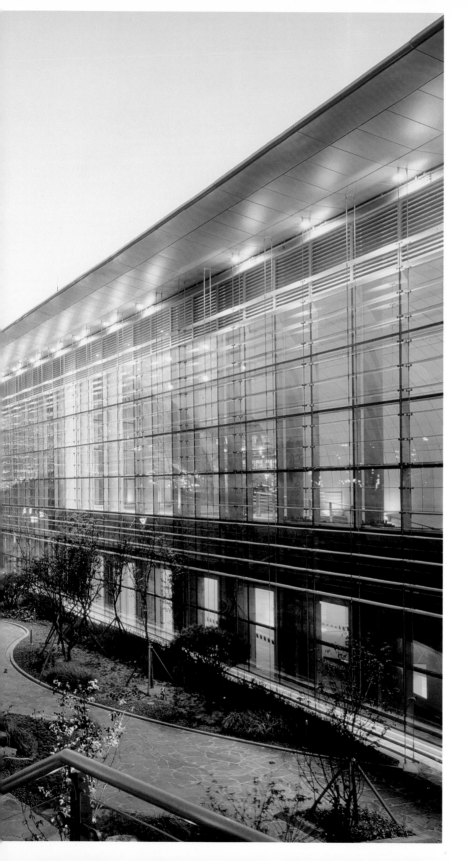

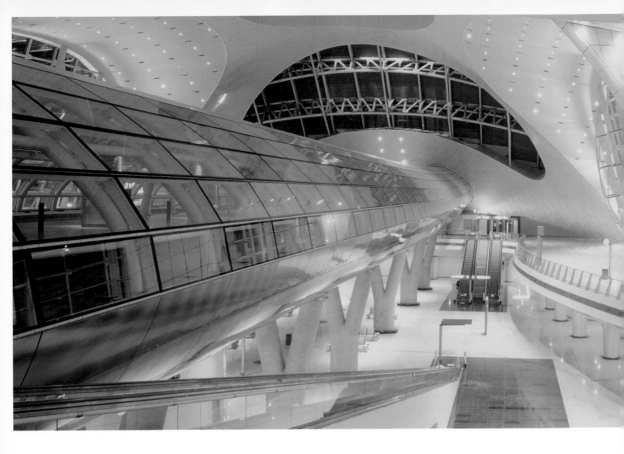

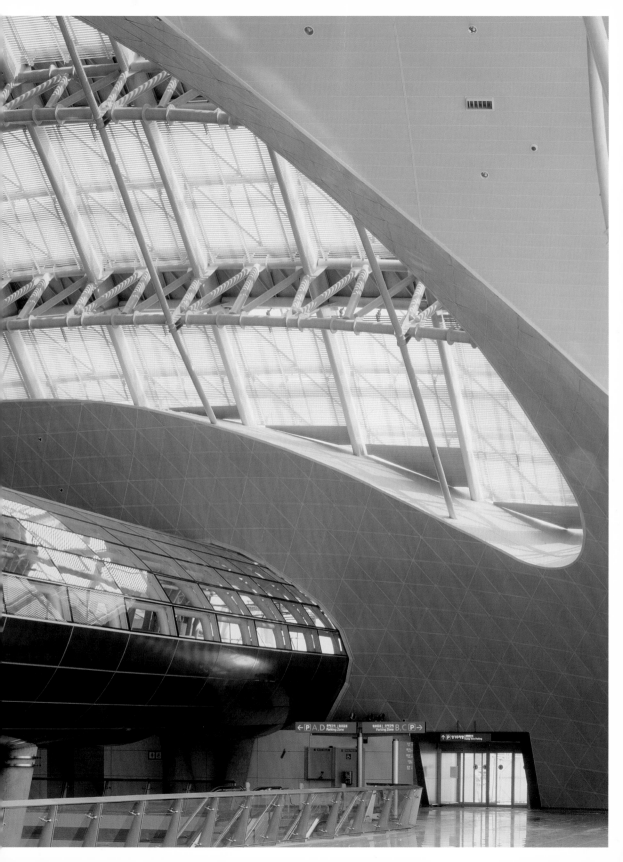

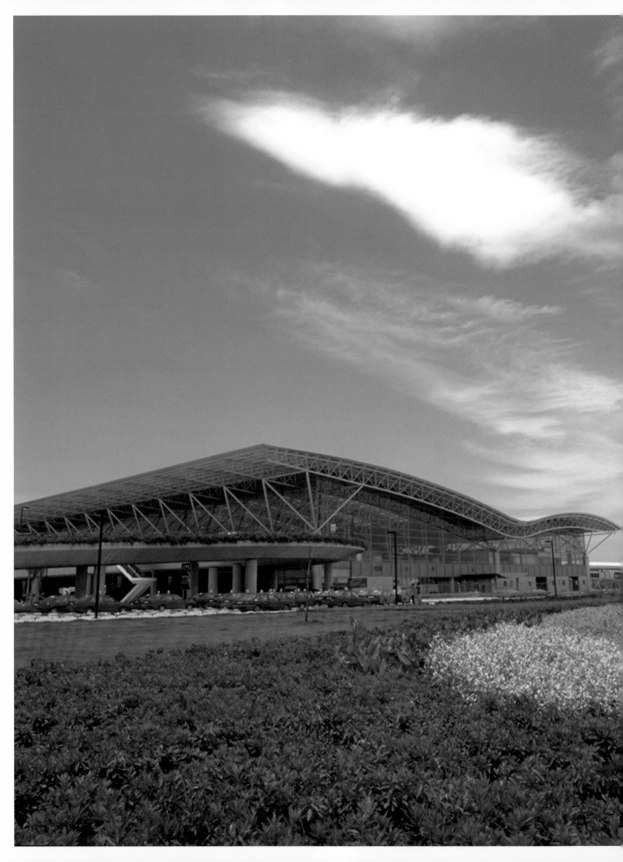

DOMESTIC TERMINAL AT SHENZHEN AIRPORT | SHENZHEN, CHINA
www.szairport.com
Llewelyn Davies | London, 2001

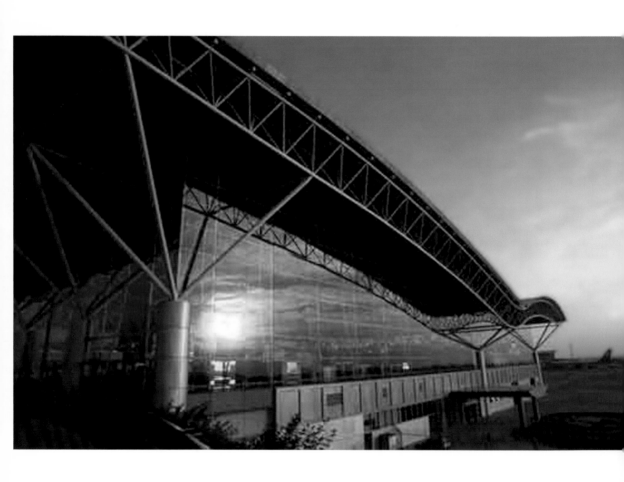

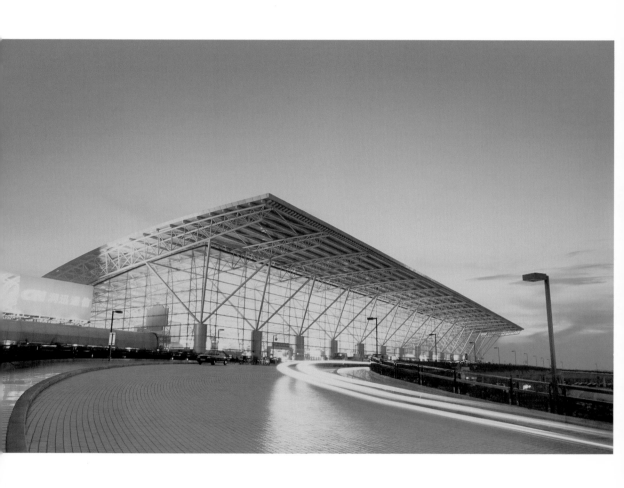

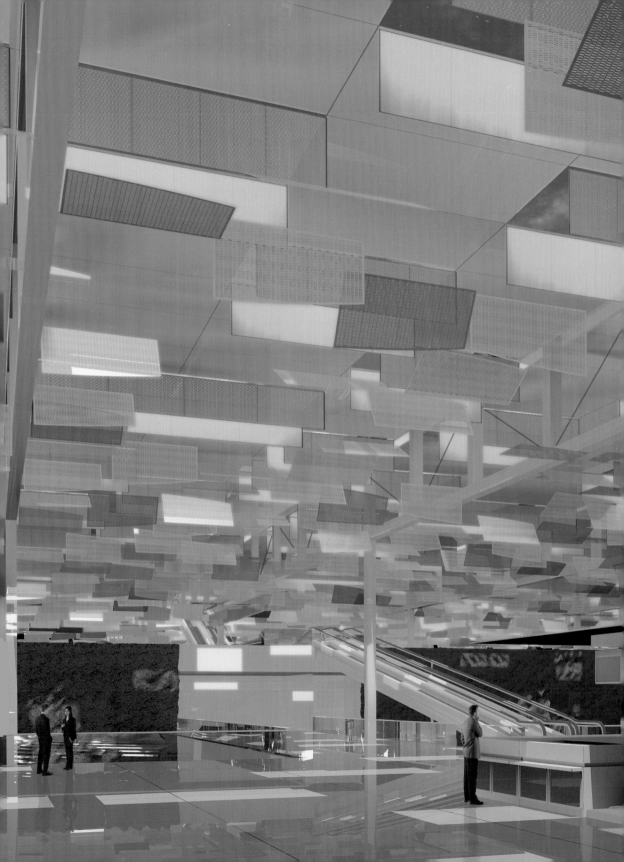

TERMINAL 3 AT CHANGI INTERNATIONAL AIRPORT | SINGAPORE
www.sats.com.sg
Skidmore, Owings and Merrill LLP | London, 2007

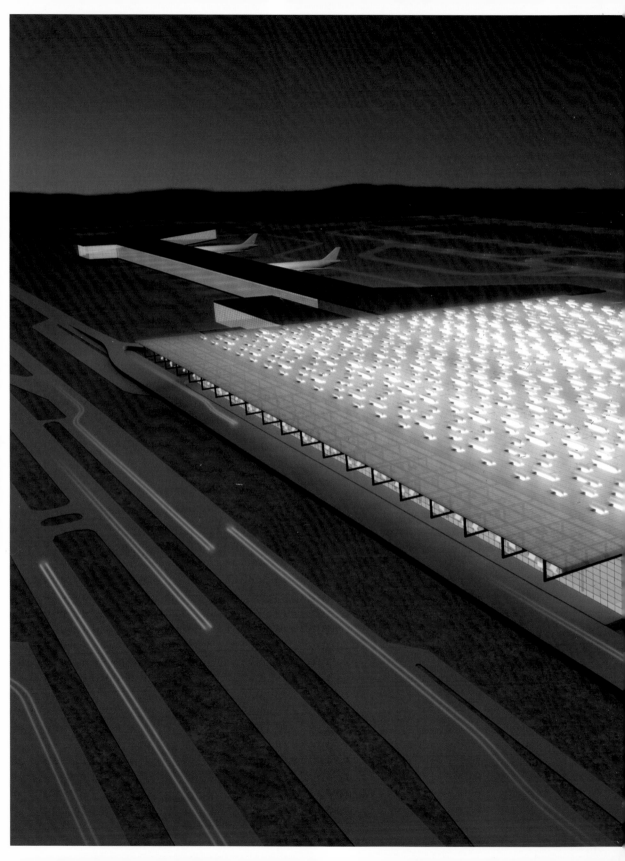

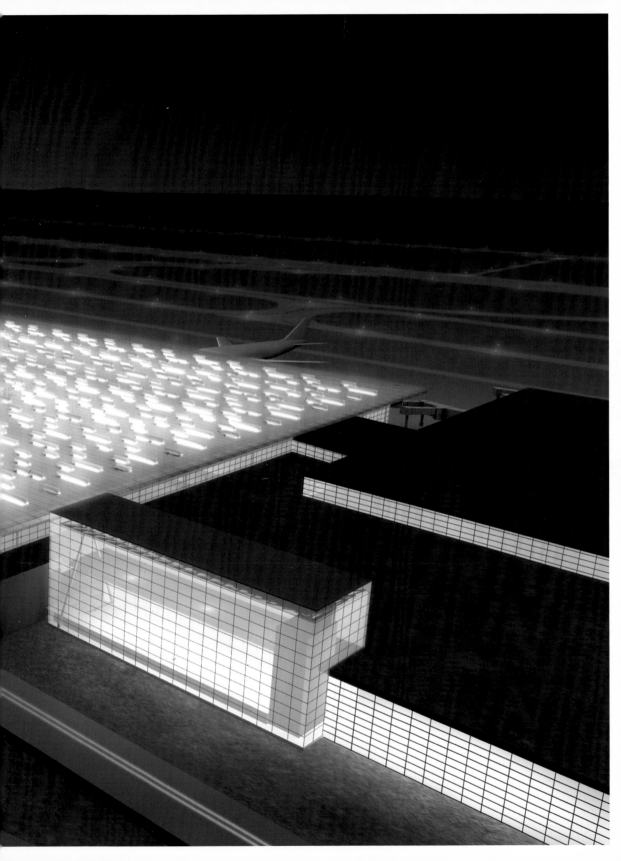

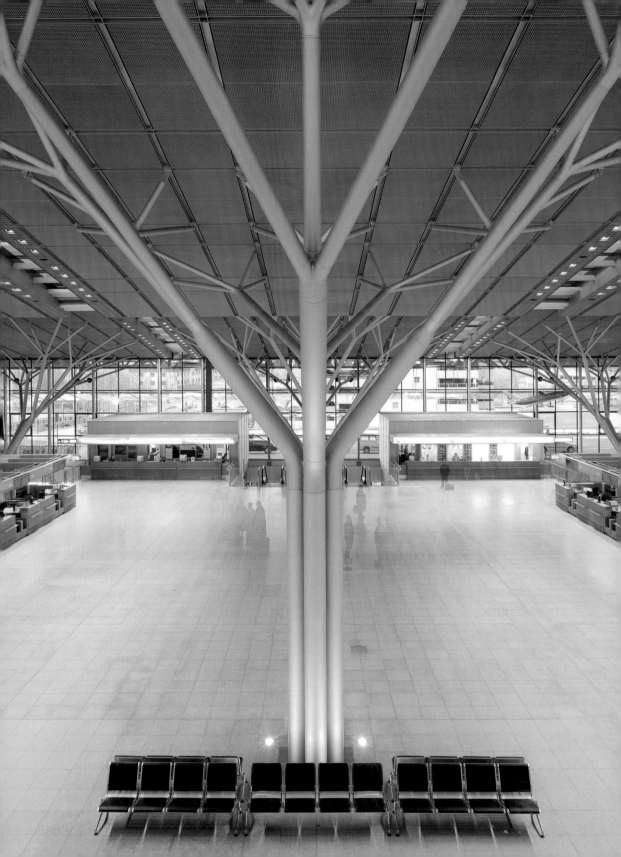

TERMINAL 3 AT STUTTGART AIRPORT | STUTTGART, GERMANY
www.flughafen-stuttgart.de
gmp – Architekten von Gerkan, Marg und Partner | Hamburg, 2004

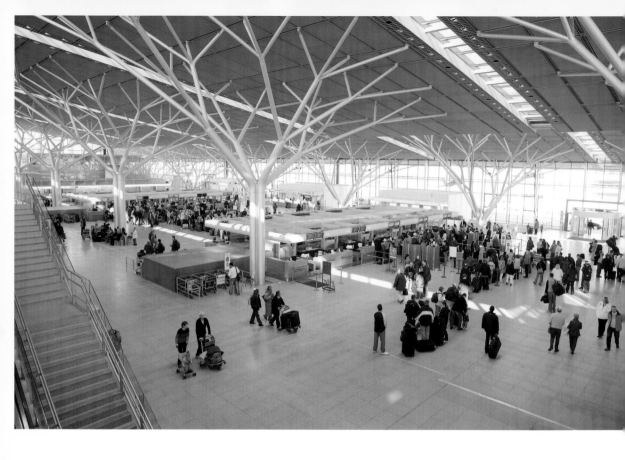

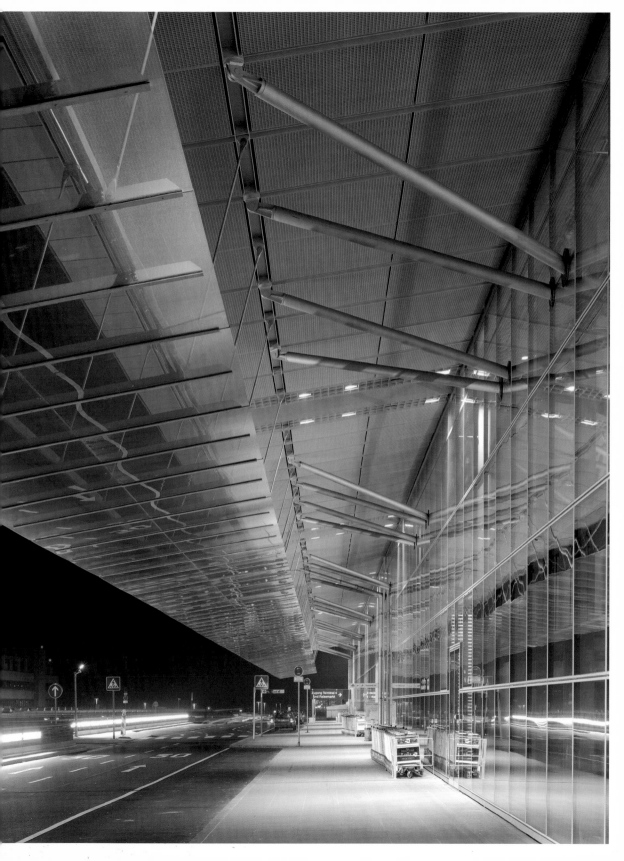

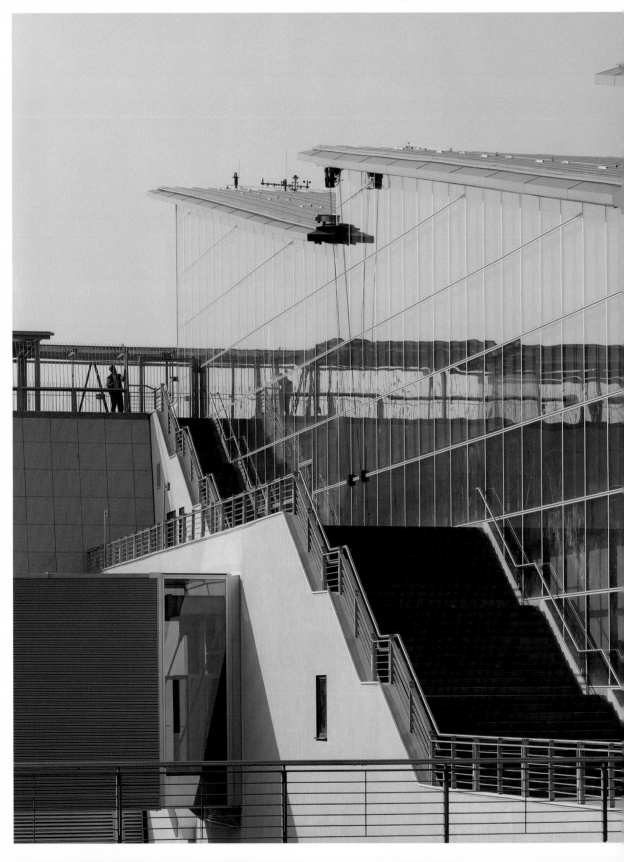

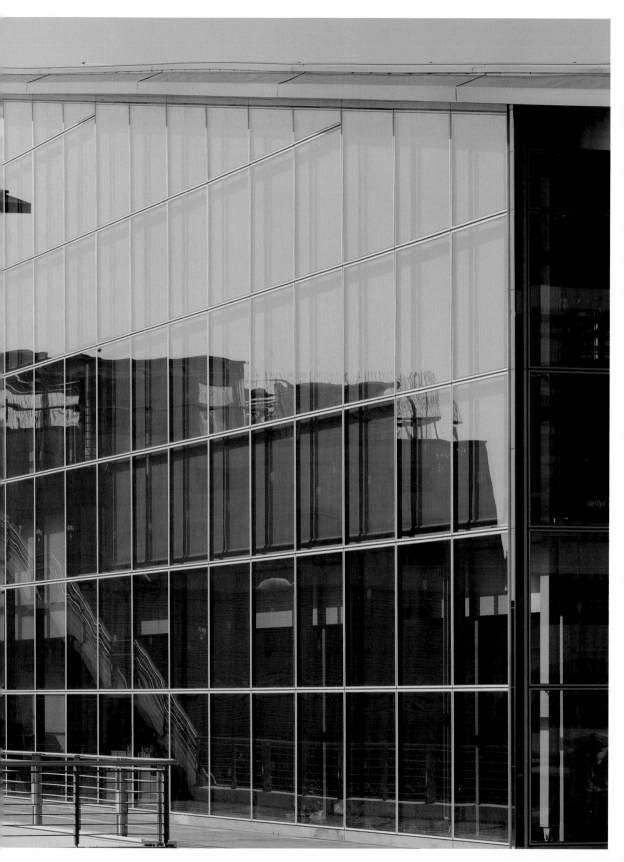

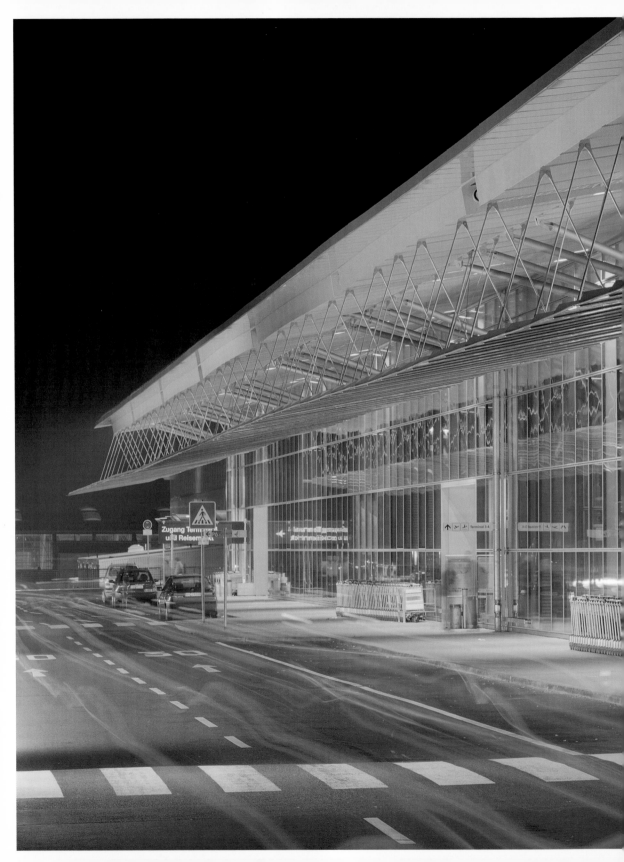

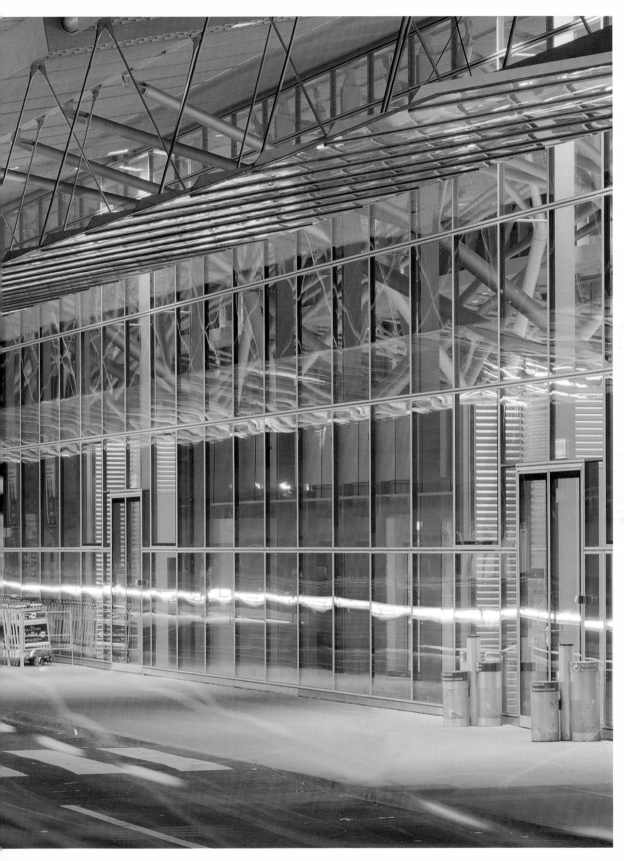

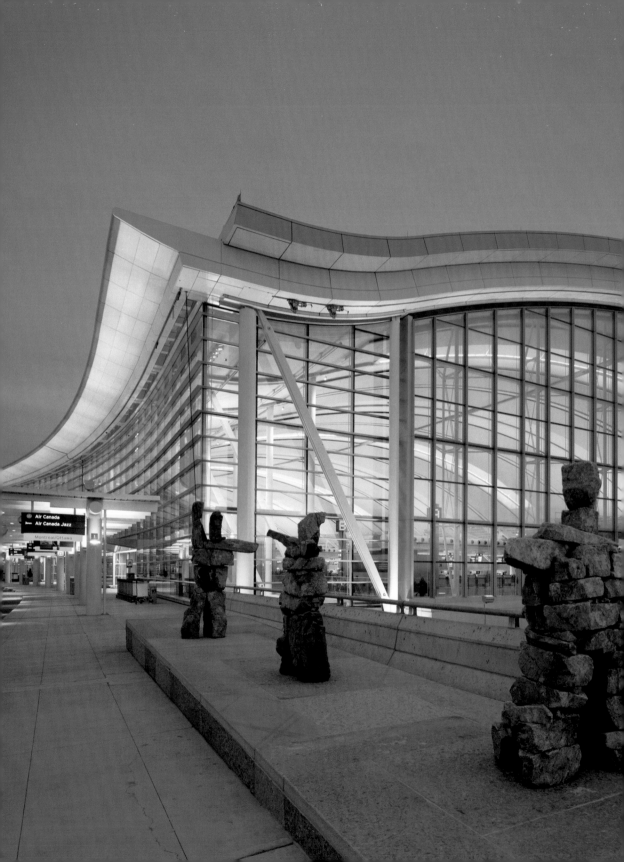

TERMINAL 1 AT LESTER B. PEARSON INTERNATIONAL AIRPORT | TORONTO, CANADA
www.gtaa.com
Skidmore, Owings and Merrill LLP | New York, 2004

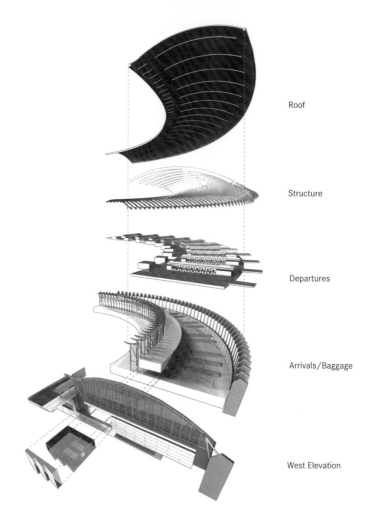

Roof

Structure

Departures

Arrivals/Baggage

West Elevation

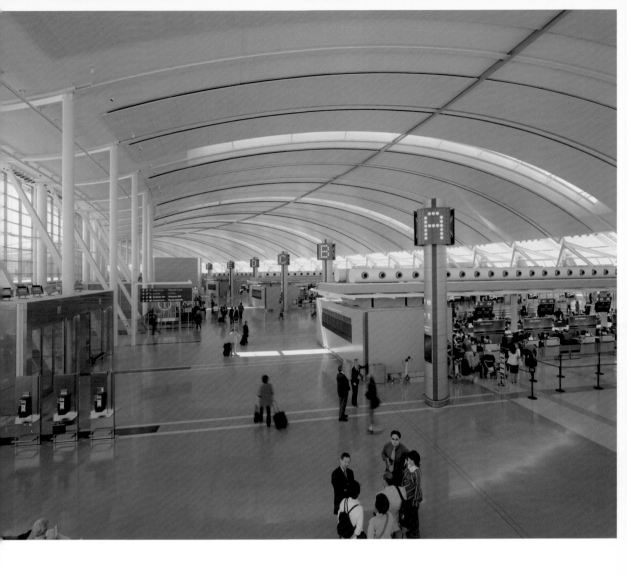

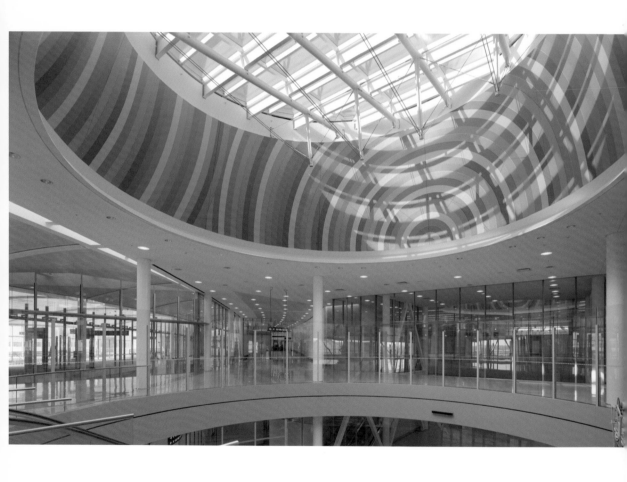

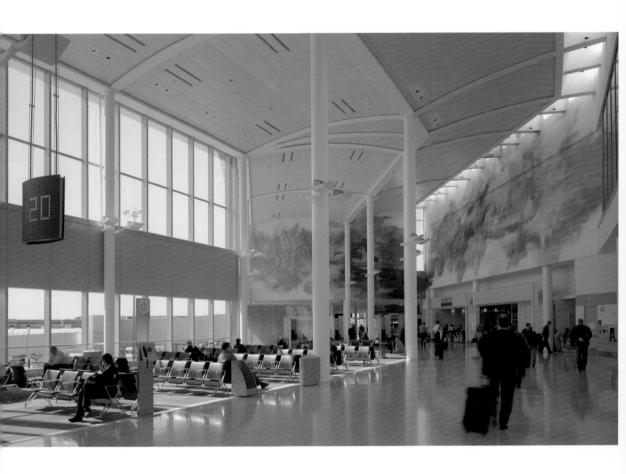

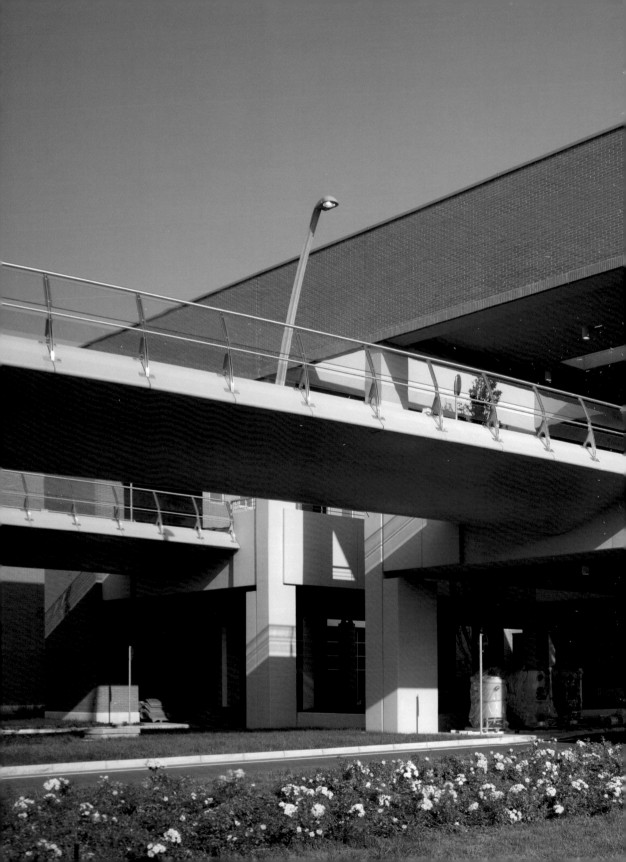

VENICE MARCO POLO AIRPORT | **VENICE, ITALY**
www.veniceairport.it
Gian Paulo Mar | Mestre, 2002

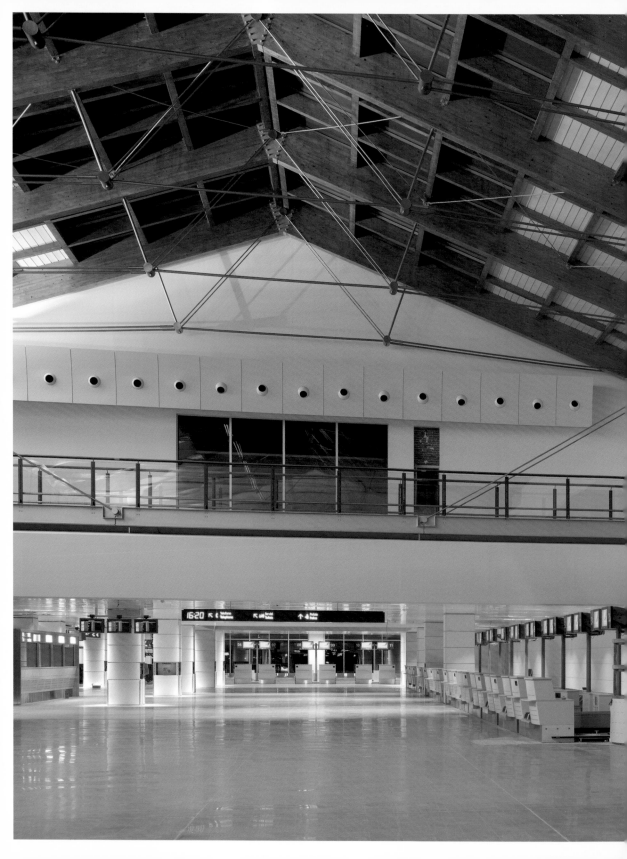

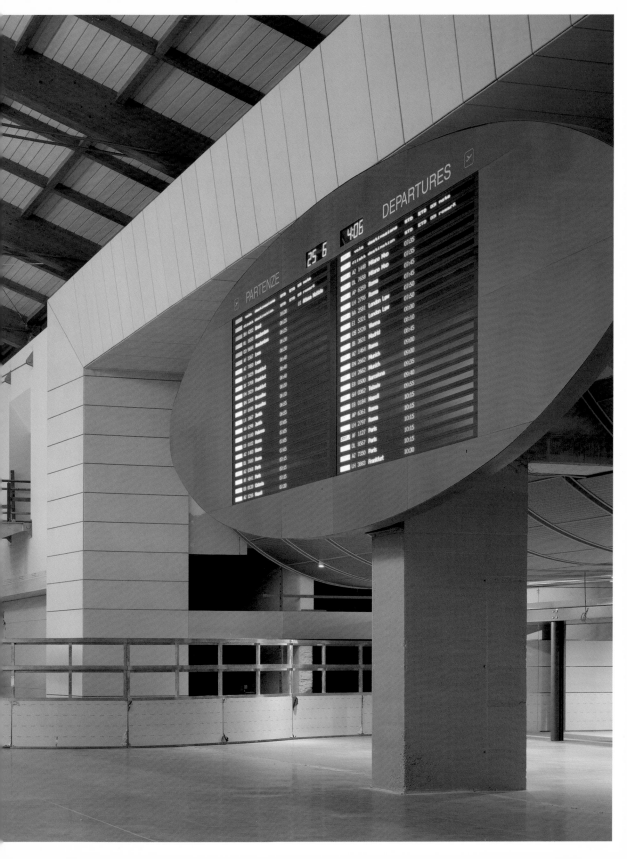

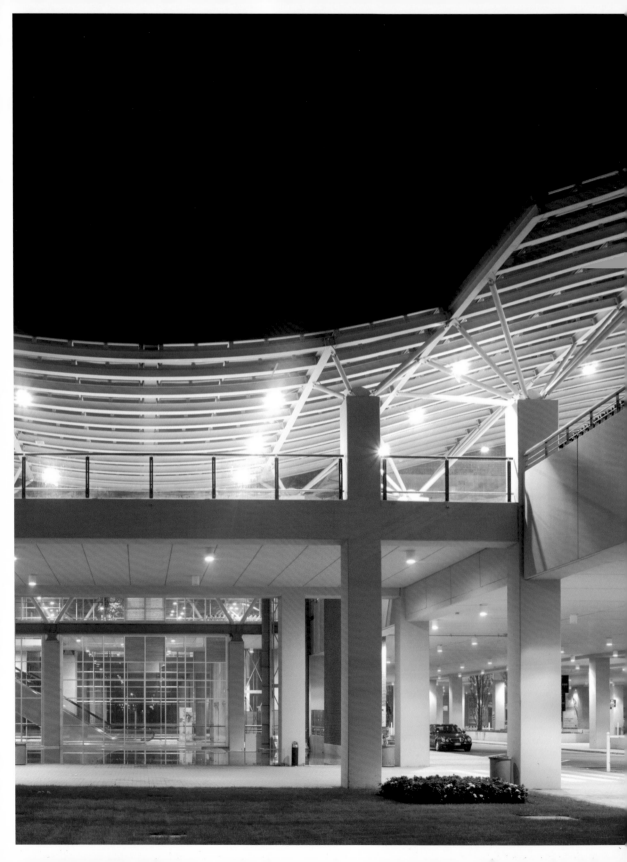

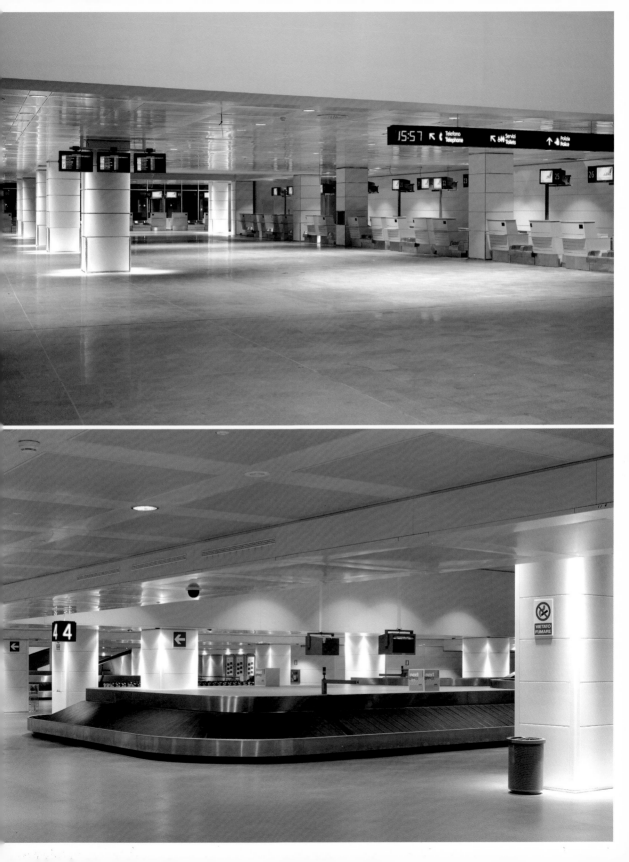

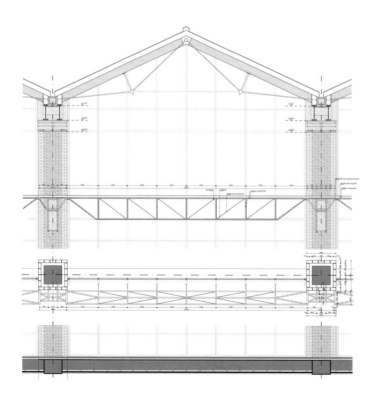

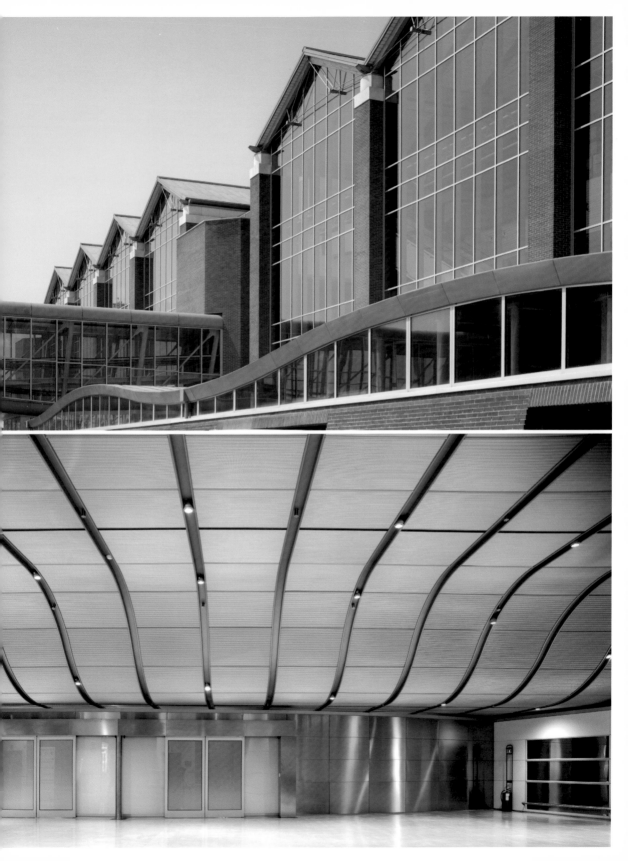

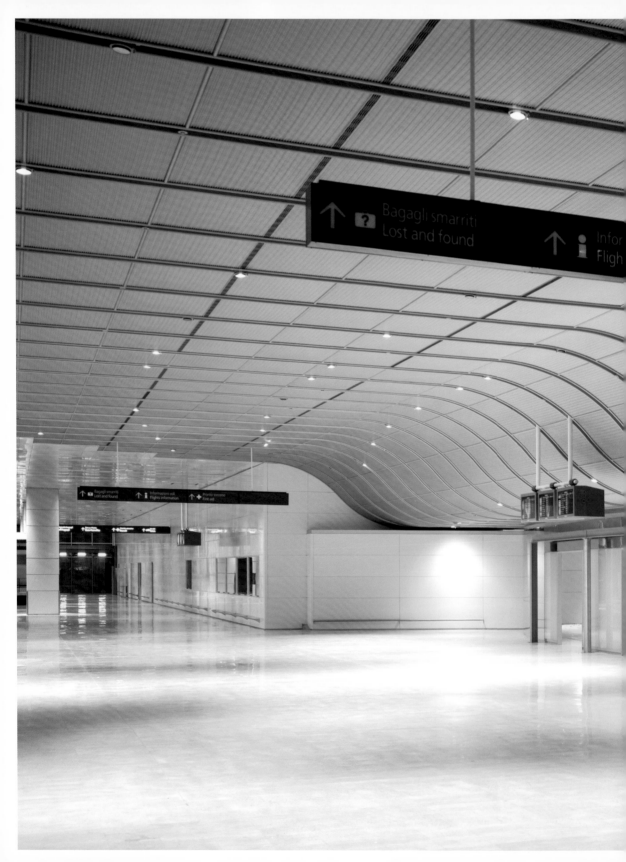

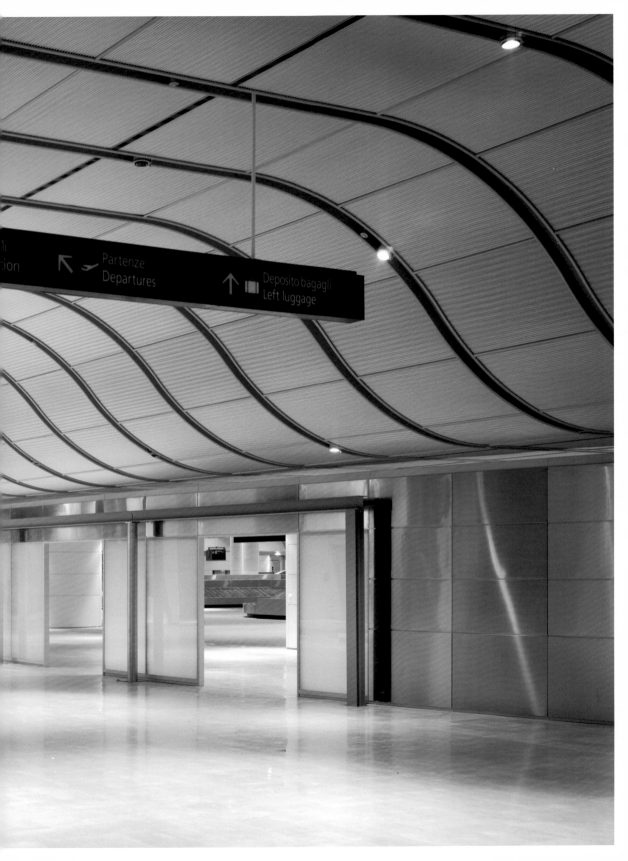

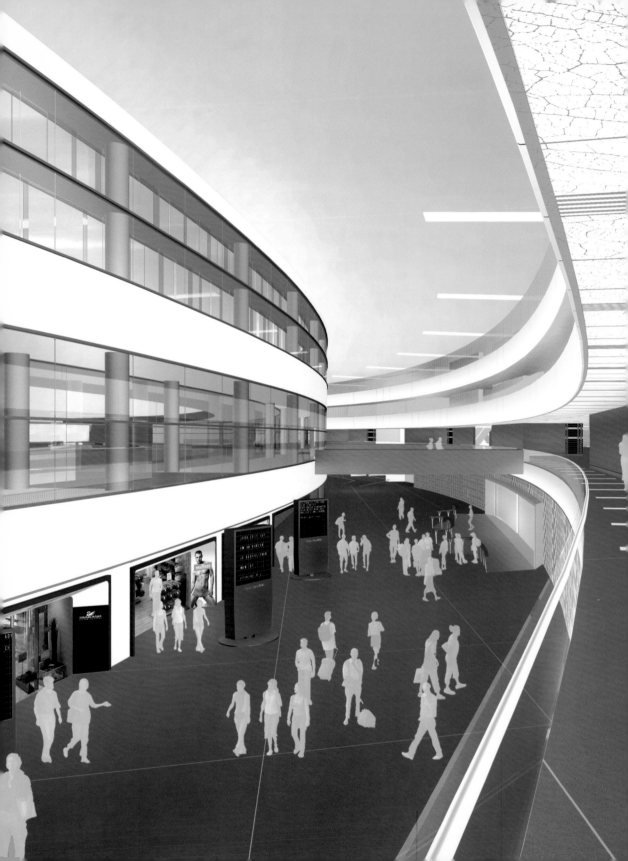

SKYLINK AT VIENNA INTERNATIONAL AIRPORT | VIENNA, AUSTRIA
www.viennaairport.com
ARGE Itten Brechbühl AG / Baumschlager Eberle GbmH | Vienna, 2008

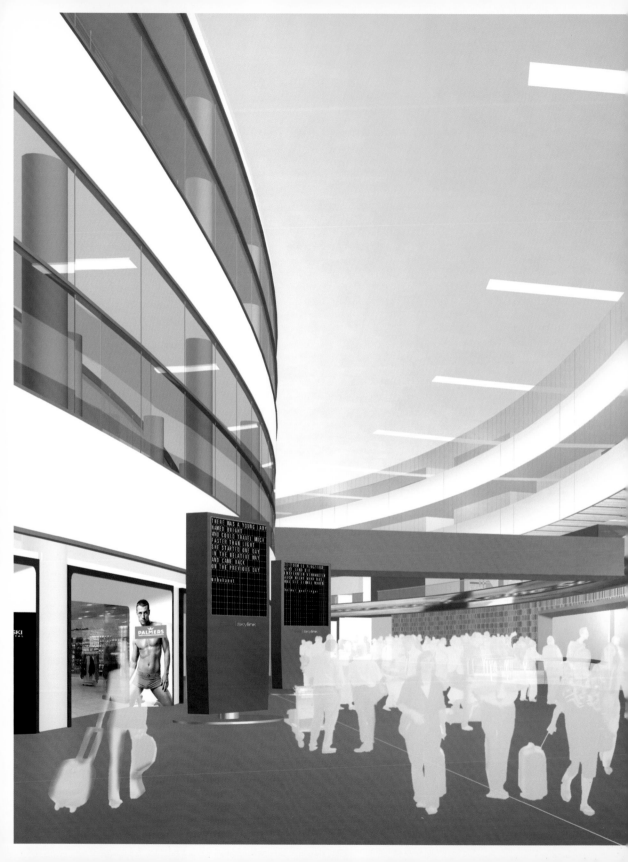

THERE WAS A YOUNG LADY
NAMED BRIGHT
WHO COULD TRAVEL MUCH
FASTER THAN LIGHT
SHE STARTED ONE DAY
IN THE RELATIVE WAY
AND CAME BACK
ON THE PREVIOUS DAY

skylink

PALMERS

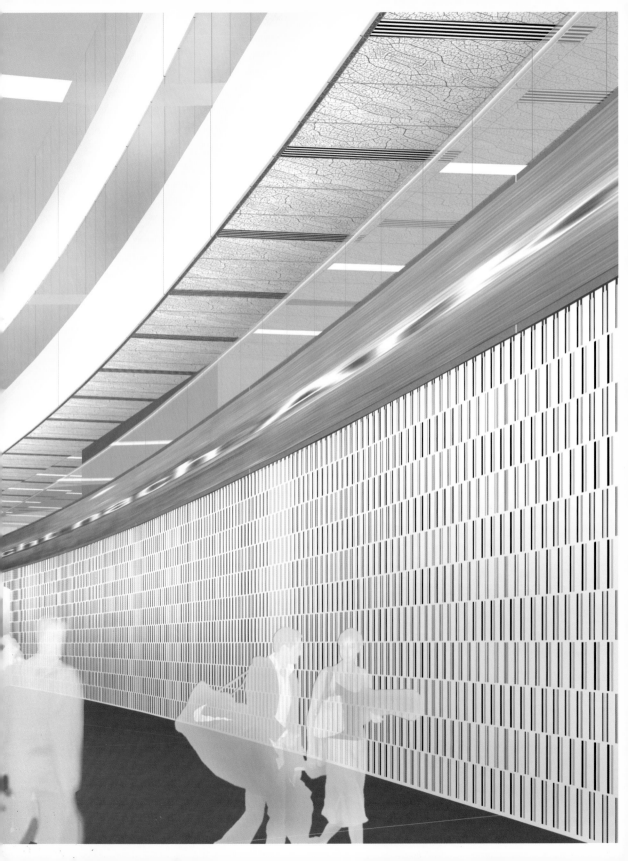

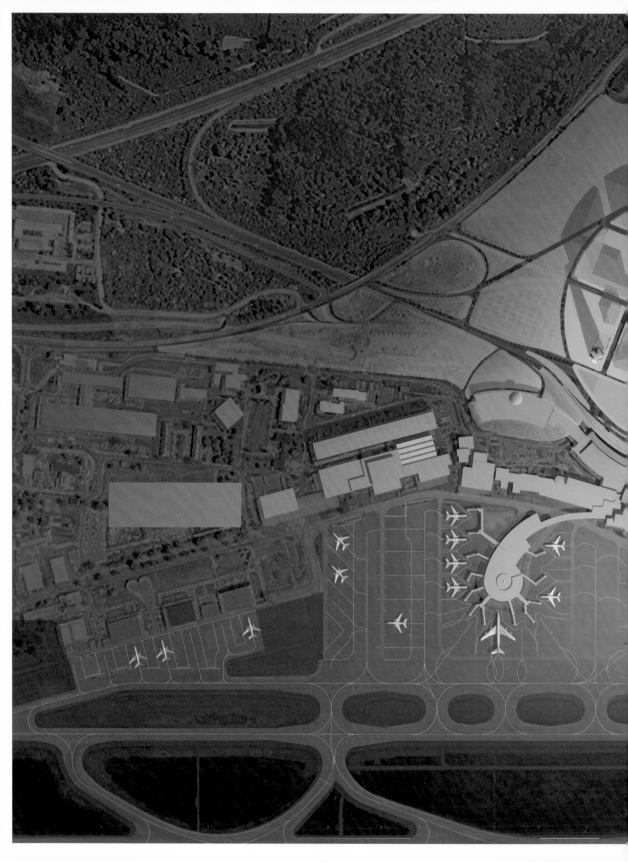

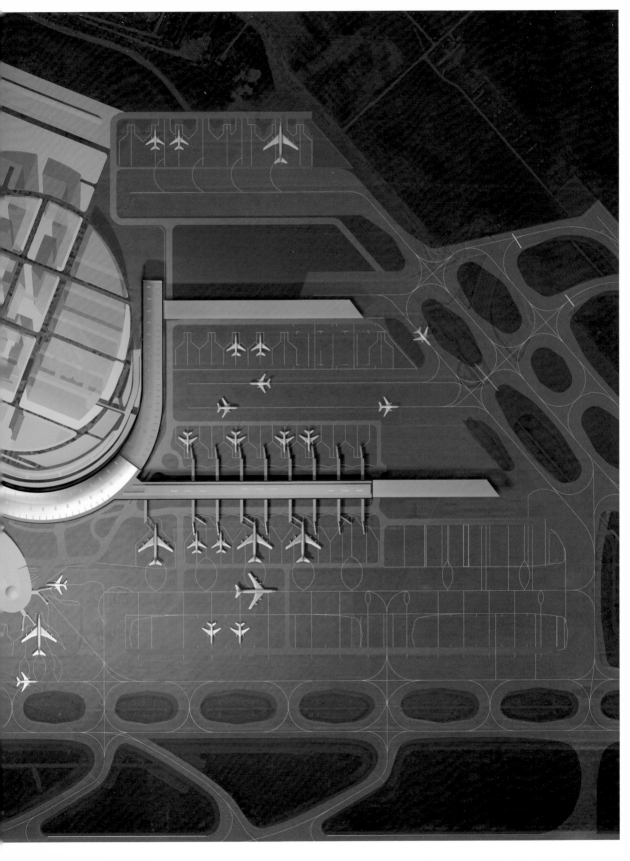

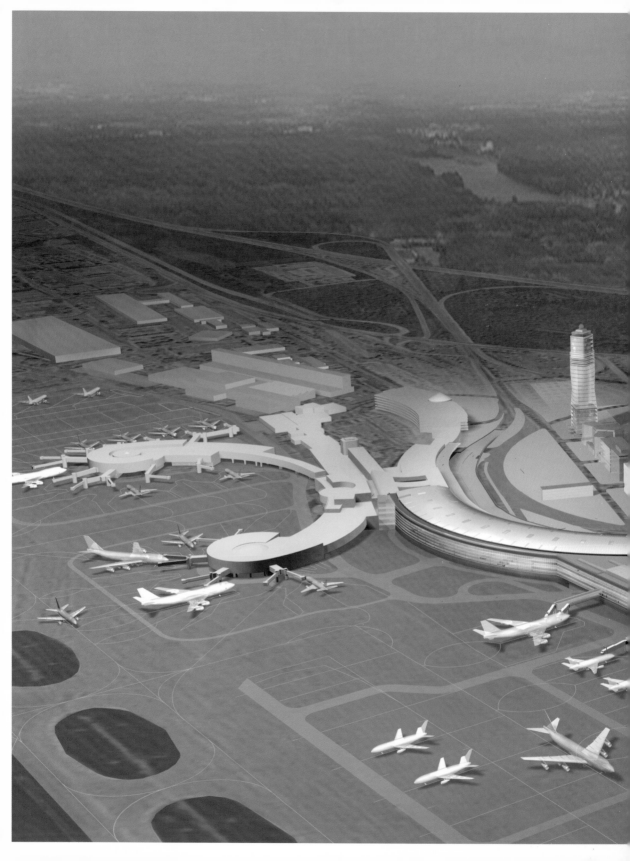

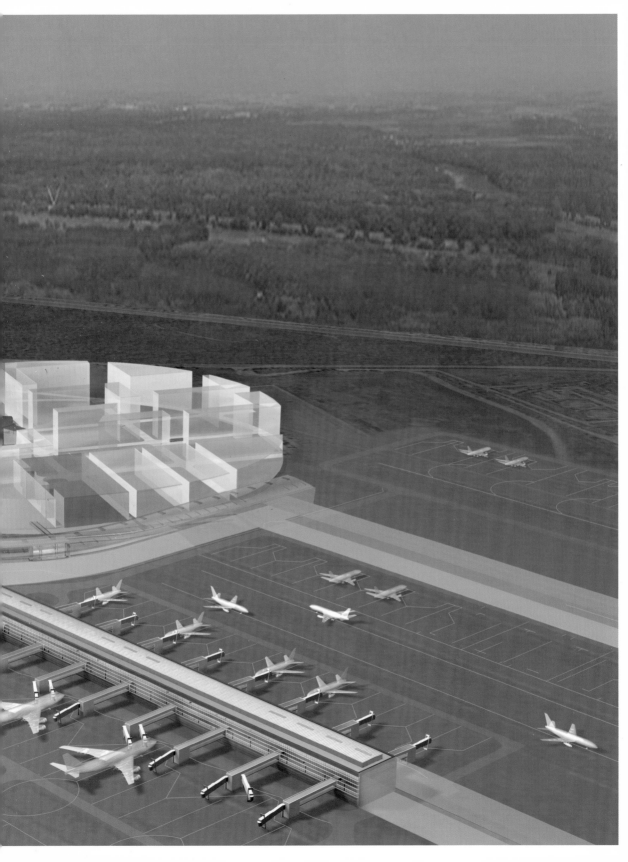

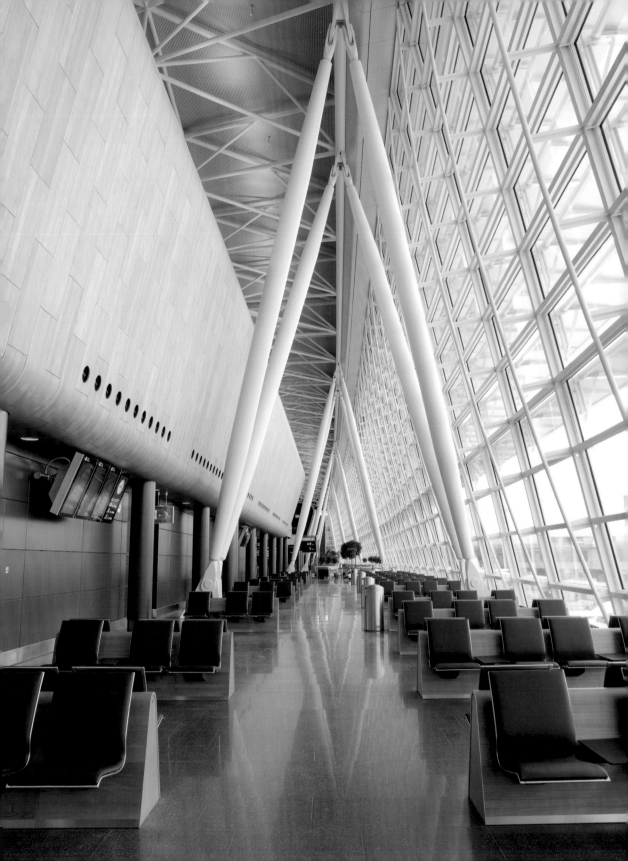

AIRSIDE CENTER AT ZURICH AIRPORT | ZURICH, SWITZERLAND
www.uniqueairport.com
Nicholas Grimshaw and Partners Ltd. | London, 2004

ZRH

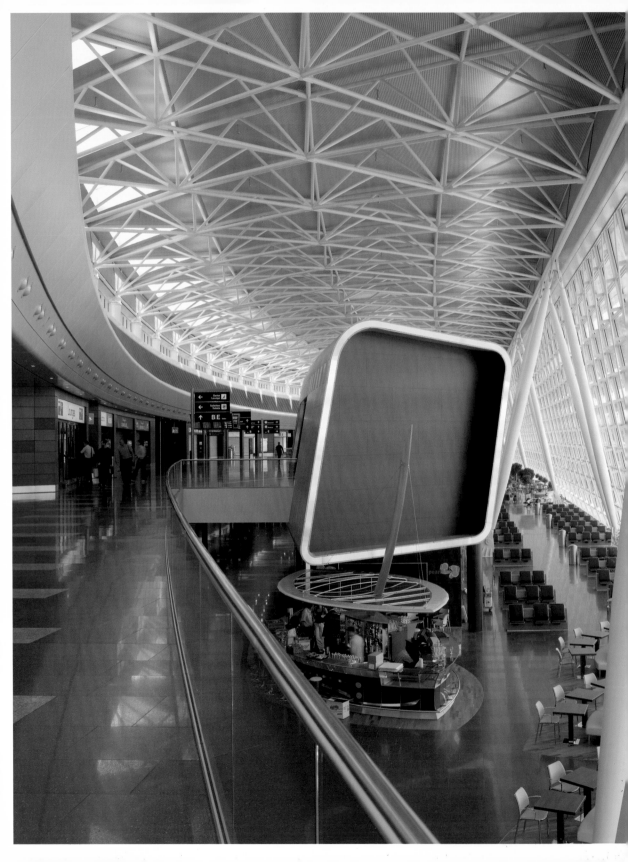

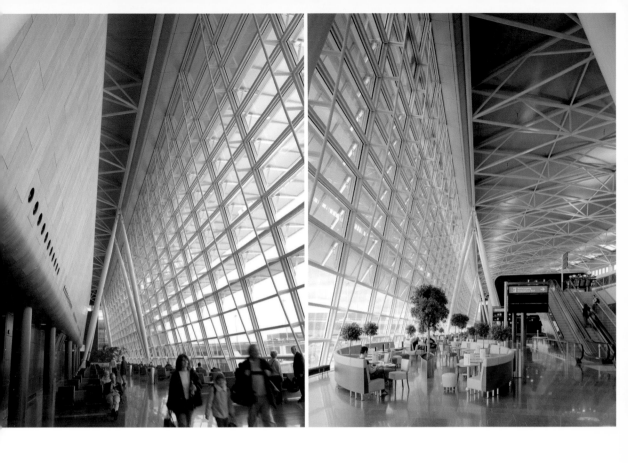

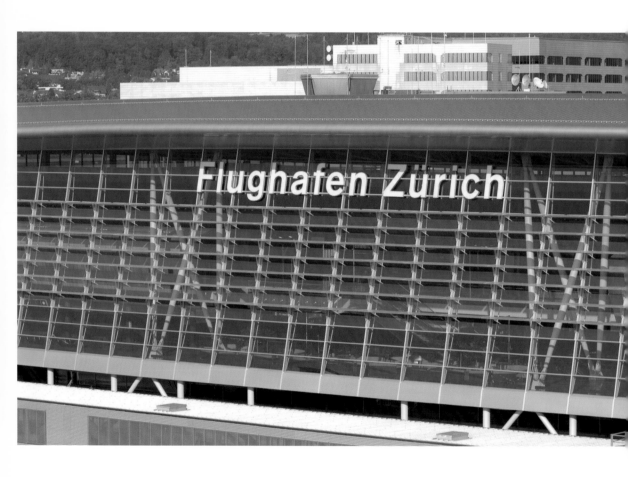

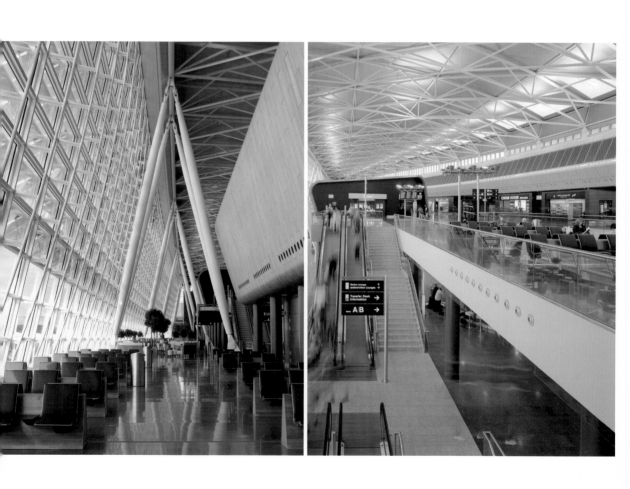

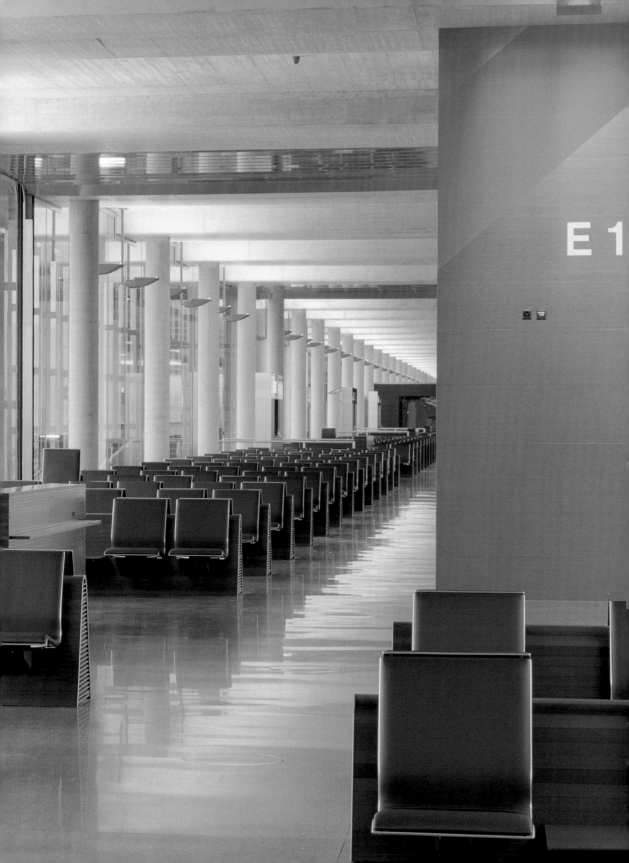

DOCK E AT ZURICH AIRPORT | ZÜRICH, SWITZERLAND
www.uniqueairport.com
ARGE Zayetta | Zurich, 2004

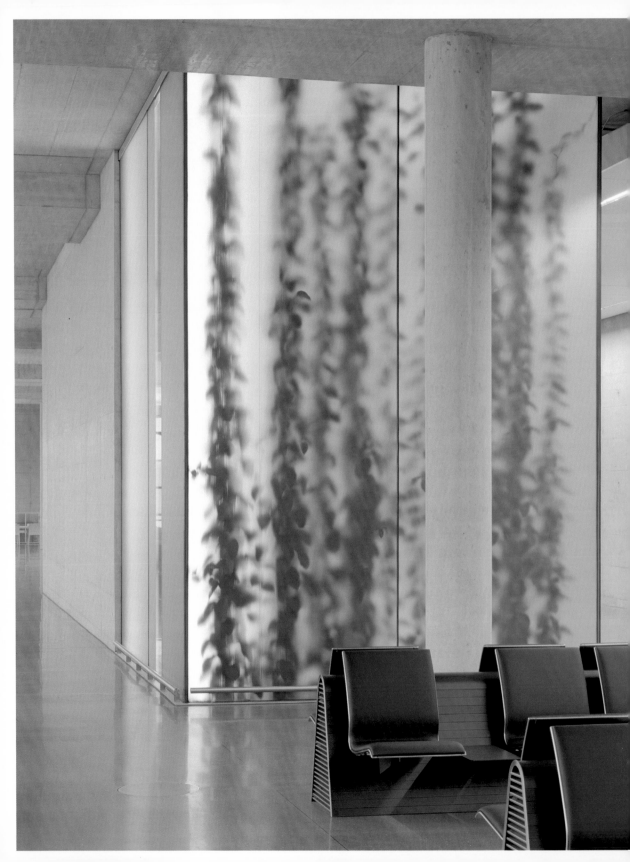

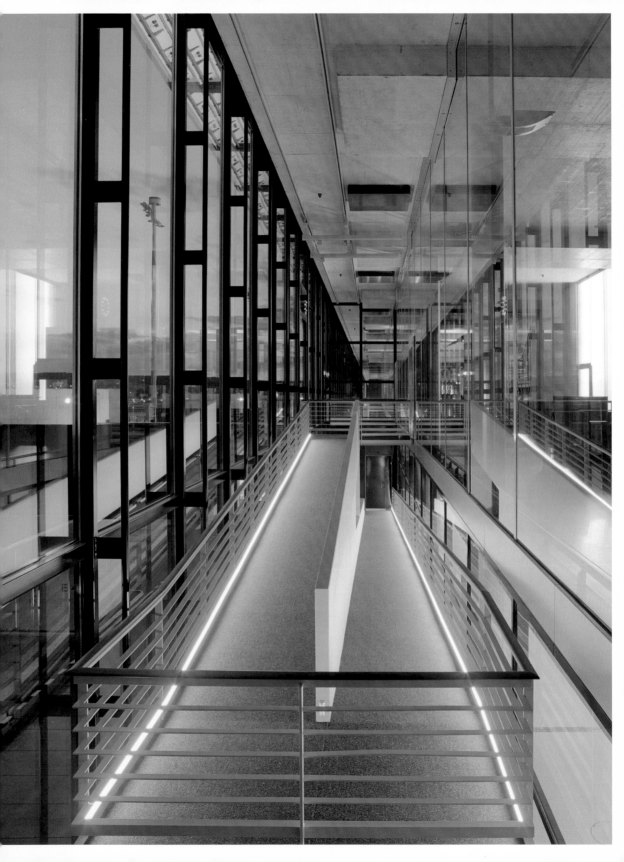

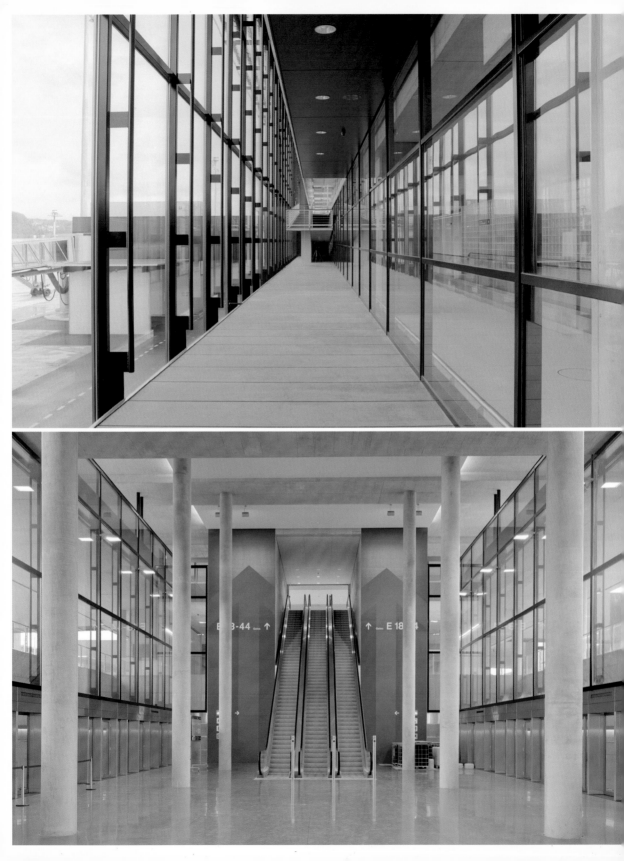

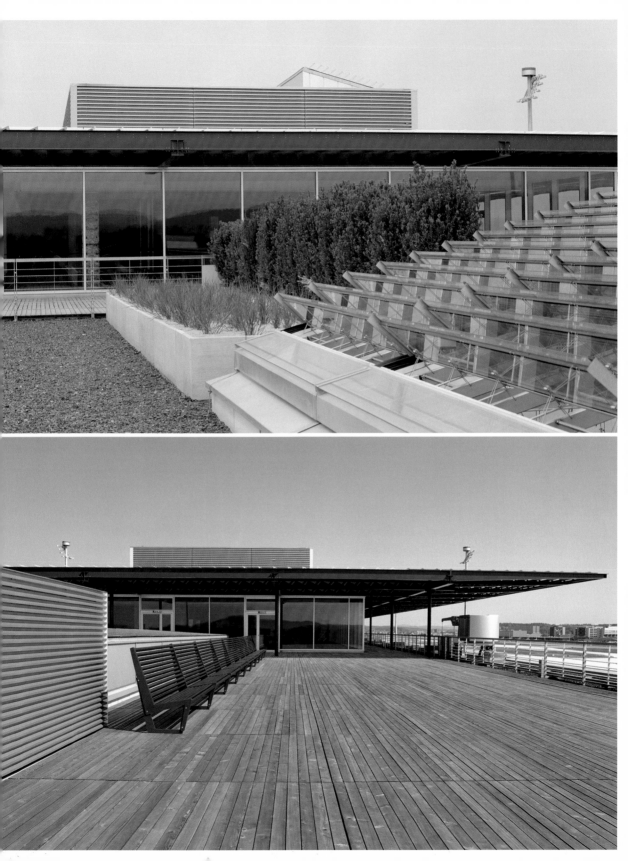

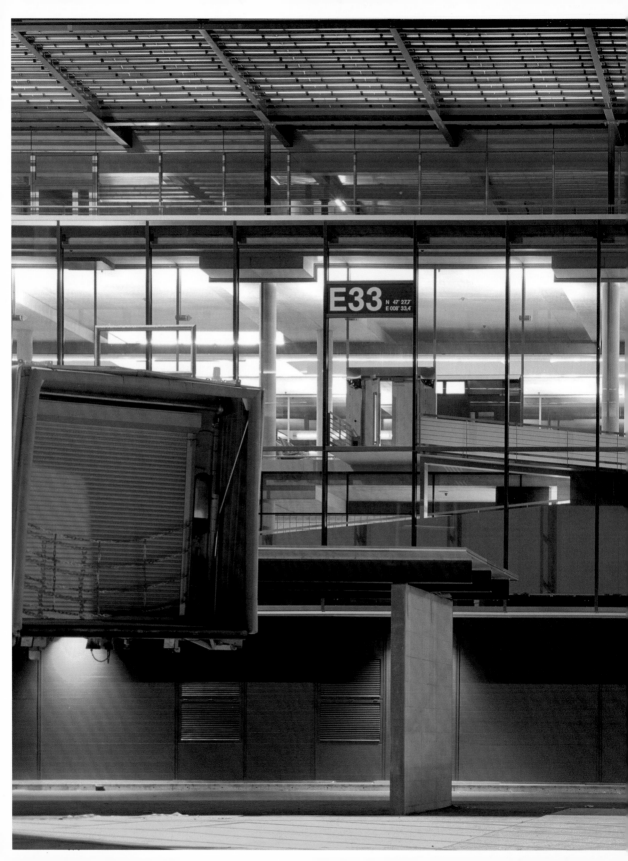

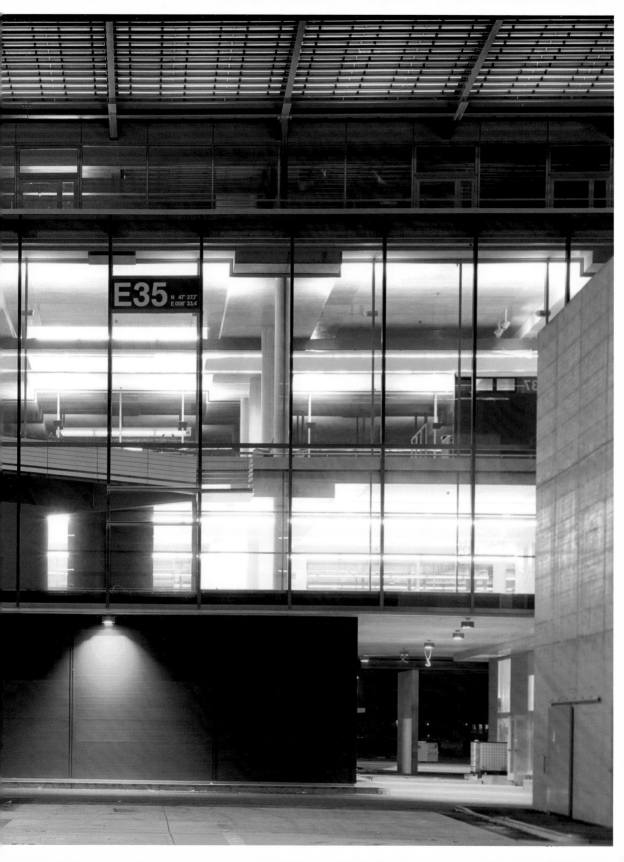

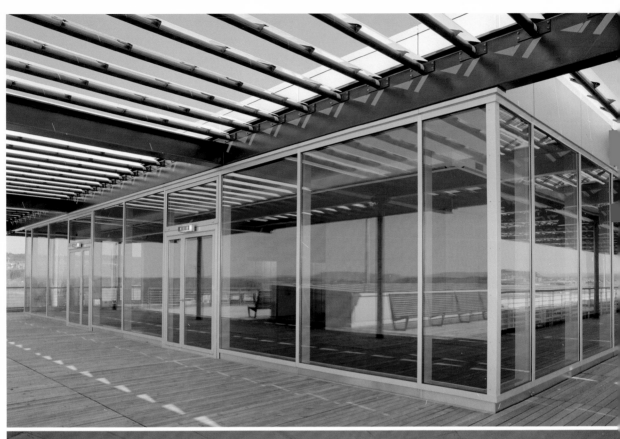

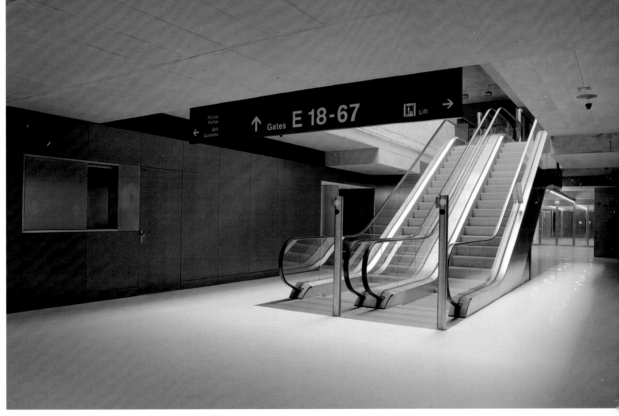

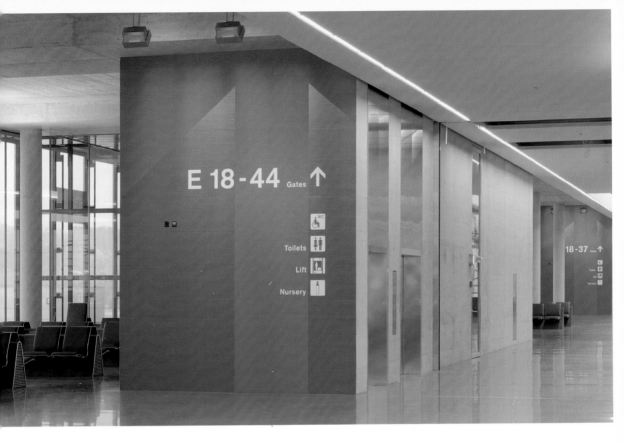

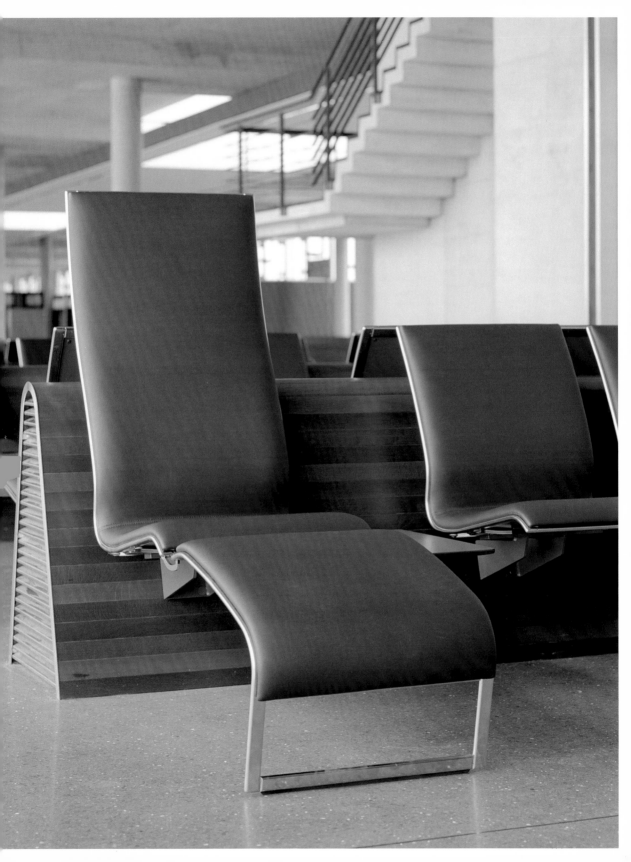

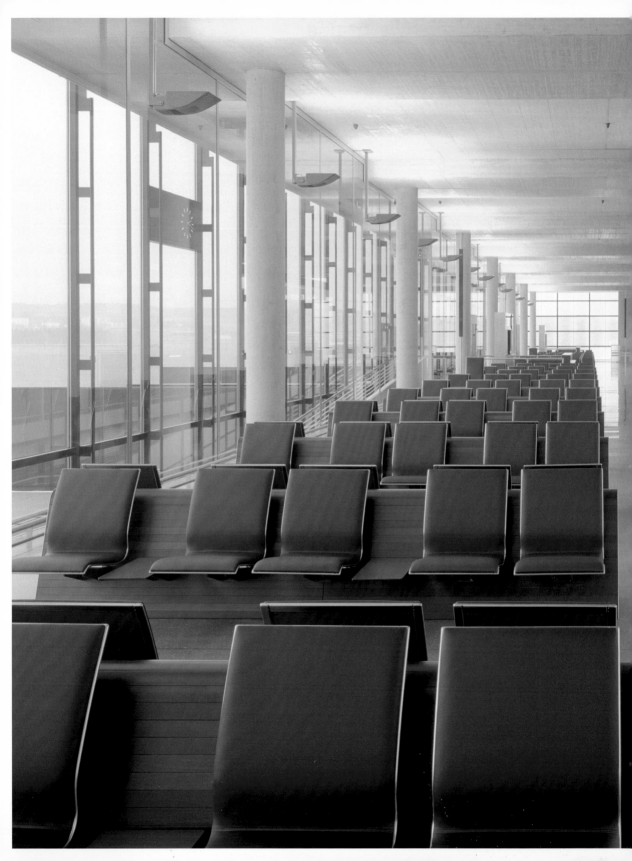

INDEX

© 2005 daab
cologne london new york

published and distributed worldwide by
daab gmbh
friesenstr. 50
d - 50670 köln

p +49 -221 -94 10 740
f +49 -221 -94 10 741

mail@daab-online.de
www.daab-online.de

publisher ralf daab
rdaab@daab-online.de

art director feyyaz
mail@feyyaz.com

editor
christian schönwetter

editorial project by fusion publishing gmbh stuttgart . los angeles
editorial direction martin nicholas kunz
editorial coordination christian schönwetter
© 2005 fusion publishing, www.fusion-publishing.com

layout kerstin graf
imaging jan hausberg

introduction christian schönwetter
translations by saw communications, dr. sabine a. werner, mainz
english translation anthony vivis
french translation béatrice nicolas-ducreau
spanish translation gemma correa buján
italian translation paola lonardi

printed in spain
gràfiques ibèria, spain
www.grupgisa.com

isbn 3 - 937718 - 32- X
d.l.: B - 36446 - 2005